Fra Girolamo Savonarola,
Florentine Art, and
Renaissance Historiography

Fra Girolamo Savonarola, Florentine Art, and Renaissance Historiography

Ronald M. Steinberg

OHIO UNIVERSITY PRESS ATHENS, OHIO

CONTENTS

LIST OF ILLUSTRATIONS

ACKNOWLEDGMENTS

My research in Florence for this study was assisted by grants from the Kress Foundation, awarded through the Department of Art History and Archeology of Columbia University, and from the Fulbright-Hays Commission. Rhode Island College has also been generous in its support for research and secretarial assistance.

I am grateful to Professor Rudolf Wittkower for his suggestion, many years ago, to "look into this Savonarola thing," and his continued encouragement when the results of my research began to prove rather the opposite of what he expected it to show was especially welcome. Professor Ulrich Middeldorf of the Deutsches Kunsthistorisches Institut in Florence was also encouraging at the initial stages of this work and helpful in his reading of the manuscript, as was Professor Wallace Tomasini of the University of Iowa.

For her ever-present inspiration as well as her patient, tough, and well-turned criticism I cannot thank Sheila, my wife, sufficiently. I wish to thank Adriana and Arnoldo Moscato of Florence for their inspiration and assistance in more ways than can be enumerated here.

PREFACE

The reader will be aware of attempts to demonstrate Savonarola's influence on art and to identify examples of Savonarolan iconography, other than those cited here. I did not intend this study to be a compendium of all the literature. This would only have greatly increased the length of the book and proportionately decreased the reader's (as well as the author's) patience. Typical examples were selected for what they revealed of past and present attitudes, faulty assumptions, and untenable inferences so as to present an overall picture of the developing myth of Savonarola's influence on art and artists and its motivations. With such an evaluation the reader will have the requisite context with which to approach other studies.

I trust that the *tabula rasa* (to use a favorite phrase of Savonarola) presented here, marked now by only a few austere, but hopefully indelible, conclusions, will be a benefit to others in their investigations of and pronouncements upon Savonarola's relation to Florence and its art.

PART ONE

HISTORIOGRAPHY

CHAPTER 1

INTRODUCTION TO PART ONE

Because of the difficulty in sharply distinguish-
ing between history and historiography, since
the latter is the structuring and communicating instrument of the
former, the study of history inevitably becomes a study of the writing
of history. Major events and personalities never totally disappear
from the literature, but in turn are stressed, de-emphasized, lauded,
and denigrated. Such has been the case with Fra Girolamo Savona-
rola and his relationship with his adopted city of Florence, its politics,
and its art.

"Let us observe, that if this Dominican was not an imposter, he
must necessarily have been a prodigious Fanatic," commented Bayle
in 1695 in his ambitious and popular *Historical and Critical Diction-
ary*.[1] Almost a century and a half later Villari concluded his biography
of Savonarola by unequivocally stating that "perhaps it will be clearly
seen that had the Church of the fifteenth century hearkened to Savo-
narola's voice, there would have been neither need nor call for a Ref-
ormation; nor religion been opposed to reason and freedom."[2] Bayle
further condemned Savonarola for the fundamental error of mixing
religion and politics, while Villari instead praised the Dominican for
his political beliefs and his attempts to bring Florence and indeed all
Italy under a beneficent government revived in spirit and united with a
church reformed in practice.[3] These summations can be ascribed to
each author's fundamental attitudes: Bayle, as a Huguenot, obviously
smarting from the intrigues of the French court which led to the revo-
cation in 1685 of the Edict of Nantes and thus of his religious freedom,
saw government as filled with "foul intrigues," "plunderings and
massacres," no place for a man of religion, particularly if the govern-

3

ment were a Catholic one;[4] Villari on the other hand, passionately interested in Italian nationalism, a movement which gave impetus to the revival of interest in Savonarola in the nineteenth century, saw in Savonarola's desire to unite religion with republicanism an exemplar for the Risorgimento.[5]

If historians evaluated Savonarola's religion and politics in the light of their own experiences and ideals, it should be expected as well for them to have measured his relation to art by their own conception of what art should be. The historical rehabilitation of Savonarola began in the late eighteenth century and was coincidental with a determination that the Renaissance had its origins in a new Christian spirituality which quickly became endangered by a resurgent paganism. Around the same time there arose the belief that the only true art, the only good art, was one that was directly inspired by God. The inspiring deity rather swiftly became specified as not only the Christian God, but the God of the Church of Rome. All this inevitably came together in the nineteenth century among the Romantics to be woven into the legend of Savonarola's salubrious influence on Renaissance art. This legend, so standardized that it may be called an historiographic *topos*, persisted into present-day literature on the Renaissance, although the interpretations of that period's art and religion upon which the legend is based have long since been questioned and largely revised. The development of this legend will be discussed in detail in the following chapters. Briefly, three early nineteenth-century writers were responsible for creating this positive relationship between Savonarola and Renaissance art.

Villari's statement, in his biography of Savonarola written in 1859-1861, that "in point of fact the Christian ideal of art, as conceived by Beato Angelico and his contemporaries [early in the fifteenth century] was in its decline in Savonarola's day,"[6] reflected the influential thesis presented by Alexis Rio in his book *De la poésie chrétienne* of 1836. Rio, perhaps the first author of consequence to associate Savonarola's piety and reforming zeal with Renaissance art, described Savonarola as the enlightened hero, the warrior of Christ, who sought to reverse the trend toward paganism in Christian art.[7] Padre Vincenzo Marchese, of Savonarola's monastery of San Marco, was largely responsible for the revival of interest in Savonarola as a forerunner of the Risorgimento in his politico-religious beliefs.[8] Marchese published in 1845-1846 his *Memorie dei più insigni pittori, scultori e architetti domenicani*, a work which should be considered as a properly Chris-

4

tian counterpart of Giorgio Vasari's well-known book *Le vite de più ecelènti architetti, pittori, et scultori italiani* written in the middle of the sixteenth century, the period of the Renaissance's supposed decay into paganism. Marchese augmented Rio's theme and gave it the ring of authenticity by replacing Rio's frenetic expostulations with a degree of scholarship.[9]

The arguments and the idiom with which these ideas were expressed by Rio, Villari, and Marchese, closely paralleling those of late eigh-. teenth- and early nineteenth-century Romantic historians, art critics, and theoreticians, will be discussed later.

Of all the events of Savonarola's stay in Florence the burning of the vanities by the monk became a focal point for the attention of historians. Although limited in scope, but nevertheless obvious, the available evidence on this event led to heated and extensive debate concerning Savonarola's positive or negative effect on Florentine art. Since it forms a comparatively simple demonstration of how Savonarola's deeds were interpreted by later factions, it is the initial chapter of our historiographic review. After consideration of the existence of Savonarola's San Marco "School of Art" and his effect on lay artists in general, we shall turn to his specific association, as related in the literature, with Sandro Botticelli, Fra Bartolomeo della Porta, and Michelangelo Buonarotti, three artists who because of their recognition as exceptional talents received the most attention by those who wished to establish Savonarola as a positive influence on Renaissance art. Following a discussion, in Part II, of Savonarola's "Theory of Art" and the possibility of determining his influence on painting style in general, we shall conclude, in Part III, with an explication of several paintings, the iconography of which is wholly dependent upon Savonarola's sermons; it is in this area of investigation that one may concretely, and with the largest degree of demonstrable proof, determine a Savonarolan "influence" on Renaissance art.

CHAPTER 2

THE BRUCCIAMENTI DELLE VANITÀ

Two *brucciamenti* directly inspired by Savona-
rola took place in Florence, one on February 7,
1497, and the other on February 27, 1498. The first of these was de-
scribed in the so-called *Vita latina*, an early sixteenth-century biography
of Savonarola, and in the diary of Luca Landucci, an acute observer
of events in Florence.[1] While the former author may have been an
eye-witness to the event, it is certain the latter was. All the vanities
and indecent things, they related, were brought to be burnt: wigs and
other vanities of women, veils, cosmetic colors, perfumes, mirrors,
and the like; games and gambling instruments; masks and beards of
carnival. Interspersed through the inventory, the following works of
the musical and literary arts are listed: books of music and harps,
lutes, cithers, *buonaccordi*, *dolzemele*, bagpipes, cymbals, *staffette*,
and horns; books of poems, both Latin and Vulgar, the *Morganti*,
Spagne, the *Dieci Novelle* of Boccaccio, the works of Dante and
Petrarch, and other "indecent" writings. Cited among the plastic
arts were: paintings of beautiful figures showing much immodesty;
beautiful ancient sculpted figures of Florentine and Roman women;
sculptured portraits by the great masters such as Donatello and
others; and all indecent paintings and sculpture and prints.[2] The
author of the *Vita latina* noted that the content of the pyre was so
valuable that a Venetian merchant offered to buy it from the *Signoria*
for the great sum of twenty-thousand ducats.[3]

Savonarola's conversion of the devilish Carnival into a Christian
"sacrifice to God" by the destruction of all vain things[4] led to his be-
ing condemned in later centuries as a person who detested art and
caused great works to be destroyed. In attempting to reverse such

6

opinions, Villari denied the artistic value of the contents of the *brucciamenti* by discrediting the account in the *Vita latina* as being over-enthusiastic; the price offered by the Venetian, he believed, gave free scope to that author's imagination in describing the objects to be burned.[5] Nevertheless, the offer of twenty thousand ducats was made, and it is extremely doubtful that a Venetian merchant would have been willing to part with such a sum merely for carnival costumes and cosmetics. Joseph Schnitzer, author of the most scholarly biography of Savonarola (1924), had even less to say about the *brucciamenti* than Villari, as if he were embarrassed by the event. While neglecting to mention either the Venetian merchant or the specific content of the pyre, he tried to mitigate Savonarola's destruction of art works by pointing out that such *brucciamenti delle vanità* were not at all uncommon in Italy in the fifteenth century.[6]

Given the accounts in Landucci's diary and in the *Vita latina*, Savonarola's diatribes against lascivious paintings, the *Morganti*, Ovid, Dante, and other poets, and the offer of twenty thousand ducats, there is every reason to believe that precious works of art were included in the bonfires. And even if Vasari's *Vite* were the only source in which two specific artists (Fra Bartolomeo and Lorenzo di Credi) are noted as having contributed some of their own work to the pyre,[7] there is no reason to believe that artists did not so contribute. Certainly, judging from all descriptions of the event, a great deal of infectious public enthusiasm (even hysteria) was engendered, an enthusiasm in which artists certainly may have participated. This possibility, however, must not allow historians to assume that any artist who was in any way associated with Savonarola, or simply was in Florence at the time, must have contributed to the fire. Nor, even if there were creditable primary sources citing the contribution to the fire of a specific artist (and there are no such sources), should the historian then presume that the artist was a devoted follower of Savonarola all his life. He could merely have been caught up in the religious enthusiasm of the moment, which could easily have quickly dissipated or even become reversed, as it certainly did with the citizens and *Signoria* of Florence one year later when Savonarola was taken prisoner, tortured, and executed.

CHAPTER 3

THE SAN MARCO "SCHOOL OF ART" AND LAY ARTISTS

Emphasized throughout the literature on Savonarola is the so-called San Marco school of artists. As nineteenth-century writers became increasingly more interested in *quattrocento* art and more confirmed in their belief that the glory of the art resided in its dependence upon an intensely spiritual Catholicism, the more attention the "San Marco school" began to receive. This attention was vastly augmented by the foundation in the nineteenth century of spiritual brotherhoods of painters and other artists who, in imitation of what they thought existed before the "pagan" sixteenth century, actually formed cloistered religious groups with conventual labors.[1]

The prime document used in the nineteenth century to attest the existence of the San Marco school was the *Vita latina*, a traditionally hagiographic work with a large section devoted to the "miracles" of Savonarola during his life and after his "martyrdom."[2] This function of the biography alone should have countered its acceptance as an unbiased source. It is related in the *Vita latina* how Savonarola desired the Dominicans of San Marco to practice the arts of painting, sculpture, writing, *murare*, "and similar things" in order to earn money for the monastery, and to pursue them with reserve so they would not become a distraction from the brethrens' religious offices.[3] It is true that Savonarola was not against the production or use of religious paintings in the church and the home, for there is ample evidence in his sermons that he thought such art could play an important role in the Christian community. It is equally true, as we shall demonstrate later, that for Savonarola the practice of painting, sculpture, and architecture, and the

8

methods of their production, formed an important basis for metaphor in his sermons. But metaphors taken from examples of the methods of these arts are always presented along with other examples from the mechanical arts or used interchangeably with them.[4] Clearly, then, for Savonarola the fine arts served a function in churches and homes, as did the other manual activities traditionally grouped together as the "mechanical arts," and Savonarola's (supposed) advice to his brethren, as recorded in the *Vita latina*, echoed this: he wished them to practice these arts as a quiet, legitimate means of support. Savonarola did not advise the practice of the "fine arts" of painting or sculpture as the nineteenth-century writers assumed; for Savonarola the fine arts were in no way distinguished from the other manufacturing arts.

Nevertheless, Marchese, after quoting the passage from the *Vita latina*, stated that although Savonarola wanted to return the monastery of San Marco to a primitive, severe observance, he nevertheless passionately promoted there the practice of the *arti del disegno* and that a little after his tragic death, a choice group of artists came to San Marco to follow the example of Fra Angelico earlier in the century.[5] Shortly after the appearance of Marchese's work, Villari published his biography of Savonarola in which he asked, "Did he not found the school of design in St. Mark's and insist that his novices should practice the arts in order to provide for the necessities of the convent without having recourse to charity? Was he not continually surrounded by a chosen band of the best artists of his age?"[6] The expansion of the meaning of Savonarola's request as reported in the *Vita latina*, a request which surely could have been (and, indeed, had been) made by a host of priors to their brethren in the monasteries of the preceding centuries, continued. John Symonds, early in the last quarter of the nineteenth century, wrote that although Savonarola denounced the heathen painting style of Florence and "forbade the study of the nude, he strove to encourage religious painting, and *established a school for its exercise in the cloister of S. Marco*"[7] (my italics). The more fully documented and detailed biography by Schnitzer published in 1924 also echoed this theme, however without the stress of Symonds;[8] and Ferrara, in his essay of 1952 on the influence of Savonarola on the arts, again reaffirmed the existence of a school of design in San Marco as the direct result of Savonarola's appeal.[9] Finally, in 1959, no less a scholar than André Chastel, giving Marchese as his source of information, stated in his book *Art et humanisme à Florence* that around 1505-1510 a new "École de Saint-Marc" was formed.[10]

9

Despite these obvious misinterpretations the question of whether there was a school of painting in San Marco at the turn of the fifteenth century must be considered, and it should be considered with two questions in mind: if there was such a school, was its existence directly dependent upon Savonarola, and, if it was dependent upon him, can the art it produced be considered Savonarolan? To answer these questions we must examine the number of artists at work at San Marco at the turn of the fifteenth century relative to the number of artists who worked there earlier in the century; we must look at the kind of work produced in the convent in both periods; and we must consider the practice of the arts in other Dominican monasteries at the time.

According to Marchese himself, the practice of the arts among the Dominicans in Tuscany and in San Marco was not exceptional. He recorded that from the mid-thirteenth century through the fourteenth century there were at least sixteen Dominicans, all but one of whom were from Santa Maria Novella in Florence, who practiced as architects, *muratori*, and carpenters; there were also many other artists and artisans from Dominican monasteries in Bologna and Lombardy. Marchese also noted the existence, in the fourteenth and fifteenth centuries, of eighteen miniaturists at work in Santa Maria Novella primarily, but also later in San Marco.[11] Of special interest is his recording that the Blessed Fra Giovanni Dominici of San Marco (died 1419), although a strict reformer of the Dominican rules, in a letter to his brethren at another monastery advised them to practice the art of the miniaturist.[12] In comparison to painting, the small scale and wholly insular art of the miniaturist is more in keeping with the monastic life, one of the reasons it was the most preferred of the figurative arts in convents. Marchese could cite comparatively few Dominican painters, with the exception of Fra Angelico, who worked outside the monastery.[13] Indeed, as we well know, and as Marchese was also aware, large numbers of miniaturists were at work in Dominican monasteries for many centuries, and that order was certainly not unique in its practice of the art.[14]

Thus the artistic activity of San Marco during and after the time of Savonarola was not exceptional for that order, nor was Savonarola the only prior to advise the practice of art for his brethren. Rather Savonarola, like Saint Antonine in the middle of the fifteenth century and the Beato Giovanni Dominici earlier in the century, was concerned with the role of art in San Marco. Marchese pointed out, furthermore, that in the *Necrologia* of the Dominican monasteries the term used to

describe miniaturists was not *miniatori*, but *"belli Scrittori."*[15] This suggests that Savonarola's purported words to his brethren to practice the art of writing, as well as the other arts, may in fact mean the art of the miniature.

Thus, if the *Vita latina* is correct, Savonarola was merely playing his role in the Dominican tradition by asking his brethren to practice the arts. If the *Vita latina* is not correct, the Dominican author was simply trying to place Savonarola in that strong Dominican tradition.

Marchese compiled a list of artists, including three miniaturists, four painters, two architects, and one sculptor, "who under the influence of Savonarola took the Dominican habit in San Marco in Florence."[16] Of these ten artists, four were either given the habit or professed by Savonarola, and one other was professed during Savonarola's year in Florence. Three others were professed in San Marco, in Florence, and the Dominican churches in Fiesole and Prato shortly after Savonarola's death. For the remaining two, only their death dates are known; they may have, for all we know, entered San Marco before Savonarola was active there.

With the exception of the last two artists, who may have been active earlier than the turn of the century, the list does indicate more Dominican artists at work in San Marco in the years around 1500 than at work there earlier;[17] that is, of course, judging from what has survived of what was recorded. Nevertheless, before drawing any conclusions from this, we must at least pose the perhaps unanswerable question of Savonarola's role in these artists' joining the Dominican order. Marchese and others indicated that four of the artists were either vested or professed by Savonarola out of their love for him.[18] But is it not possible that since Savonarola was prior of San Marco at the time the performance of this ceremony would normally fall to him anyway? Furthermore, considering that three of these artists were miniaturists, would it be unjustified to question the possibilities for the pursuit of this art outside the monastery at the turn of the fifteenth century in Florence? And did they practice the art before they joined the monastery? That they were miniaturists may also have been, after all, only incidental to their religious vocation. However, one of the miniaturists, Fra Benedetto (or Bettuccio) according to the documents, did have a further relation to Savonarola. His name appears in the documents relative to the *Signoria*'s investigation of those involved in the armed defense of San Marco when it was attacked by the anti-Savonarolan forces; the author of the *Vita latina* mentioned him twice in this re-

gard.[19] No attempts have been made in any of the literature to discern an "influence" of Savonarola in the works of these miniaturists. Such an attempt would be sorely frustrating from the beginning, since only some of the works of one of the artists, Fra Eustachio (1473-1555), are known. Several works are attributed to him, but none can in any way be associated with Savonarola either personally or iconographically.[20]

Of the four painters, only one was professed in San Marco during Savonarola's priorship there. The other three were professed elsewhere after his death.[21] The outstanding name among the painters, as well as in the total list, is that of Fra Bartolomeo della Porta. His association with Savonarola and his work will be discussed later. Hardly anything beyond their entrance into San Marco is known of the other three painters. At times, one or another of them is cited in the literature as helpers of Fra Bartolomeo, or of Fra Bartolomeo's successor, Fra Paolino da Pistoia.

The sculptor at work in San Marco who was professed into the order by Savonarola at the end of 1495 was Fra Ambrogio (Pier Francesco) della Robbia.[22] During his thirty-two or thirty-three years in San Marco, Fra Ambrogio is known to have executed fourteen works, of which one is a *stemma* and another a series of apothecary jars; two attributions are also included in this number and none are known to have been done for San Marco.[23] The remaining ten works cannot be associated with Savonarola (aside from their being of Christian subjects) either by the identification of the attitudes of their commissioners toward Savonarola, or by the iconography of the individual works, which are only standard representations of traditional religious subjects. Only the two medals attributed to Fra Ambrogio bearing portraits of Savonarola have on their reverse sides an iconography based upon Savonarola's sermons. However the total iconography of the object is that of commemoration of Savonarola and his prophecies, and not that of a new religious subject introduced by Savonarola or a standard religious subject changed as the result of Savonarola's teachings. Thus the medals will be discussed in the chapter on commemorative images of Savonarola.[24]

The two architects on the list are known merely from that title next to their names in the San Marco annals in which they are noted as having died in 1501 and 1522, respectively.[25]

Thus the activity of the School of San Marco, which was supposed to have been "revived" by Savonarola, was in reality only slightly ex-

ceptional when viewed in the context of artistic activity among the Dominicans and wholly insignificant when viewed in the context of the artistic activity outside the monastery's walls in Florence. Furthermore, the importance of this school for its indications of an "influence" of Savonarola on art, which is made so much of in the literature (i.e., simply by the repetition over and over again of Marchese's list), must be tempered by the fact that apparently, with the exception of the works in the first few decades of the sixteenth century of Fra Eustachio, Fra Bartolomeo, and Fra Ambrogio, the remaining seven Dominican artists were either comparatively inactive or of such minor importance at the time as to have left behind no record of their works. Some of them may well have been personal adherents of Savonarola, but in the context of Savonarola's influence on their art, their importance and historical roles are negligible.

Further indication of the relative unimportance of the three painters in Marchese's list who were contemporaries of Fra Bartolomeo in San Marco lies in the fact that it was a much younger painting *frate* from San Domenico in Pistoia, Fra Paolino (1490-1547), with whom Fra Bartolomeo chose to work and who produced paintings from Fra Bartolomeo's drawings; it was also to him that Fra Bartolomeo willed his possessions.[26]

Fra Paolino arrived in Florence in 1503; his works date from the second decade of the sixteenth century until his death. A large number of his paintings were commissioned by Dominican institutions and contain much Dominican iconography.[27] Only one of his paintings bears any direct relationship to Savonarola. It represents Christ seated on a cloud in the heavens above the city of Florence with the Virgin, also raised on a cloud, kneeling at His right side and looking up to Him; below them, kneeling on the ground, are three Dominican saints, one of whom, Saint Dominic, represented by a distinct portrait of Savonarola, looks up at Christ and the Virgin and points to the city of Florence below them. Rather than interpreting this painting as an instance of Savonarolan iconography, we should understand it as an example, as in the medals attributed to Fra Ambrogio, of an iconography developed to commemorate Savonarola and, in this case, his role in Florence; as such it will be discussed in the appropriate chapter.

According to the literature Savonarola's influence extended to a large number of lay artists as well. The first association of artists' names with Savonarola occurred in the *Vita latina*. In addition to the Dominican miniaturist, Fra Benedetto, whom the author cited as taking

13

arms in defense of San Marco when it was attacked by the *arrabiati*, he mentioned Lorenzo di Credi and a certain Lapo, a marble sculptor, as being among those who obtained relics of Savonarola after his execution, and Baccio da Montelupo as being one of the unfortunates who, because of their adherence to Savonarola, had to flee Florence when Savonarola was imprisoned. Baccio fled to Bologna where he fell ill and was cured by a miracle enacted by Savonarola.[28] It should be kept in mind that these men were not cited by the author of the *Vita latina* because they were artists; their professions simply identify them, as do the professions and origins of other people mentioned in relation to Savonarola throughout the book. (The author, however, did note that Baccio da Montelupo, while staying in the house of the canon of the Bologna cathedral, carved a Christ with the twelve Apostles that was so marvelous that all the city came to see it.) Fra Bartolomeo, a Dominican painter whose artistic importance was recognized at the time and who bore a particular relation to Savonarola, was not mentioned at all, since apparently none of his activities in this relationship seemed important for the author's account; as merely an artist, there was no need for him to be included.

Later in the century, Vasari added several names to this list of artists associated with Savonarola, although he had nothing to say about Baccio da Montelupo's partisanship for Savonarola.[29] Lorenzo di Credi, two of the della Robbia, Il Cronaca, Sandro Botticelli, and Fra Bartolomeo della Porta, according to Vasari, were devotees of Savonarola; he also noted that Giovanni delle Corniole and Raphael did portraits of the monk.

In the second edition of the *Vita* of Fra Bartolomeo, Vasari stated that Lorenzo di Credi added his studies of the nude to the burning of the vanities,[30] an incident which is not mentioned at all in either the first or second editions of the *Vita* of Lorenzo di Credi himself. It is difficult to conceive of Vasari's reason for omitting this incident from Lorenzo's *Vita*, particularly since he apparently desired to strengthen, in the later *Vita*, his account of Lorenzo's passion for Savonarola.[31] The effect of this omission, however, is to temper any firm acceptance of Vasari's account of Lorenzo's role in the burning of the vanities.

The same elaboration of scanty material for what we must presume to have been literary purposes, that is, to give the reader a fuller, apparently more complete and understandable biography of the subject, can be found in the *Vita* of the architect Il Cronaca. In the first edition, Vasari wrote that Il Cronaca worked on the Sala del Gran

Consiglio in the Palazzo Vecchio, then he stated that "there entered the head of Cronaca such a frenzy for Savonarola, for whom he was so impassioned, that he did not want to think of anything but him."[32] This account is embroidered in the second edition as follows: "At that time, there was to be built the great hall in the Palazzo for the Consiglio of Fra Girolamo Savonarola, who was a famous preacher, . . . and a great friend of Cronaca who was devoted to him." Then, "Cronaca was put in charge of the work as an ingenious artist and also because of his friendship for Fra Girolamo." At the very end of the *Vita*, the same description of Cronaca's passion for Savonarola as found in the first edition is repeated.[33] Even greater differences between the comparatively simple first edition and the elaborated second edition can be found in the *Vite* of Fra Bartolomeo and Sandro Botticelli; the relation of these two painters to Savonarola will be discussed later.

In the second edition of the *Vita* of Luca della Robbia, Vasari noted that two of Andrea della Robbia's sons were invested as *frati* in San Marco by Savonarola, to whom, as he wrote, the della Robbia were always devoted; they also, according to Vasari, executed portrait medallions of Savonarola.[34] The sons in question are probably Mattia and Ambrogio della Robbia, who were frocked by Savonarola, according to the documents, on February 23, 1496, and December 8, 1495, respectively.[35]

Vasari cited two other portraits of Savonarola, one executed in intaglio by Giovanni delle Corniole, and the other in fresco by Raphael. The Corniole intaglio of Savonarola, who "in his time was adored in Florence," is mentioned in the *Vite* of Valerio Vincentino and other cameo carvers in the second edition.[36] According to Vasari, the Raphael portrait of Savonarola is included among the depictions of the doctors of the church and theologians in the *Disputà*.[37]

Thus Vasari cited Il Cronaca, two of the della Robbia, Lorenzo di Credi, Fra Bartolomeo della Porta, and Sandro Botticelli as adherents of Savonarola. Of these, only the citations of the della Robbia and Fra Bartolomeo can be substantiated with primary documentation; no other source associated Il Cronaca with Savonarola; the association of Lorenzo di Credi received a kind of substantiation in the undocumented account in the *Vita latina*. It is worth noting once again that the rather full account of Baccio da Montelupo's relation to Savonarola as recorded in the *Vita latina* is not referred to at all by Vasari, nor does he even associate the two names.

The question that must be posed is to what extent we should accept

15

or discount Vasari's reports of the devotion of these artists to Savo-
narola. Surely any acceptance must be qualified by the inconsistencies
in the *Vite* (the treatment of Lorenzo di Credi's participation in the
burning of the vanities, for example), and by the author's elaboration
and enlivenment of the material of his *Vite* for the second edition,
which was not necessarily prompted by newly discovered evidence.[38]
But can we, because of this, deny completely that Vasari had any
basis for his statements? He was, after all, correct in the cases of the
della Robbia and Fra Bartolomeo. Should we assume that Vasari had
some basis for his accounts of the involvement of the other artists
with Savonarola? Certainly he could have had his stories by word of
mouth from still living contemporaries of the artists and events in
question (and thus not have felt any need of corroborating evidence
as a modern historian would in a similar situation), but there may be
no way of ever knowing this. Furthermore, primary documentation re-
vealing personal aspects of artists' lives at the turn of the fifteenth
century is extremely scarce. The question, then, remains moot. Even
if we had the answer, its relevance for determining an influence of
Savonarola on the artists' works may be negligible.

If the paragraph in the *Vita latina* stating Savonarola's desire for
the monks to occupy themselves in the mechanical arts was accepted
without question by past historians, there seemed no reason to question
Vasari's more detailed and appealing accounts of artists' involvement
with Savonarola. Even Corniole and Raphael, who Vasari did not say
were devotees of Savonarola but only that they did portraits of him,
are later included among the "Savonarolan" artists.[39] Marchese wrote:
"the artists who were partisans of Savonarola were easily recognized
to be the foremost of the Florentine school in all forms of design," and
he went on to name Corniole in gem-cutting, Baccio Baldini and
Botticelli in engraving, Il Cronaca in architecture, the della Robbia
family in modeling, Baccio da Montelupo in sculpture, and Fra Barto-
lomeo and Lorenzo di Credi in painting.[40] The only thing Vasari said
about Baccio Baldini was that since he was not very inventive in design
he engraved the drawings of Botticelli. The assumption was that he
also engraved a *Triumph of Faith* by Botticelli which, it was also
(erroneously) assumed, was based on Savonarola's treatise *Il Trionfo
della Croce*.[41] Villari, referring to Vasari, reaffirmed the connections of
these artists to Savonarola and added Michelangelo to the list. Michel-
angelo, he stated, "constantly read and reread the Friar's sermons."[42]
Similarly, we are informed that Lorenzo di Credi, Baccio da Montelupo,

and Il Cronaca were to be seen daily through the 1490s in the cloister of San Marco.[43] Further additions were made by Ludwig Pastor in his widely used book *Geschichte der Päpste* with the names of Perugino and Francesco di Simone Ferrucci. Perugino was added because he supposedly painted hardly any subjects but the Pietà in the last years of the fifteenth century—a subject supposedly "Savonarolan." No reason was given for the inclusion of Ferrucci's name.[44] Additions to this now rapidly growing list and further amplification of the artists' involvement with Savonarola were supplied by Joseph Schnitzer in his influential biography of Savonarola.[45] Perugino was cited for the same reasons proposed by Pastor; Villari's and Pastor's accounts of Savonarola's influence on Michelangelo were greatly expanded. The name of Francesco Francia was also brought into the circle of Savonarolan artists, because, according to Schnitzer, although he lived and worked in Bologna and not Florence, he had much concourse with the *frati* in Bologna, and his paintings of the *Deposition* and *Entombment* reflect Savonarola's descriptions of the sadness of the Virgin at these incidents, while his *Adoration* reflects Savonarola's words about the Virgin's joy at this moment.[46] Similarly, the portrayal of the Virgin by Perugino and Raphael in their paintings of the Entombment further indicated for Schnitzer their adherence to Savonarola.[47]

After Schnitzer, more recent works such as Ridolfi's biography of Savonarola and Ferrara's essay on the influence of Savonarola on the arts have been somewhat more circumspect. Besides the usual list of Dominican artists working in San Marco, they mentioned only Baccio da Montelupo, Il Cronaca, the della Robbia, Lorenzo di Credi, Botticelli, Fra Bartolomeo, and Michelangelo; concerning Corniole's gem portrait of Savonarola, Ridolfi merely noted, after listing the above artists, that others, such as Corniole, did portraits of the *frate*.[48]

In this survey of the literature a particular trend is observable. At first, it only seemed necessary to indicate that artists were followers of Savonarola; Marchese and Villari show no concern for how this devotion of the artists to Savonarola might have been manifested in their art. Rather, as staunch advocates of Savonarola and his cause, they saw in his influence on artists a much desired countermovement to the growing paganism of the arts, as they viewed it, toward the end of the fifteenth century; a straying away from the "Christian ideal of art" which, "conceived by Beato Angelico and his contemporaries, was in its decline in Savonarola's day."[49] This belief of early nineteenth-century historians in the "paganism" of the later fifteenth cen-

tury was strongly reaffirmed by Burckhardt in 1860, persisted in by Pastor and Schnitzer, and used as the foil against which Savonarola and his artist-followers admirably reacted.[50] For these authors, the reaction was specifically against the profaning inclusion of donor's portraits in religious paintings; the depicting of mythological subjects more than Christian subjects (or, which was considered worse, including them in Christian subjects); the "sensuous naturalistic style"; the unnecessary use of the nude; and numerous other "unChristian" motifs, subjects, and styles. The words of Savonarola on art were also used as indications of the prevalence of this "paganism" in art against which he had to contend, and were, according to these historians, heeded by his artist-followers. Thus, it was considered sufficient to demonstrate that through Savonarola's influence the errors of paganism were corrected at least in the works of some artists. Indeed, granting the existence of a trend toward a pagan art, it was more important to show how the movement was fought by Savonarola and the artists than to reveal how a single painting in particular reflected the words of Savonarola,[51] for in removing any "pagan" elements the paintings become more Christian and thus essentially better.

Another reason for this stress on demonstrating through whatever means possible Savonarola's salubrious influence on art and artists existed in the rehabilitation in progress during the nineteenth century of his character and deeds and concomitant attempts to prove that he was not an iconoclast as had previously been believed. What better way of doing this than by showing that painters, sculptors, and architects who were recognized to be the best of the period were his adherents in the good cause of "re-Christianizing" art? Furthermore, his followers among artists were often enumerated along with his followers among humanists, the members of the most noble Florentine families whom he brought into the Dominican order, important political figures, poets, and the like, thus indicating his positive role in all that was currently held to be glorious in Florentine history.

18

CHAPTER 4

BOTTICELLI, THE RENAISSANCE, AND THE ROMANTICS

Five monographs on Sandro Botticelli were published between 1893 and 1908 in England, Germany, and Italy; these have formed our current understanding of Botticelli's art and life.[1] In the intervening generations since these studies by Ulmann, Steinmann, Supino, Cartwright, and Horne the overall picture they presented, although refined in parts, has remained basically unchanged and essentially unchallenged. They reviewed the evidence relating Botticelli to Savonarola and enthusiastically concluded that Botticelli was a partisan of Savonarola and that this allegiance seriously affected the artist's life and work. So convincingly did they create this image that an historian of the next generation proclaimed that even without the documentary evidence of Botticelli's love for Savonarola his paintings reveal "thousands of instances of proof" that he was a follower of the monk.[2] And so literally has the artist's partisanship of Savonarola been accepted that in a recent scholarly publication we find it stated, in passing but nonetheless unequivocally, as if it were common knowledge, that Botticelli had been "openly an ardent *piagnone* or ultra-religious supporter of Savonarola."[3]

One of the primary sources used by historians at the turn of the century for establishing a relation between Botticelli and Savonarola was the activity of the artist's brother Simone, who was such an ardent partisan of Savonarola's that he had to leave Florence for safety after the uprising against the monk in April, 1498, as he himself recorded in his *Cronaca*.[4] Unless Simone merely neglected to record his brother's similar plight we may assume that it was safe for Botticelli to remain

in Florence, or at least that he had no equally compelling reason for flight. Cartwright (1904), however, wrote that although Sandro was a partisan of Savonarola he did not have to leave Florence because of his friendship with Lorenzo di Pierfrancesco de' Medici, who served, she believed, as Botticelli's protector in this instance.[5] Actually, Lorenzo left Florence for Lyons in March, 1497, and did not return until the end of 1498, six months after the uprising.[6] Horne (1908), noting Cartwright's error in chronology, nevertheless accepted her assumption. According to him Sandro did not have to flee the city at that time because he had not yet become the "avowed and open supporter of Savonarola that Simone had been."[7]

The authors generally agreed that Botticelli's *open* adherence (note that *covert* adherence was never established) to Savonarola's cause did not begin until about one and a half years after Savonarola's execution, for it was not until then that Simone, in his diary, mentioned his brother's name in relation to Savonarola. In his entry for November 2, 1499, Simone recorded an exchange that took place in Botticelli's workshop between the artist and Doffo Spini, the outspoken leader of an anti-Savonarolan faction. Simone wrote that Sandro asked Spini where Savonarola was at fault and why he was executed. Spini, Simone continued, replied that no sin was found in Savonarola but that matters had gone too far for him to be reprieved. After this reply Simone noted that "they then fell to speak of other matters, which there is no need to repeat."[8] From another contemporary source we learn that Botticelli's workshop was a notorious "*accademe di scioperati*," a hang-out for ne'er-do-wells, and that Spini was often there,[9] a fact that surely must temper any conclusions to be drawn from the exchange. Despite Horne's contention (followed by later writers) that Botticelli's question signaled a change in the moral atmosphere of the workshop, which then became a meeting place for Savonarola's adherents, this isolated inquiry (part of a general conversation, as Simone indicated by his concluding remark) may be indicative of nothing more than the artist's rather belated, cursory (and somewhat naïve) interest in Savonarola, which Simone, given his own predilection, would certainly not fail to record in his *Cronaca*. Nevertheless, Horne saw the conversation between Botticelli and Spini as the stimulus behind the iconography of Botticelli's so-called *Mystic Nativity* in the National Gallery, London; Cartwright believed that this painting "was completed a few weeks after Botticelli extorted the confession of Savonarola's innocence from Spini."[10] Once the meaning of the exchange

between the two men was thus established it should not be surprising to find a later author stating that in Simone's chronicle it can be seen how Botticelli systematically and painstakingly collected proofs of Savonarola's innocence.[11]

Botticelli's relations with Lorenzo di Pierfrancesco de'Medici have also been interpreted as demonstrating the artist's love for Savonarola.[12] The last document attesting to a painting commissioned by Lorenzo from Botticelli is dated July, 1497.[13] Horne, therefore, concluded that Botticelli, reacting to his friend's anti-Savonarolan activity, severed their relationship and no longer would accept commissions from him.[14] Aside from this conclusion having its basis on the questionable ground of negative evidence, it is based on the assumption that commissions were in fact offered; and there is absolutely no indication that any were.

We do know that when Lorenzo returned to Florence late in 1498 he was involved in lawsuits with Caterina Sforza, no easy antagonist, over possession of the villa at Castello and over money he had embezzled from her son (his nephew); in addition he had to face the animosity of an older branch of the Medici against whom he had plotted in the mid-1490s. Moreover, when he left Florence he had abandoned possession of the family palace in via Larga, and when he returned Castello was also taken from him.[15] We may therefore ask whether, even if Lorenzo had the mind to commission paintings from Botticelli, he had the money to do so, or even the walls on which to hang them. Nonetheless, Lorenzo's unfortunate situation does not necessarily indicate a cessation of friendship between him and Botticelli. And, if Botticelli did drop Lorenzo as a friend because of the latter's possible antagonism to Savonarola, then it is odd that he would have remained on friendly terms with Doffo Spini as late as the end of 1499. Furthermore, if Botticelli would not accept commissions from his friend Lorenzo, then one must explain his apparently contradictory behavior in accepting commissions from Guidantonio Vespucci in 1499, presumably a comparative stranger, who was an acknowledged, inveterate, and outspoken enemy of Savonarola and all his faction.[16]

Given the historians' obvious desire to associate Botticelli with Savonarola, it is not surprising to find that they interpreted Vasari's biography of the artist toward that same end. Vasari stated that Botticelli gave up painting because of the intensity of the religious feelings that Savonarola inspired in him, and that he would have starved in his old age had it not been for the help of Lorenzo de'

Medici.[17] Any excessive behavior, including overindulgence in religious enthusiasm, as is apparent throughout his *Vite*, violated Vasari's concept of the decorous behavior appropriate to an artist. In the instance of Botticelli, the results of his excesses were, with great fortune, Vasari related, mitigated by the generosity of Lorenzo de' Medici.

But to which Lorenzo did Vasari refer? Lorenzo il Magnifico was certainly intended, but his aid must be discounted since he died in 1492, eighteen years before Botticelli, when Savonarola had only just arrived in Florence. Lorenzo di Pierfrancesco de' Medici (d. 1507) could not have been Botticelli's savior either. He is not mentioned at all by Vasari in the *Vita* of Botticelli, and as indicated above, he in effect disappeared from the scene thirteen years before the artist died. Another Lorenzo de' Medici, the duke of Urbino, was only eight years old when Botticelli supposedly stopped painting, and eighteen when the artist died. Furthermore, he did not have an influential position in Florence until 1513.[18] The statement of Lorenzo's aid can only be found in the second edition of Vasari's *Vita* of Botticelli, which begins with encomiums citing Lorenzo il Magnifico's days as a "veritable Golden Age for men of genius."[19] The inclusion of such a statement is typical of the fundamental differences between the first edition of the *Vite* published in 1550 and the second edition published eighteen years later. In the 1568 edition of the *Vite*, Vasari clearly intended to single out the Medici, Lorenzo il Magnifico in particular, for their largess and patronage of artists as a demonstration for the Grand Duke Cosimo I de' Medici, to whom the *Vite* were dedicated, of a great family tradition, thus inducing him to continue it and bring it to its climax with, in part, his patronage of an Accadèmia di Disegno. Lorenzo il Magnifico and Botticelli were roughly contemporary. Vasari knew this and others may have known it as well, and nobody would have checked dates. Indeed, according to Renaissance historiographical traditions the accuracy of the data was comparatively unimportant in relation to the noble and didactic function such data could serve.[20]

Did Botticelli actually give up painting from the mid-1490s until his death in 1510 as he is alleged to have done because of his supposed new interest in spiritual matters?[21] The evidence cited for the affirmative is the above-noted statement by Vasari and a letter of September, 1502, to Isabella d'Este from her agent in Florence, informing her that both Perugino and Filippino Lippi were too busy to undertake work for her, but that another painter, Botticelli, much praised for his excellence, was willing to assume the commission.[22]

22

Would Botticelli have been "much praised" if he had not been active in his art for seven years? Indeed, his willingness to serve Isabella must indicate that he had *not* given up painting. This conclusion, which for us is obvious, has been overlooked by previous authors in their need to establish Botticelli as a *piagnone*, totally removed from mundane pursuits. Instead, most authors have used the letter as proof of Botticelli's inactivity, arguing that had he been active, as Filippino and Perugino were, he would not have had the time to take on the added work—an untenable conclusion based on an illogical assumption.

Scholars today agree that Botticelli did as many as forty paintings between 1490 and 1510, a number that compares favorably with the approximately sixty paintings they also agree must have been executed in the preceding *three* decades of his career.[23] Nor do we have for most artists of the period any more paintings for an equal span of years, that is, any more paintings that have survived the vicissitudes of 450 years. Clearly there seems to have been no cessation of Botticelli's activity during the latter part of his life. And if there actually were such a decrease in work, could it not be ascribed as well to the fact that Botticelli was fifty-five years old, a relatively aged man, at the time of his assumed conversion to Savonarola's cause? Horne adduced, however, rather different reasons for Botticelli's decline or cessation of production. First, he believed that Botticelli's paintings were not especially acceptable to rich patrons because of his partisanship for Savonarola, and secondly, that a new generation of artists had arisen whose artistic ideals were more readily understood by their contemporaries.[24] The first reason is negated by the fact that Botticelli did receive a commission from a rich (and, incidentally, anti-Savonarolan) patron during that time, as noted earlier. Horne's assumption that the wealthy were not to be numbered among Savonarola's patrons is easily and markedly proved false; indeed, it is a vestige of the whole Romantic approach to Savonarola and his cause.[25] As to the second reason, we must assume that Botticelli, too, had contemporaries and that they might have preferred his paintings to those of the younger artists.

It must also be kept in mind that even if it were possible to prove a clear interest by Botticelli in Savonarola, and even if that interest were demonstrably profound, indeed a passion, we would then have to determine how such an interest might be manifested in Botticelli's art and then discover means of identifying it, if indeed we believe it has to be there in the first place.

Botticelli's later works, those dating from the mid-1490s until his death in 1510, have been described in the seminal monographs at the

23

turn of the century as having a "spiritual" style reflecting an "impassioned spirit of moral austerity," a "sadness" and "melancholy," and an unreal quality of form that is identified as stemming from the artist's infatuation with Savonarola.[26]

Only a few paintings are commonly identified by these authors as embodying this "Savonarolan" style, however. They are the *Lucrezia* and *Virginia* panels, the Fogg Museum *Crucifixion*, and the London *Mystic Nativity*.[27] Careful viewing of the paintings now dated between 1490 and 1510 reveals, rather, a variety of styles, a phenomenon that should not be at all surprising considering the variety of patrons for whom the artist worked during these twenty years and the varied demands of individual commissions in size, media, subject, and projected location.[28]

There are, furthermore, elements in these works, as well as in others of the same period, that progress stylistically from Botticelli's "pre-Savonarolan" paintings: we can trace stylistic predilections and idiosyncracies that did not necessarily require a Savonarola for their development. The fault is clearly that of assuming *a priori* that those paintings done by Botticelli after Savonarola's advent in Florence were done under the monk's influence, and then expecting, indeed seeing, these works as forming a separate and cohesive group. In addition, if in fact Botticelli did evolve a new "spiritual" style in response to his Savonarola-inspired religiousness, is it perhaps strange to find that he totally ignored Savonarola's insistent injunctions concerning painting style, injunctions calling for paintings rather different from those Botticelli produced?[29] Also odd is the fact that the same "spiritual" style occurs in Botticelli's paintings on non-Christian subjects commissioned by adversaries of Savonarola.[30] Finally, it should be remembered that Savonarola was not the only religious stimulus in Florence at the turn of the fifteenth century, nor that all religious patrons and artists as a matter of course must have been his partisans. For example, Guidantonio Vespucci, Botticelli's patron, was vehemently anti-Savonarola, but he was, nevertheless, a religious Catholic: his opposition to Savonarola was based on political, not religious, grounds.[31] In fact, with that in mind it is also quite possible for Botticelli's exchange with Spini to have been over Savonarola's political activities, and not, as has always been assumed, over Savonarola's religious beliefs.[32]

There is no further evidence to suggest an association between Botticelli and Savonarola. The available evidence allows only one conclusion: Botticelli obviously knew of Savonarola (which certainly is to

24

be expected), and for an unknown length of time, to an unknown degree, and for unknown reasons, he may even have been interested in Savonarola (which is also to be expected).

The destruction of a myth is relatively easy and has as much historiographic momentum and historical inevitability as the myth's creation had. It is to that creation we now turn.

A clue to the pattern developed in the nineteenth century which led to the close association of Botticelli, his "spiritual" style, and Savonarola's attempts at religious reform lies in Wilhelm von Bode's statement that in his youth Botticelli "had responded to the call to life through classical antiquity and humanism; but the medieval feeling, the mysticism that was deeply rooted in him, gained ground steadily, till at length Savonarola drew him quite away from life and made him in his art the interpreter of the monk's dogmatic views."[33] The equation of humanism with classical antiquity and mundane pursuits in opposition to Medieval mysticism and a spiritual life indicates an essential dichotomy which was fundamental to the nineteenth-century understanding of the Middle Ages and the Renaissance.

The situation with which we are concerned may be said to have had its start in the last years of the eighteenth century with the publication of W. H. Wackenroder's *Herzensergiessungen eines Kunstliebenden Klosterbruders*. Although not totally novel in his ideas, Wackenroder in very specific, even simplistic, terms set forth an approach to art which had a remarkable influence.[34] Reacting to rationally constructed theoretical constants as the basis for art, the art-loving friar (which latter Wackenroder was not, but it is significant that he assumed that guise) promulgated an approach to art which had its basis in the unconscious, or at least in a naïveté, a kind of divine innocence of the artist, and a similar innocence in the beholder that allowed him to react to the work of art: *Kunstverstand* replaced by *Kunstgefühl*.[35] Art, he wrote, is like nature. It is a totally different kind of language that miraculously and powerfully affects man's heart through secret and obscure means.[36] No rules can be construed from it, nor can it be constrained to formulae. For him, and significantly for us, art was viewed as intimately connected with religious motivations; conversely only religious, specifically Christian, art could be good.[37] The painter of Christian subjects must himself be pious and follow only divine directions in his art. Fra Angelico, Wackenroder's ideal, prayed each time before he painted, and then "proceeded to paint only as heaven directed him, without pondering his work or self-criticism. Painting for him was a holy office."[38]

25

The high quality of Fra Angelico's art was compared with the poor quality, the empty technical achievement of painters like Albertinelli because of his interest in luxurious living, and Parmigianino because of his impious behavior.[39]

Wackenroder also praised Raphael as the supreme artist. Indeed, praise of Raphael, so characteristic of eighteenth-century theorists and historians,[40] could not be totally withheld by Wackenroder, but he could change its focus. Raphael, he asserted, was an unsophisticated painter who received his inspiration directly from God because of his piety.[41] Shortly after the turn of the century, however, when Wackenroder's ideas were gaining force, the "classicist" Raphael and his followers would be purged from the ranks of true Christian artists. Friedrich Schlegel could muster the impressive range of knowledge to do this, and his essays had the broad popularity that enhanced his crusade for a totally Christian art. In his essays and letters published between 1802 and 1804, Schlegel took issue with those who praised Raphael unstintingly. Raphael's *Transfiguration* was "treated with superficial, lightly kindled enthusiasm, not with that simple, earnest power, that profound meditation and deep devotion with which the reverential love of the earlier masters would have approached a subject so truly divine and holy."[42] Introduced here also is the distinction, which was to become very popular throughout Europe, between the "old and new schools of Italian painting; the devout, pious, deeply significant style of the former, and the florid pomp of the latter."[43] The opposition then was between the *trecento* and the *quattrocento* versus the *cinquecento*, with Raphael a transitional figure whose work incorporates both styles.[44] Schlegel emphatically stated: "The beauty of Early Christian art consists not so much in the external parts as in the tranquil, pious spirit universally pervading; and the cultivation of this spirit will give inspiration to the painter, guiding his steps to the pure neglected source of Christian beauty"[45] Generally, Schlegel believed that the expressive intent of a work of art is most important, and that this intent and motivation must be Christian, for only pious Christian artists can produce good art and only Christian art can be good.[46]

Schlegel reflected the belief, which gained ascendency at the time, that the Renaissance became more and more pagan as it progressed,[47] and associated that idea with its art, uniting classicism with worldly rationality and interpreting spirituality as spontaneous, unformulated, and under the direct influence of God. With the publication of Chateau-

26

briand's book *Le Genie du christianisme* coetaneously with Schlegel's essays in 1802, Wackenroder and Schlegel's ideas were given a firm foundation in theology. Chateaubriand wrote that the ancient Greeks believed art originated with the tracing of the contour of a shadow on a wall.[48] Therefore, he concluded, because the art of Greece was naturalistic the Greeks obviously believed in a natural source of art. But Christians believe that man is made in God's image. Thus God, in making man of clay, was the first artist, and He breathed divine breath into that clay replica and made it with inspiration that comes directly from Him. Thus unlike naturalistic pagan art, Christian art is divine in origin and thus spiritual in style. That is, of course, if the artist is a good pious Christian; if he is not, then his art cannot be truly Christian or good.[49] The praise Wackenroder, Schlegel, and Chateaubriand lavished on pre-sixteenth-century art, leaves no doubt that for them Christian, that is pre-Reformation art, was synonymous only with Roman Catholic art.

By 1809 the theoretical ideas of these men were put into practice with the formation of the Brotherhood of Saint Luke by a group of German painters. These painters were among the more than five hundred German artists who lived in or visited Rome between 1800 and 1830. Many of them converted to Catholicism, perhaps following the lead of their advocate Friedrich Schlegel, who became a Roman Catholic in the first decade of the century.[50] In 1810 the members of the brotherhood moved to Rome, lived for a while in a Franciscan monastery on the Pincio Hill, venerated Fra Angelico, and divided their time religiously among prayer, good deeds, and painting such large multi-figured canvases as *The Triumph of Religion in the Arts*, *The Introduction of the Arts into Germany Through Christianity*, and such simpler works as *Italia and Germania Embracing*. This last presumably is a reference to a vision which Wackenroder recorded as having experienced, of Raphael, a personification of southern Catholic genius, embracing Albrecht Dürer, the mystic painter of Germany.[51]

It was inevitable then, in the weaving of such a fabric of Christianity and art, that the Savonarolan thread should soon be discovered. This was done by Alexis-François Rio with his *De la poesie chrétienne* and *De l'art chrétien*, published respectively in 1836 and 1851. Rio, whose books were translated into several languages,[52] became the most influential of the propagandists of the new ideal, the link between the movement on the Continent and the English pre-Raphaelites. With chapter headings like "The Invasion of Art by Naturalism," "The Fatal Influence of the Medici," "The Favoring of Pagan Art by the Medici,"

Rio, like Schlegel, maintained the inseparability of Christianity and art and contended that although the Renaissance became pagan in its later stages it nevertheless began as a spiritual movement with spiritual causes.[53] It is worth noting here that this idea was also expressed, significantly, at the same time by Franz Kugler in his *Handbuch der Geschichte der Malerei* (Berlin, 1837), in which he ascribed the growth of the new Renaissance art to the devotion inspired by Saint Francis. The same idea was further developed and more emphatically stated by Heinrich Thode in his volume on Saint Francis and the beginning of the Renaissance.[54]

Rio explained that in art signs of decay, that is, naturalism, which he equated with classicism or paganism, began to appear in fifteenth-century Italian art because of the interests of the Medici in the art and literature of the pagan past. In a large chapter which was to become an historical *topos* for the next hundred years, he carefully described how Fra Girolamo Savonarola fought bravely to avert this trend toward paganism and to turn art back to its pristine and pious Christian beginnings.[55] In support of this thesis Rio related, in a rather simplified fashion, Savonarola's definition of beauty as a spiritual perfection and not a quality resulting from such mundane and structural concepts as color or proportion. He also described in detail how Savonarola, in order to combat naturalistic paganism in art, founded a school of purely spiritual art in San Marco (presumably Rio's Christian counterpart of Lorenzo de' Medici's school of "pagan" art which Vasari recorded was located across the street from San Marco, a school which is, incidentally, as mythical as that of Savonarola's at San Marco).[56] According to Rio the most talented of Florentine artists flocked to Savonarola's school because of their enthusiasm for the *frate*'s teachings, an enthusiasm which demonstrated again the innate affinity between true art and Christianity.[57] It is not surprising also to find that the more late *quattrocento* artists that were "discovered" as a result of the new interest of the nineteenth century in pre-"classical" (i.e., pre-early sixteenth-century) Italian art, the more artists could be found flocking to San Marco. This highly successful school accordingly practiced a spiritual style of painting, while the style of such "anti-Savonarolan" painters as Piero di Cosimo and Albertinelli was characterized by naturalism.[58] The artists named by Rio as Savonarolan formed the basic list which, with additions over the following century, is still cited authoritatively.[59]

"This celebrated artist—the especial voice and exponent in Painting

of that religious rapture or ecstacy produced by the action of the Spirit, or the moral principle, on Sense through the medium of the Imagination, and which finds but an insufficient expression even in Poetry— was born at Vicchio"[60] Thus Lord Lindsay, in 1847, began his discussion of Fra Angelico, the last Italian artist whom he treated at length in his book *Sketches of the History of Christian Art*. In a chapter which the beatified Dominican painter of the *quattrocento* shared with Orcagna, the painter of the mid-*trecento* whose works were characteristic, according to Lindsay, of a kind of anti-naturalistic or "Anti-Giottesco" style.[61] Lindsay's *Sketches*, from their opening essay entitled "The Ideal, the Character and Dignity of Christian Art," to their conclusion with a condemnation of "the pictorial iniquities of the last three centuries,"[62] are the English corollary of *L'Art chrétien* by Rio, whose works were published in English translations in 1854. England, for at least a decade, had been well prepared for these concepts through the Oxford Movement, an attempt to purify and strengthen the Church of England by re-affirming the principles of the early church. W. G. Ward's vehemently pro-Roman tract *The Ideal of a Christian Church* of 1844, various other tracts and pamphlets, the works of John Henry Newman and his conversion to Catholicism in 1845,[63] along with such primers as Mrs. Jameson's *Sacred and Legendary Art* of 1848, and histories such as Lord Lindsay's, made, by the middle of the century, the general revival of interest in the older church and older Italian art (what might be called in that context, the Church's "native" art) specifically English. With John Ruskin writing from the 1850s through the remainder of the century, the movement acquired a literary spokesman whose works were to remain influential well beyond the turn of the century.[64]

With Rio, Savonarola was discovered as the impassioned but unsuccessful (and thus more endearing) savior of an art turning pagan, a characterization not wholly untrue but greatly exaggerated and eminently fitting the early nineteenth century. It was not long before the Botticellian thread was to be discovered and woven into the fabric.

In the 1830s, when Rio published his first volume, one of the few people to even comment on Botticelli's works condemned them for their mediocrity, barbarousness, and dry minuteness.[65] In contrast, around forty years later, John Addington Symonds observed that "In the last century and the beginning of this, our present preoccupation with Botticelli would have passed for a mild lunacy"[66] This revival of interest and preoccupation with Botticelli was actually

also initiated by Rio.[67] For Rio the good qualities of Botticelli's style resulted from the artist's advocacy of Savonarola. Botticelli's earlier "naturalistic" style was replaced later in his life with a "spiritual" style, and his engraved illustration for Savonarola's treatise *Il Trionfo della Croce* was considered by Rio to be his finest work. (However, the engraving can no longer be attributed to Botticelli, nor does it illustrate Savonarola's treatise.[68]) This and other excellent works were done by Botticelli, according to Rio, during Savonarola's duration of activity in Florence. Upon Savonarola's execution, so Rio interpolated Vasari, Botticelli resolved rather to die than continue painting.[69] Later in the nineteenth century, Botticelli was praised for many and differing reasons,[70] but by the time the first monographs on him appeared in the 1890s, climaxing with that of Horne in 1908, Savonarola and Botticelli had become intimately related, each in their sphere adding to the glory of the other. Indeed, Botticelli became the best example of an artist who demonstrated, after a life of error, a new and more powerful religious devotion which enabled him to produce some of the most Christian, and thus finest, paintings.

Concomitant with this emphasis on Savonarola's spiritual campaign and Botticelli's artistic expression of it, a number of other studies appeared which glorified the *frate* and associated many other artists with him. For example, in 1845 Padre Vincenzo Marchese's *Memorie dei più insigni pittori, scultori, e architetti domenicani*, (a thoroughly Christianized version of Vasari's *Vite*) counterposed Fra Angelico and his contemporary at San Marco, Saint Antonine, Savonarola's predecessor as prior, in the earlier chapters with Savonarola and Fra Bartolomeo, a painter who became a Dominican in 1500, in the later chapters. The first monograph on Fra Bartolomeo appeared in 1879.[71] And, as should be expected, the first in a succession of biographies of Savonarola appeared in the 1850s along with a great number of scholarly investigations and fictional portrayals of his life and deeds; among the latter may be noted a *trauerspiel* in five acts entitled *Der Prophet von San Marco* of 1838 in which Savonarola is depicted as an apostolic reformer, and George Eliot's novel *Romola* of 1863, with its endearing characterization of Savonarola. Also of the mid- and later nineteenth century are a host of guide books, descriptions, and histories of the San Marco convent.[72] In 1879 Gustave Gruyer published his collection of statements on art and beauty culled from Savonarola's sermons and treatises, along with reproductions of illustrations from late fifteenth- and early sixteenth-century editions of Savo-

narola's works—a collection which unfortunately came to be used as a compendium for determining Savonarola's views on art.[73] Politically as well Savonarola had his uses. Because of his political ideas he became for the proponents of the Risorgimento a desirable herald of their movement.[74]

If we, in conclusion, compare Schlegel's statement of 1805 that "the remembrance of the glorious times of old, and the hope of a richer future, are all the present can give art" with Bode's concluding remark in his monograph on Botticelli of almost one hundred years later, that Botticelli demonstrated in his later life and work a "preoccupation with the life of the soul which was never again reached in Italy,"[75] we find our subject enframed by a mode of thought, a basic and universal constant. It is a yearning for a lost purity, a lost spirituality held to be characteristic of earlier art and also of the pristine early church, or at the latest of the Medieval church. This nostalgia and attempt at reviving a lost piety and essential spiritual art demonstrated in the age of rationalism a desire for a time when unsophisticated, and therefore, divine innocence prevailed, a Golden Age which every age attempts to revive, (even the fifteenth century yearned for the purity and simplicity of the early Christian period), a belief that things were better once.[76]

CHAPTER 5

FRA BARTOLOMEO DELLA PORTA

Of all the artists associated with Savonarola in the literature, only in the case of Fra Bartolomeo della Porta (1472-1517) is there some indication that the relationship between the artist and the monk may have been a personal one. Because of this association, and because Fra Bartolomeo produced paintings as a monk in San Marco for that and other Dominican monasteries, it is quite possible that his paintings more than those of other artists may reveal a Savonarolan influence.

After Vasari's biography the most important accounts of the life and work of Fra Bartolomeo are those of Marchese (1879), Knapp (1903), and Gabelentz (1922). Since all the later literature is based on Vasari's *Vita* of Fra Bartolomeo, we shall first test the credibility of Vasari's narrative.

In the first edition of the *Vite*, Savonarola is introduced as an eminent theologian preaching in San Marco among whose auditors was the young Bartolomeo.[1] In the second edition, the reader is first informed that the painter was a virtuous young man and enjoyed listening to sermons; then Savonarola is mentioned as before.[2] In fact, the reader is given, in the second edition, a full description of the content of Savonarola's sermons at this time, a description totally lacking in the first edition.[3] According to Vasari, Savonarola preached daily against lascivious pictures, music, and amorous books as things which lead men astray and argued that it was not good to have these, along with pictures of naked men and women, in houses where there are children. Furthermore, Vasari continued, the vehemence of Savonarola's condemnation so enflamed the populace that at Carnival (Shrove Tuesday) the customary festive bonfires became pyres in which these van-

32

ities were ritually burned.[4] There were two such *brucciamenti* during Savonarola's years in Florence, one on February 7, 1497, and the other on February 27, 1498.[5] From November, 1496, to May, 1497, (before and after the first *brucciamento*), Savonarola was delivering his sermons on Ezechiel. Although immorality in Florence was a constant theme in this series, the only sermons containing passages at all similar to those described by Vasari occurred in the sermons of March 16 and 17, 1497, well after Carnival.[6] Nor could Vasari have been referring to the second *brucciamento* of February 27, 1498, and the sermons which preceded it, since after the sermons on Ezechiel, Savonarola did not resume preaching until February 11, 1498, (on the text of Exodus), and for the half-year until that time he remained in his cell under an excommunication.[7] His Carnival-season sermons were given in the cathedral on February 11, 18, 25 (Carnival Sunday) and on February 28.[8] In none of these sermons is there a text similar to the passage in Vasari, for they are generally rebuttals by Savonarola of his critics and excommunication. There is, however, a passage from another series of sermons of which Vasari's statement is practically a paraphrase, but this occurs in the first sermon on Haggai, delivered several years before the *brucciamento*, on November 1, 1494. In this passage Savonarola mentioned the various vanities and asked the populace to bring them to him to be put to flames as a sacrifice to God.[9] Obviously Vasari knew about these *brucciamenti* and Savonarola's moralizing sermons and properly, according to his lights, worked these elements into Fra Bartolomeo's *Vita* to produce a more meaningful and cogent narrative.

Although it is difficult to imagine what source was available to Vasari for his description of Fra Bartolomeo's pious and virtuous youth, in view of his subject's later life, it was certainly a safe assumption on Vasari's part, and it served to give the reader a more complete picture of Fra Bartolomeo's character, aiding him in understanding the painter's motivation, particularly when in the next paragraph (only in the second edition) the reader is informed that Fra Bartolomeo brought his studies of the nude to the pyre and burned them.[10] The same techniques of literary craftsmanship apply to the passage from Savonarola on the *brucciamento*: even if the time given by Vasari for the sermon and the bonfire was not accurate, as a cause-and-effect relationship it appeared valid and was for purposes of a literary biography a clear, readable, understandable, and therefore, convincing rendering of events.

We next learn from Vasari that because of affection for the *frate* Fra Bartolomeo painted a portrait of him and later defended him when, on April 8, 1498, San Marco was attacked by the anti-Savonarolan forces and Savonarola was taken prisoner.[11] The attack was fierce and we are told by Vasari that Bartolomeo, weak and timorous, vowed that should he come through it alive he would immediately assume the Dominican habit.[12] (One cannot help but wonder, if Fra Bartolomeo had been weak and timorous, would he actually have gone to defend the monastery?) The interviews by the *Signoria* with the prisoners of San Marco[13] reveal the names of many of the defenders, including the names of several artists,[14] but not the name of Fra Bartolomeo. In fact, it was not until two years later, July 26, 1500, that Fra Bartolomeo entered the cloister of San Domenico in Prato. This was recorded by Vasari in both editions of the *Vite*, and in the second edition he gave the specific date which he stated could be found in the chronicles of the monastery.[15] Also in both editions Vasari recorded the distress of Fra Bartolomeo's friends when they heard he was taking orders, especially when they found that he was determined to forsake his artistic career.[16] After a few months at Prato, according to Vasari, Fra Bartolomeo was sent to San Marco in Florence. (The San Domenico chronicle recorded that Fra Bartolomeo was professed in that monastery a year after he entered it.[17]) Vasari, in both editions, stated that it was not until four years later that Fra Bartolomeo, who was only intent on divine offices, was finally persuaded by his friends and the prior of San Marco to resume painting and to accept a commission from Bernardo del Bianco, which was offered in 1504;[18] from then on Fra Bartolomeo continued to paint. There are no further references to Savonarola in the vita of Fra Bartolomeo.

Thus, although Vasari presented the reader with a consistent and even logical development of Fra Bartolomeo's character in relation to Savonarola, all we can be sure about is Fra Bartolomeo's assumption of the Dominican habit in Prato in 1500, his subsequent return to Florence, and the fact that he *apparently* did not produce any paintings from that time until 1504. But this is hardly sufficient for the thorough biography Vasari, we must assume, wished to produce. It is also difficult to imagine the sources available for his statements on the personality and idiosyncracies of Fra Bartolomeo unless they were passed on to Vasari by word of mouth, and the second edition of his *Vite*, in which these occur, appeared a half-century after the artist's death. Although it would be considered rash now, four hundred years

later, to say that all Vasari's statements are true, it would be equally rash to say that they are beyond possibility. Given Fra Bartolomeo's vocation as a Dominican and his coetaneity with Savonarola, it is quite likely that he had some degree of regard for the preacher. Vasari's account must be read as interpolations by the author which were based on known, salient biographical and historical events, and thus within the realm of plausibility, and which, considering Vasari's aim, were justified on literary grounds.

In this regard there is no argument against Vasari: he presented his readers with a clear, rational, and consistent sequence of events and development of character, obviously a prime aim of any biographer, particularly when his subject lived so long before him and there was a decided lack of recorded information. Vasari's *Vita* of Fra Bartolomeo is convincing, that is, convincing literarily, and it was historically feasible and instructive; that was far more important than its accuracy. It was not Vasari's aim to sift evidence and ponder inferences; rather, as succinctly stated by Felix Gilbert, Renaissance historians "were not averse to stylizing and embellishing the event or the person about whom they were writing, for their intention was to make the lessons which history taught as clear as possible."[19] In the case of Fra Bartolomeo, Vasari was intent upon describing to his readers that artist's fundamental religious calling as well as how that calling could not, and should not, keep the painter from his art, the practice of which Vasari, through his *Vite*, was carefully trying to delineate as an essential noble activity, in harmony with society and worthy of patronage.

This account from the sixteenth century, necessarily colored by the stylistic conventions of the period, became the foundation upon which nineteenth-century authors built; the latter group's own predilections led them to accept unquestioningly the earlier account. The possible, although unproved (even unprovable) relationship between the two *frati* as described by Vasari was embroidered, even belabored, by subsequent authors.

Some further remarks on Vasari's depiction of Fra Bartolomeo's character are in order, for they contrast somewhat with Vasari's overall picture of him as a pious, noble-minded man who preferred the offices of a monk to the more practical affairs of the world. These remarks are not necessarily contradictory, but they do tend to qualify a clear-cut presentation of Fra Bartolomeo as a meek and unassuming religious. At the very beginning of the *Vita* we read that Fra

35

Bartolomeo worked in company with Mariotto Albertinelli.[20] In Vasari's life of that artist he stated that Albertinelli profoundly detested the ways of friars, of whom he continually said nothing but evil, and that he was a member of the faction contrary to Savonarola, all of which prevented his becoming a monk to be near his companion Fra Bartolomeo. We are also informed that Albertinelli was a restless and lustful man who enjoyed good living.[21] Thus Fra Bartolomeo had concourse with someone who was not only a totally different personality, but who was outspokenly contrary to his own profoundly religious views and way of life. Three anecdotes related by Vasari also contrast sharply with his presentation of Fra Bartolomeo as an assiduous workman, quiet, good-natured and God-fearing, who preferred a peaceful life, avoided vicious pleasures, and was fond of sermons. These anecdotes refer, in turn, to Fra Bartolomeo's annoyance at being taunted by his fellow Florentines for his alleged inability to do nudes and the steps he took to contradict this; to his arguments with the frame-makers who always covered up with their frames an unnecessary fraction of his paintings, and how he outmaneuvered them; and finally to how he demonstrated that he could do large figures to confound those who said his style was small.[22] The three incidents are related in rapid sequence as if Vasari desired to stress the abilities of Fra Bartolomeo in one emphatic paragraph. Although these stories may be apocryphal, it seems as if the author was not quite content with his image of a simple, unworldly painting monk which he suggested in his earlier pages. Certainly anecdotes like these stirred his reader's interest and appealed strongly to the mid-sixteenth-century artist because of their indications of an artist's ability to surmount criticism. Even if the episodes were true they need not be incompatible with a religious nature, but it is the characterization of Fra Bartolomeo as a devoted religious which solely has interested later commentators; qualifying anecdotes such as the above have been forgotten, while those relating to the piety of the artist, although equally unprovable, are stressed. Padre Vincenzo Marchese in his account of the lives of Dominican artists written in the mid-nineteenth century made much of Vasari's statements of Fra Bartolomeo's desire to remain at his holy offices and duties in San Marco and not to return to painting. This steadfastness, as Marchese interpreted it, was maintained by the painter until he was finally persuaded to return to painting by his friends, his prior Sante Pagnini, and Bernardo del Bianco who wished to commission a painting from him. The relationship (a hypothesis of

Marchese) of Pagnini and Fra Bartolomeo was likened by Marchese to that which existed earlier at San Marco between Fra Angelico and Saint Antonine, who was prior at that time.[23] Marchese drew a parallel between Fra Angelico and Fra Bartolomeo whenever possible and even believed he saw a portrait of Fra Angelico in Fra Bartolomeo's *Last Judgment* of 1499.[24] The fact that when Bianco's painting was completed Fra Bartolomeo had an apparently sharp dispute with him over the price of the work, as Marchese noted from the documents,[25] did not lessen, for Marchese and other writers, their belief in Fra Bartolomeo's holy divorce from mundane affairs. Indeed, the document specifically recorded Fra Bartolomeo's great concern for his honor and reputation!

Marchese continued Vasari's characterization of Fra Bartolomeo's religious fervor, but added many details which can only be inventions based on Vasari's *Vita*. From Marchese we learn, for example, of Fra Bartolomeo's "simple and ingenuous character" (which is hard to believe, considering the documented concern for his reputation and honor, as well as, if one credits it, Vasari's tale of the artist's dealings with the frame-makers and with those who spoke against his style); and of his having been educated in piety which grew owing to examples of the domestic virtues of his home. Fra Bartolomeo, according to Marchese, after finishing painting for a day went to church; his co-worker Albertinelli (who, as a foil to Fra Bartolomeo's goodness, is made more opprobrious here than in Vasari's *Vite*) went to the inn for revelry; while their master Piero di Cosimo went off looking for sylvan animals and plants; and Cosimo Rosselli, a contemporary painter and friend, looked for the *Lapis Philosophorum*. Marchese continued to present "details" on Fra Bartolomeo's virtues in a "corrupt time and place"[26] until he summed up the painter's character by stating: "In short, in another time and with other masters, Baccio [Fra Bartolomeo] renewed the exemplar of Fra Angelico in virtue as well as in art."[27] Clearly Marchese, as a Dominican writing a history of Dominican artists, saw Fra Bartolomeo in the role of a new Fra Angelico and thus amplified Vasari's account to create a stronger argument demonstrating the inseparability of Christianity, morally good artists, and good art, and set off Fra Bartolomeo's piety against the background of a corrupt, irreligious period. With similar forced contrasts Savonarola's goodness was brought into sharp relief.[28]

Knapp and Gabelentz, in their monographs on Fra Bartolomeo (published in 1903 and 1922, respectively), adhered to the relation-

ship between the painter and the preacher set forth by Vasari and Marchese and attempted to discern general indications of Savonarola's influence within the paintings of Fra Bartolomeo. Marchese, as one would expect, associated various works of Fra Bartolomeo with Savonarola in a very general fashion. For him, the paintings expressed "religious" feelings similar to those of Savonarola (and similar as well, he added, to those expressed in the paintings by Fra Bartolomeo's precursor at San Marco, Fra Angelico).[29] Gabelentz was convinced that the life and death of Savonarola had a profound effect on Fra Bartolomeo, which was manifested in his paintings.[30] However, Gabelentz only found it necessary to indicate the effect in the most general manner. For example, he wrote that the sermons of Savonarola were important for Fra Bartolomeo's conception of his fresco of the *Last Judgment*, but gave no reason for his belief.[31] He also associated two drawings of *Charity* by Fra Bartolomeo with Savonarola's sermons, but then rightly added that one cannot really know if this association is correct.[32] Vaguer still is his claim that in Fra Bartolomeo's painting of the *Assumption* Savonarola's influence on the painter's "soul" could be seen.[33] There is no need to dwell on the numerous echoes of this theme in all the literature on Fra Bartolomeo (as well as in the literature on Fra Girolamo); it is sufficient to point out that no doubt has ever been voiced about Fra Bartolomeo's adherence to Savonarola. Nor do we doubt it here; we only question its absolutist nature and the function given it by past historians. The consensus has also been, however, that this adherence was manifested by the painter in all his paintings,[34] and it is with that conclusion we do disagree and with which we take issue in Part III of this study.

CHAPTER 6

MICHELANGELO

Michelangelo Buonarotti, the most brilliant artist of his time, is the most difficult to consider in a scrutiny of Savonarola's influence on Renaissance art. From no other artist of the period do we have expression of religious thought as profound or iconography as exceptional or indicative of an all-powerful, wrathful, yet intensely loving deity. Therefore in the past half-century Michelangelo has been seen as one of the artists most affected by Savonarola and his preaching. Yet the evidence attesting to this influence in the case of a particular work is unquestionably tenuous. Even such a partisan as Schnitzer, fifty years ago, recognized this problem, despite his efforts to prove a positive influence of Savonarola on all the great artists of the period.[1]

Michelangelo is exceptional for the creatively synthesizing abilities of his art and intellect. Vasari, as Erwin Panofsky noted, first called attention to this quality of his art, and Panofsky detailed the same abilities in relation to Michelangelo's distinctive Neoplatonic ideas and pictorial iconography.[2] We cannot then expect to find a clear reflection in Michelangelo's art of Savonarola's theology. Indeed, Michelangelo was as capable himself of abstracting ideas from the early church fathers, associating them with current theological beliefs, and uniting them all with a particular blend of Neoplatonic philosophy as was Savonarola. Both men knew the sources well, and we should not be surprised to find both expounding, on occasion, similar ideas, or using the same kind of imagery to express them. Such parallels are common and should be expected between two roughly contemporary men with similar interests.[3]

The only contemporary source in which Michelangelo is related to Savonarola is Condivi's *Vita* (1554) of the artist. Condivi wrote:

> With deep study and attention he [Michelangelo] read the Holy Scriptures, both the Old and the New Testaments, as well as those who have expounded them, such as the writings of Savonarola, for whom he always had a great affection, keeping always in mind the memory of his living voice.[4]

We may assume, since Condivi wrote his biography in part to correct and refute Vasari's, that his statement on the artist's regard for Savonarola had the tacit approval of Michelangelo, his friend. But it must be kept in mind that Condivi referred to Savonarola in the context of the artist's reading of the Old and New Testaments "as well as those who have expounded them." Michelangelo's interest in Savonarola need not have been greater than his interest in other writers who interpreted the Bible, indulged in speculative thought, and sought to synthesize philosophical systems. That Michelangelo kept in mind the memory of Savonarola's voice need not be questioned either; certainly Savonarola was impressive and the young Michelangelo impressionable, as were undoubtedly a host of other Florentines, both artists and laymen. Vasari, who said nothing about Savonarola in the first edition (1550) of his *Vita* of Michelangelo, included in his second edition (1568) a passage, as DeTolnay noted,[5] which is obviously based upon that of Condivi, stating that Michelangelo "delighted greatly in the Holy Scriptures like the good Christian he was, and had great veneration for the writings of Fra Girolamo Savonarola, having heard his voice from the pulpit."[6] Indeed since the Condivi passage is followed by a statement concerning Michelangelo's love for human beauty, and a very similar passage can be found at the same point in Vasari's second edition which is lacking altogether in his first edition, there can be little doubt that Vasari's source for this information was Condivi.[7]

The literature in which these passages from Condivi and Vasari are cited and used as a nucleus for the construction of a portrait of Michelangelo as a "faithful follower of the *frate*" (as Schnitzer called him)[8] is vast, but fortunately summarized in Charles DeTolnay's *The Art and Thought of Michelangelo.*[9]

DeTolnay basically followed the early studies on Michelangelo by Thode (1903) and Beyer (1926), but stated that he attempted to define in specific terms Savonarola's influence on the style and iconog-

raphy of Michelangelo's works which the earlier writers did not actually do.[10] Thode and Beyer discussed the artist's "religiousness" in relation to Savonarola and ascribed a general influence of the *frate* on the artist's work.[11] For example, following Schnitzer, Beyer saw an influence of Savonarola on Michelangelo's *Madonnas* because of their "stern grandeur"; his painting of the *Deluge* became a "pictorial reflection" of Savonarola's sermons on that subject; and in general the "profundity" with which Michelangelo looked at the Old Testament was derived, according to Beyer, from Savonarola because the Old Testament provided the basis for his sermons (a rather misleading statement).[12]

Nor is Thode any more specific. He indicated that Michelangelo's Christianity was the same as Savonarola's and thus his works of art reflect the conceptions of Savonarola.[13] This should indicate, rather, the parallelism of their ideas, as we mentioned earlier. Beyer took issue with this belief of Thode, pointing out that Savonarola was a Thomist and Michelangelo was not![14]

Despite DeTolnay's intention, his arguments nevertheless are not any more substantive, as the following example indicates:

> Michelangelo was commissioned to complete the tomb of St. Dominic [in Bologna] by adding three statuettes. He must have esteemed it a great honor to carry out this task, for this monument was erected to the founder of the order to which Savonarola belonged as did his eldest brother, Lionardo, another admirer of the great preacher. It may be the influence of Savonarola's sermons that we see in the conception of these three statuettes which were to finish the monument begun by Niccolo dell'Arca. Instead of following his predecessor's dell'Arca's style by making calm and serene figures full of passion: St. Proculus, St. Petronius, and the kneeling Angel look like sentinels aware of their sacred mission, which is to watch over the tomb. It should not be forgotten that before going to Florence, Savonarola spent seven years at Bologna, from 1475 to 1482, in the very monastery where Michelangelo was then working, and where the memory of the Brother must still have been vivid.[15]

Here DeTolnay stated that the Saint Dominic statues "may" have been influenced by Savonarola. Later, in the same chapter, DeTolnay became more convinced, writing ". . . it is true that the three figures for the tomb of St. Dominic . . . betray the influence of Savonarola's exalted prophetic spirit"[16] The other instances of Savonarola's influence on Michelangelo adduced by DeTolnay are no more credible despite his statement that of the artists who were parti-

sans of Savonarola (Botticelli, Lorenzo di Credi, Fra Bartolomeo, and Il Cronaca), only in Michelangelo's works was a "profound echo" of the Dominican's words to be found.[17]

Despite the several hundred years separating DeTolnay and Condivi, DeTolnay's "profound echo" of Savonarola reveals as little of an influence of the monk on Michelangelo as does Condivi's statement about the artist's remembering Savonarola's "*viva voce*." The distance between the childhood memory and the art of a mature artist is as great as the distance between DeTolnay's beliefs and his proof. Savonarola's influence on Michelangelo has, nevertheless, not been disproven, for it actually has never been proven in the first place. Nor can that be done here. We have found instead only parallels between some of Michelangelo's art and Savonarola's ideas.[18]

PART TWO

*THE VISUAL ARTS IN
SAVONAROLA'S SERMONS*

CHAPTER 7

INTRODUCTION TO PART TWO

In one of his later sermons Savonarola recalled that he was not initially successful as a preacher, losing his audience whenever he relied on abstractions, learned language, and scholarly allusions to express his message. The same thing was true, he related, for past and contemporary preachers.[1] Nor, he said, was he in the pulpit to preach Aristotle, Plato, Ovid, or Dante.[2] To preach philosophy, he believed, was insufficient because philosophy cannot penetrate the spirit and, similarly, sermons with canon law as their subject would be of the church, that is, the exterior, not the interior soul. As to the preacher himself, he, Savonarola believed, must have something more than great rhetoric and eloquence, for these "please the ear and not the spirit."[3]

Two contemporaries, Guicciardini and Cerretani, recorded that Savonarola's sermons were filled with a "natural and spontaneous, not artificial, eloquence," that he returned to the "Apostolic" manner of preaching and did not divide his sermons into parts or propose questions, and that he shunned cadences and all devices of eloquence.[4] His style, couched in a direct everyday language, reached apparently natural climaxes in the course of a sermon which would bring forth, on various occasions, impassioned cries of *"misericordia"* from his auditors, particularly when an exposition of a scriptural story was suddenly, and with startling relevance, brought home to them as an exact analogy to their lives, customs, and clerical or political institutions. If such a sophisticated auditor as Giovanni Pico della Mirandola could write that Savonarola's exegesis of Noah and the relation of this book to the new and imminent return of the castigating flood made his hair stand on end,[5] we can easily construe Savonarola's effect on the community.

Savonarola's more recondite explications were presented, not in a language and method of argument which would be equally opaque to his audience, but rather in terms readily apprehensible and appealing to them.[6] Along with such a mundane approach, Savonarola's rhetoric was founded on the use of rich and varied imagery, an imagery which was taken from the pursuits of everyday life, its customs, professions, labors, and physical environment. His messages thus presented were easily comprehensible to his listeners and readers whose daily pursuits were thus woven into the fabric of each sermon. In turn, when the populace went about those daily activities, the activities themselves would, after a while, call to mind their use by Savonarola and the message he conveyed through their example. Thus Savonarola preached for six years with, as Guicciardini marveled, an ever-growing regard by the people in a city where no one had ever succeeded in preaching for more than two successive Lenten seasons.[7]

CHAPTER 8

ART AND SAVONAROLA'S IMAGERY

Considering Savonarola's fundamental use of imagery it is not surprising to find that metaphors derived from the visual arts are rather numerous in his sermons. The visual arts have an inherently graphic value which appealed to him and was related to his rhetorical style. He drew the following parallel between rhetoric and painting: "Ask the painters which pleases more, a figure that is affected and unnatural or one that is without such affection. They will reply that the natural figure is better and more pleasing. Thus rhetoric pleases more when it is hidden, because it is more natural than when you reveal it and force it."[1] Certainly such passages could be, and indeed were, interpreted in the nineteenth century and more recently as indicative of Savonarola's profound interest in the great art of his adopted city and his desire to instruct artists so that they might once again paint in the proper Christian mode. These passages on the visual arts and on the nature of beauty were culled from the sermons in 1879 by Gustave Gruyer[2] and have formed the basis for subsequent discussions of Savonarola and Renaissance art. But before we enter into this discussion we should consider another reason, the prime reason as Savonarola himself stated, for his use of such graphic imagery (examples of which will follow).

The *raison d'être* of Savonarola's preaching style, as he himself declared, was the necessity, even efficacy, of imagery for the understanding of God.[3] In his treatise *Il Trionfo della Croce*, as well as in numerous and lengthy passages in his sermons, Savonarola described the twofold related powers of an image. An image, he believed, assists man in remembering divine things, since it can become a simultaneous

constant available for study as a whole without the memory being burdened by sustained sequential development. Also, the image can represent in one easily perceived and concentrated form something too vast and profound to be otherwise grasped and comprehended. For example, the works of Christ which Savonarola wished to present and discuss in his treatise on the triumph of the cross did not lend themselves easily to view. Therefore, Savonarola said, he would present them in the image of a triumphal chariot, an easily perceptible form that could be pictured in the mind. With that image one could contemplate each of the parts, as well as the harmonious whole of the concept, at once. Furthermore, through one easily perceived image various aspects of a concept could be explored and understood by interpretation of the image on successively profound levels. The image becomes, in effect, awesome in its power. Indeed, it is the physical aspect of the Chariot of the Cross, in this case, that becomes a vehicle (in all senses) that actually conducts man to the knowledge of the ineffable and invisible deity. Man's ability to make images, verbal or visual, and to use and understand them is a divine gift; as such, according to Savonarola, it must be indulged.[4] Painted images also can have the same function as he clearly stated in a sermon on divine love: "Love is like a painter, and a [morally] good painter, if he paints well, greatly delights men with his paintings. In contemplation of the painting men remain suspended, and at times in this way appear to be in ecstacy and outside themselves and seem to forget themselves [as corporeal beings]".[5] The "good painter," furthermore, becomes a metaphor for grace and faith, which have the same effect on man as that of a good painting or verbal image—they unite him with the deity.

In addition to this parallelism between verbal and visual imagery developed by Savonarola, he used the practical elements in the visual arts for his metaphors. To demonstrate the faulty conception of God created by secular philosophers, Savonarola again drew on the art of painting. He stated: "It is said that every painter paints himself, not that he paints himself in every image, for he also makes images of lions, horses, men, and women which are not himself. But he paints himself in that he is a painter, i.e., according to his *concetto*." In other words, every figure he paints depends upon his conception of that figure; similarly, because the ancient philosophers were proud they created a proud God, one according to their own image.[6] A complicated discourse on sensual and intellectual perception is also clarified by a reference to "certain painters who make figures which appear

48

living," and which may fool those without good eyes or good *fantasia*.[7] Explications of causality on several occasions are aided by lengthy analogies taken from the relationship of the master painter and his disciple.[8] The necessity for good fundamental rules to govern one's activities called for a description of the dependence of painters upon rules, such as the canons of human proportion to construct the best possible forms.[9] Mundane affairs and pursuits are put in their proper perspective as the vanities they are by affirming that all things of the world are paintings in comparison to the reality of the Virgin.[10]

Savonarola's evaluation of his own homiletic style, his estimation of the power of rhetoric in conjunction with the power of the painted image, and his stress on the role of the preacher and that of the painter indicate that he was aware of the antique associations, revived in the fifteenth century, between the "rhetoric" of painting and that of the spoken or written word.[11] That metaphors and analogies from the figurative arts appealed to his auditors, particularly the more sophisticated of them, should not be surprising given the Florentine involvement with painting and sculpture at the end of the fifteenth century. But Savonarola clearly tried to keep the importance of these arts within the specific circumscribed bounds of their older functional classification. For him the only value of art lay in its didactic functions and as an aid to spiritual or mystical experiences.

At the same time that Savonarola ennobled painting by comparing it with rhetoric, he clearly and emphatically allied it with the arts traditionally classified as mechanical.[12] The arts of manufacture were considered by him to be undifferentiated from what may be called the crafts, (e.g., shoemaking, bricklaying, baking); thus metaphors based upon the art of painting often appear with similar metaphors taken from the art of carpentry or shoemaking.[13] Even when discussing the three divinely ordained modes for the generation of things, Savonarola stated that the objects produced by the first mode, the artificial, could not generate themselves "as a painting cannot be made without the hand of a painter, or a shoe without the hand of a shoemaker."[14] These two arts are also referred to in the same context when Savonarola defined the use of the appelation "good." He stated that a person is not "good" who is good only in one thing, but it is said of this person only that he "is a good painter, a good shoemaker"; in another instance, the art of the blacksmith is similarly related to painting.[15] Although it is clear from the sermons that the fine arts for Savonarola were not distinguished from the other practical and me-

chanical community-serving Christian labors (and in this way he reflects a Thomistic view of the subject and also the view of his illustrious predecessor of a generation earlier at San Marco, Saint Antonine),[16] metaphors involving painting are nevertheless rather more numerous in his sermons than those depending upon the mechanical arts.

This apparent contradiction is resolved only when Savonarola's attitude toward painting is placed in the perspective of his regard for all human activity: that is, painting should serve man's sole purpose in this world, which is achieving proximity to the deity. He undoubtedly sensed and saw what would be inescapable to any Florentine with intellectual interests, namely that for Florentine artists and their associates art was becoming important in its own right:[17] it seemed no longer to function only as a servant to the Christian community. Its nobility, which Savonarola readily granted, was however derived, for him, not from its own practice and theoretical basis but from its God-ordained role in assisting man in achieving divine knowledge and union with the deity.

The musician should be guided by his mind when he plays the organ, as Savonarola stated in one of his sermons, and not let the sound itself guide his hand.[18] In other words, the sound should not be indulged in for its own sake as sensual pleasure or empty intellectual artifice. Savonarola was more explicit on this theme in regard to painting, stating that the paintings to be found at the time in the churches contained so much artifice and ornamentation that they hindered the light of God and contemplation of Him; one no longer, in viewing such paintings, considered God but rather the artifice in the paintings. The same was true, he continued, with organ music and the *canti figurati*.[19] Indeed it was this far higher divine function that Savonarola sought to present as the reason for art. Thus he singled it out for references, associated it with other pursuits with well-known and properly acknowledged intellectual pedigrees, but always carefully insisted on its role as merely a part of the Christian community of labors, lest its practitioners fall prey to the sins of pride, self-satisfaction, and consequent isolation from the community.

Savonarola also directed more attention to painting than to the other arts of manufacture, because of its public didactic and mystical uses; that is, a poorly made shoe may be privately uncomfortable, but an improperly made painting may be publicly dangerous. Even among the other "higher" arts the figurative arts need more control. It is not because Savonarola had little interest in music, poetry, or other literary

forms that he spent so little time discussing them in his sermons,[20] in comparison to painting, but rather because those arts were less public and therefore less dangerous. The sensuality of the *canti figurati* were real enough, but they were only occasional; similarly the lures of poetry were rather limited, since children could not read and the poor could not buy books. But paintings and sculpture could always be seen by all in churches and public buildings and in houses as well as on their façades. The Egyptians and even Aristotle, who was only a pagan, as Savonarola pointedly reminded his audience, prohibited improper paintings in the home; paintings of nude men and young women in obscene poses and acts should not be seen in public places and in private houses. Instead, paintings of Paradise and the Inferno should be placed on the walls to be contemplated and to stand as lessons for children; sacred pictures, as Savonarola was not the first to suggest, are after all the Bible of the poor and illiterate. These themes were presented by Savonarola with his usual repetition on many occasions, obviously reflecting his concern for the proper use of an appealing and common art form.[21] At times his criticism was specifically directed toward the manner in which holy images were treated. For example, he called on "you Christian painters" to white-wash or destroy those images which were not proper and paint images which would be more pleasing to God and to the Virgin.[22] Furthermore, the quality of the gods worshipped in Florence can be seen, Savonarola preached, in the pictures of those gods, for when youths pass someone in the street they say, "there goes the Magdalen" or "that one is San Giovanni" because certain actual people are represented as the saints by painters. They also paint the Virgin, Savonarola further said of the artists, dressed and ornamented as if she were a harlot when she actually was attired as a poor woman, very simply. Such things can cause great harm.[23] In sum Savonarola desired that the painter of religious images should be a good Christian and an excellent and accomplished master so that his works would incite people to devotion and not bad habits or derisive laughter.[24]

Perhaps the worse sin for the artist, be he sculptor, painter, or musician, is *superfluità*, an error which Savonarola stressed for its seriousness from his earliest sermons, as part of the practice of the arts as well as the uses to which the objects are put. He preached against the overly ornate paintings in the churches; the unnecessary *canti figurati*; the sensuality of organ music; the sculptured images of the Christ child dressed in silk; the decorated cells in monasteries

and the similarly decorated tombs of the prelates; the draperies hung in churches on holy days; the coats of arms throughout the churches to the degree that one time when he entered a church and looked up what he thought at first to be a simple crucifix was actually an ornate armorial plaque.[25] This sin of *superfluità* was not only to be found in the arts and their uses but unfortunately in every aspect of human endeavor, including—to man's greatest detriment—his relations with his deity and His church. The virtuous counterpart of this sin for Savonarola, *semplicità*, was fundamental for man's sole purpose in life, his union with God.

Simplicity as a most important Christian virtue was associated by Savonarola with the quality of naturalness as concomitant essentials for achieving the divinely ordained purpose for which man exists. As one should expect, Savonarola chose to make clear this message by metaphorical language, and the metaphors again were based in large part on the visual arts.

CHAPTER 9

SAVONAROLA'S "THEORY OF ART"

Because Savonarola believed in simplicity and
essential nature as the basis for all man's ac-
tivities, and because the visual arts were his medium for expressing
their importance, scholars in the past have attempted, somewhat
naïvely, to consider Savonarola as the promulgator of a "naturalis-
tic" theory of art. Furthermore, since the concept of beauty was in-
volved in Savonarola's descriptions of the benefits of simplicity and
naturalism, it also became part of the theory of art constructed from
his sermons. Using Gruyer's compilation and analysis of some of
Savonarola's statements on, and metaphors of, art and beauty, schol-
ars have viewed Savonarola's "theory of art" as an incomplete, even
contradictory amalgam of Neoplatonic and Thomistic concepts; a
strange mixture of outdated Medieval tenets alongside beliefs that
were decidedly modern. Also puzzling to them was Savonarola's
supposedly clear call for art to imitate nature.[1]

There are two basic faults in this approach to Savonarola's views
on art. Devoting much attention to Savonarola's definitions of beauty,
its composition and function, these same scholars then felt con-
strained to relate these ideas to the fine arts[2] when Savonarola him-
self never so related them. For Savonarola there were two kinds of
beauty: the composite and the simple. Composite beauty may be found
in man: "You do not say that a woman is beautiful only because she
has a beautiful nose or beautiful hands, but only when all these are
in proportion. Beauty consists of the correspondence and proportion
of forms and colors." But a higher beauty lies behind this and may
even transcend mere appearances of the flesh: a holy man who is
"*brutto di corpo*" will be seen as beautiful because of the divine light

53

with which he is filled, and which is expressed in his visage. Similarly, "when the soul is taken away [in death] the body remains broken and pallid, and no longer beautiful," or when an artist paints a picture from nature the actual figure will always be more beautiful than the painted one. This higher, simple beauty thus consists of light, not color or proportion which is necessary to express physical, composite beauty; thus the sun and blessed spirits have simple beauty, and God, the brightest of all, is the most beautiful and most simple of all. Thus the closer man is to God, the more he will participate in that ultimate simple beauty of light which will affect his soul and be manifested in his appearance.[3] This Neoplatonic idea of purification of the flesh by proximity to the deity and an increase in sharing His essential beauty[4] clearly shared by Savonarola demonstrates that for him beauty was only a "metaphysical attribute of God."[5] Beauty was not an attribute of the arts, since it cannot be manufactured by man. Insistence upon linking Savonarola's words on the subject of beauty with his ideas on painting because both subjects are associated today (and were associated by art theoreticians of the fifteenth century)[6] does not, therefore, aid in understanding Savonarola's own attitude toward the arts.

The second fault lies in implying, or specifically stating, as Schnitzer did,[7] that Savonarola's theory of art was based on the concept of the imitation of nature. Savonarola was not presenting a theory of art, but rather workable precepts for a practical craft while closely associating that craft with his basic ideas on the virtuous simplicity of the Christian life and all that pertains to it and serves it. He did believe that art should imitate nature. This is readily apparent throughout his sermons and particularly and significantly in his treatise *Della semplicità della vita christiana*,[8] because nature, or the natural, became for him synonymous with simplicity and purity, and thus with virtue and goodness. These qualities are then contrasted with the contrived and the ornamented, or those things in which there is an emphasis on the physical exterior, which are then equated with the sins of *superfluità*, *superbia*, and *lussuria* that man and the later church are suffering from. These sins can be found, he reiterated constantly, in all aspects of "spiritual" and mundane life, including the arts, and one of his basic purposes in preaching is to return mankind to the simplicity and greatness of the early Christian church. He railed against the excesses of clerical and secular dress; against the *drappelonni* and other festive decorations in the churches; against elaborate tombs,

pomp and display of all sorts; against the contrivances of the *canti figurati* sung in the churches and the complexities of organ music.[9] His position can be summed up by his own oft repeated phrase that "there once were priests of gold and chalices of wood, now it is the reverse of those ancient days and there are priests of wood and chalices of gold."[10] In short, the ideal church (the early Christian church) was "ornamented only by its virtues."[11] It is a return to a simplicity natural and uncontrived that he urges. Recognizing the importance of the figurative arts for instruction and inspiration to piety, Savonarola also wished these arts to be straightforward and simple, in a word, natural. Art should imitate unsophisticated nature and reflect the basic virtuous simplicity of the original church.

Savonarola's statements on the virtues of "naturalism," therefore, cannot be considered alongside the writings of art theoreticians. Clearly he was not interested in art or art theory *per se*, but rather in its practical implications for presenting to the Christian community explicitly, even simply, rendered and functional works of art. His views on art are, furthermore, thoroughly integrated with and motivated by his overall and basic concept of Christianity, and as such have more relevance in that context than in the history of art theory. If, as noted in the preceding chapter, Savonarola believed that a painting had the power while one contemplated it of producing a state of religious ecstasy which brought the viewer closer to God, then certainly he would object when something interfered with that important virtue of art. Indeed, he stated in one sermon that in his time the figures in the churches were filled with such artifice that they destroyed one's ability to contemplate the painting and thus, through it, be brought closer to Him: one could only contemplate the artifice in the work.[12] The lack of simplicity, or lack of the natural state in the work, impedes the viewer in his attempt at union with the fundamental simplicity which is God. Similarly, the natural (as opposed to the contrived figure in painting and rhetoric—as in Savonarola's analogy referred to earlier) pleases more because it is closer in its simplicity to its divine origin, producing a pleasing affinity.

The foundation and character of Savonarola's naturalism is theological. He firmly believed in the Aristotelian concept that everything in nature, and all its operations, is ordained by a supreme intellect toward its own specific ends or purposes. Of the great number of references to this in the sermons, the following passage serves as an excellent example of his thoughts on the subject; the kinds of similes

drawn from the arts as well as from common everyday experiences which he used here to explicate these thoughts are also of importance in this discussion.

> Regard the things of nature: the order of the universe demonstrates that they are guided by some intellect. Aristotle, whom you call great indeed, said that in nature there is error;[13] this could not be if nature were not guided by some intellect, because error is that which goes against the intellect. Let me extend this idea into the realm of manufactured things. For example, a man goes into a goldsmith's shop and sees there many silver vases and the instruments for making them. Although he has never seen such things before he immediately postulates that the work had been guided by a man. If he is told that the instruments themselves made the vases, he would reply that they could not possibly have done so unless they were guided by a hand; and he posits an intellect which guided the hand. A *maestro* in the *arte* knows when there is a defect in a letter. A painter knows when there is a defect in a painting and says:—this is against the order, there is an error.
>
> Order comes from a purpose (its end, *fine*), because if there were no purpose there could be no error in the thing made, and thus no error would be against the purpose. Thus when one is born without a hand we say that nature has erred and, therefore, we must say that nature works in an ordered way toward an end. Whence, from the order that is to be seen in nature and in the universe, the philosophers have understood that there is an intellect which regulates all this order; for example, if you entered a house where everything is well ordered, you would say that the order proceeds from some intelligent man, and thus you would be referring to an intellect. Now if you see that order can exist in this lowly house, how much greater and how much more suitable is it for us to believe this of higher things, as I have told you many times before If a painter gives his disciple a *stampa* to paint, and the disciple does not follow the order of the *stampa*, the painter says:—you have made an error. Thus, God, in his things, wishes to make a *stampa*, so who strays from its order goes in sin and is punished.[14]

In another passage in which Savonarola declaimed to the Florentines that it was not possible for them to do anything without the guidance of Christ and that the similes he presented from nature also pertain to matters of faith, he stated:

> Look at what the philosophers say: *Ars praesupponit naturam et natura praesupponit divinam virtutem.* This means that it is not possible to make anything without nature; the smith cannot make anything without fire, the painter can not do anything without nature.[15]

Yet the natural thing will always be different, and discernably so, even to lesser creatures than man. In one sermon, Savonarola re-

quested that a painter come forward and asked him if he knew how to depict a bunch of grapes, and how to color them so that they appeared real (in an aside he informed his listeners that painters, mainly the good painters, had certain colors which gave a luster of reality to the works). He then stated that if a wood carver carved a bunch of grapes resembling real ones, and the painter colored them like those of natural grapes and hung them on a trellis next to real grapes, a passing bird would not go to them but only to the real grapes. Thus, as much perfection as an art may have it can never imitate nature in every way. The point of this analogy, as Savonarola concluded, is that those who are closer to the deity in their simplicity or naturalness can detect the differences with their eyes of grace between the true and the false or the natural and the unnatural.[16]

The concept of divine necessity for the imitation of nature is to be found in Federico Zuccari's book *L'Idea de'pittori, scultori ed architetti* published in 1607, a treatise which has striking parallels with the Thomistic and Aristotelian concepts of art and its imitation of nature[17] found in Savonarola. But Zuccari, in contrast to Savonarola, used Thomistic and Aristotelian ideas to establish a theological basis for his theory of art, the writing of which was his prime aim, whereas Savonarola incorporated these concepts of imitation into a total theological systematization of man and the universe in which the production of art played a specific, although minor, role as a craft serving a Christian function. Although Zuccari and Savonarola may seem to agree on the necessity of imitating nature, this radically different matter of focus and emphasis is very important. In addition to these concepts serving Savonarola's theme of the Christian virtue of natural simplicity, it is also related to his belief in the ultimate end of all things, or, of all effects, lying in their union with their cause. In short, the closer a thing comes to its cause the more it partakes of perfection; the more it differs from its cause the less it participates in perfection. To stray from that prime cause, that divinely ordained order of functions, is to stray from God.[18] This is the very basis of his theology, and thus the basis of all his thoughts on man and the pursuits of man, including man's role as a maker of images.[19]

CHAPTER 10

SAVONAROLA AND PAINTING STYLE

Savonarola's constant advice to artists, combined with his criticism of their painting style and subject matter, has prompted many historians to postulate a general influence of Savonarola on the painting style in Florence at the turn of the fifteenth century. This was practically required because of their belief in a widespread influence of Savonarola on "the best" of Florentine artists; they ascribed to Savonarola a responsibility for many of the best characteristics of Florentine painting style.

Two fundamental questions must be asked before investigating possible associations between Savonarola's words on art and painting style in Florence: what assumptions can we make and what constitutes proof of an association? Determination of these is particularly important in this case because of the extent to which Savonarola's influence on painting is believed. Furthermore, in relation to style we are working with the inherent difficulty of proving cases in which one cannot use documentary evidence but must rely rather on highly interpretive visual analysis. Finally, we must be aware that fundamental changes have taken place in our concepts of style as well as in our knowledge of the working procedures of Renaissance artists.

In a recent study of Florentine painting of the 1490s, the Savonarolan episode, which the author apparently felt had somehow to be included in his analysis, was described as the agent and symptom of "polarity and crisis" in Florentine society and Florentine painting style. That style was characterized as a polarization of two different styles in which Sandro Botticelli and Domenico Ghirlandaio represented extremes. These "problems of conflict," which supposedly first matured in the 1470s, grew in the last decade to the dimension of a

full "crisis." The "Savonarolesque revolution was only temporarily successful, and it represented a historical reaction rather than a new beginning, but it still performed a function which was related to the inception of a new period of culture and a new style of art. It posed in drastically present, pervasive terms, the problems of conflict between the physical and the supernatural"[1] This founding of broad generalizations about one area of culture upon equally broad interpretations of other areas is not very revealing. Nor are we enlightened when the author bases his interpretation of both on his assumption of an underlying "absolute" spiritual-physical dichotomy in society during that time. We cannot help wondering as well about the uniqueness of such qualities to any given period of history; some historians may see them as characteristics common to man throughout time.

More particularly we are neither informed of what this relationship or influence consisted, nor how this Savonarolan relationship to the arts can actually be seen and demonstrated in them. In the author's discussion of Fra Bartolomeo who, evidence indicates, became a monk in San Marco as a result of Savonarola, no mention was made of Savonarola or his influence on the painter's style, an influence, if it existed, one would expect to find in that painter's work. Instead, classicism, Leonardo da Vinci, and Raphael were discussed as the informing sources for Fra Bartolomeo's style.[2] The author postulated the general condition, but avoided its implications in obvious specific cases.

The opposite fault can be found in an older study of Renaissance painting. Heinrich Wölfflin wrote that Fra Bartolomeo the "pupil of Savonarola cherished an ideal of a potent simplicity, by force of which he would annihilate the worldly vanity and the petty conceits of Florentine Church pictures."[3] Wölfflin specifically associated both Fra Bartolomeo and his painting style with Savonarola, in contrast to Freedberg, but erred in disregarding the styles of Fra Bartolomeo's predecessors and contemporaries, who share many of the artist's stylistic qualities. However, Wölfflin did reflect in his summation of Fra Bartolomeo's style certain ideas of Savonarola which were referred to in the previous chapter. The question is the accuracy of Wölfflin's observations of Fra Bartolomeo's paintings and the relationship of his style to those of other painters who presumably had no association with Savonarola, and of all their styles to certain general stylistic tendencies at the turn of the fifteenth century. Certainly, the possibility remains that Wölfflin, knowing Fra Bartolomeo's relationship to Savonarola and Savonarola's published estimations of the art of

59

his period and his injunctions to artists, may have read Fra Bartolomeo's style according to *a priori* expectancies. Naturally, historians viewing Savonarola as an effective reformer of a Christian art turned pagan and worldly would expect to see in the works produced by artists who were his followers a return to early Christian simplicity which Savonarola so strongly urged.

In contrast to Florentine painters working before the turn of the fifteenth century, or to those older masters who were still working in the first few decades of the sixteenth century (such as Botticelli, Ghirlandaio, Verrocchio, Filippino Lippi), Fra Bartolomeo's works do display simplicity. The works of the other painters contain involved drapery patterns, with the drapery often varicolored and ornamented with brocaded designs, extensive landscape vistas filled with objects, and numerous attractive and visually arresting details. In short they present a multiplicity of forms and colors spread throughout the paintings, whereas Fra Bartolomeo's paintings can be characterized, as Wölfllin noted, by a lack of ornament and detail and a concomitant concentration on large, simple, expansive forms and areas of color.[4] This difference, however, does not necessarily point to Savonarola, but rather indicates that Fra Bartolomeo's style reflects qualities which were generally prevalent in Florence among the younger generation of painters in the first two decades of the century. For example, the works of Andrea del Sarto and Mariotto Albertinelli (who was, incidentally, Fra Bartolomeo's irreligious former associate in painting) display the same basic characteristics, and these common features can be traced to the influence and heritage of such painters as Leonardo da Vinci and Raphael. The latter's innovations while he was in Florence from 1504 to 1508 depended on Leonardo's and Perugino's interests in softer, more broadly treated areas with less emphasis on the absolute evenly lighted clarity of contour and the complicated linear rhythms made possible by multiple forms. It is therefore more accurate to state that Savonarola may have echoed certain stylistic trends in Florence which he found pleasing than that he was responsible for the style of one master. At most, in the case of Fra Bartolomeo, Savonarola's words may have given an already established stylistic direction a degree of monastic authorization. Fra Bartolomeo's style was also formed by some rather practical considerations. Because of his vocation and the limited variety of patrons for whom he consequently worked, his range of subjects was more circumscribed than that of other Florentine painters; nor did Fra Bartolomeo

have the opportunity to work on an extensive fresco cycle nor even on a single monumental fresco, all of which, as a matter of course, would have made new and different aesthetic demands, resulting in a more varied style. Also to be considered in any interpretation of Fra Bartolomeo's style are the limitations imposed on it by his comparatively short span of artistic activity (twelve years) after he entered San Marco.

Finally, there is the question of the necessity of expecting Savonarola to have influenced the styles of artists who came into contact with him. Is this truly justified? Must there have been an influence of this sort? Such a question should certainly not prevent scholars from looking for the influence, but the expectancy should not be allowed to determine the frequency of positive results, for another question inevitably must be answered, and that is, if the influence is expected— for example, with an artist such as Fra Bartolomeo who may have been quite close to Savonarola—how may it have been manifested in the artist's style and how may it be discerned?

The same scholars who have associated Fra Bartolomeo's style with Savonarola found a profound effect of Savonarola on Botticelli's style as well. Botticelli's later works, those dating from the mid-1490s until his death in 1510, have been described as having a "spiritual" style reflecting an "impassioned spirit of moral austerity," a "sadness" and "melancholy" and an unreal quality of form[5] which was identified as stemming from the artist's infatuation with Savonarola. However, only a few paintings are commonly identified by these authors as embodying this "Savonarolan" style, that is, the *Lucrezia* and *Virginia* panels, the Fogg *Mystic Crucifixion*, and the London *Mystic Nativity*.[6] Careful viewing of the paintings dated between 1490 and 1510 reveals rather a variety of styles which should not be at all surprising considering the variety of patrons for whom the artist worked during these years and the varied demands of individual commissions in regard to size, media, subject, and the projected location of the work.[7] The fault is clearly that of attempting *a priori* to classify these paintings done by Botticelli after Savonarola's advent in Florence as being under the *frate*'s influence. Furthermore, if in fact Botticelli did change to a new "spiritual" style because of Savonarola, it is strange to find that he totally ignored Savonarola's insistent injunctions concerning style noted earlier. Also it is odd that the same "spiritual" style occurs in Botticelli's paintings of non-Christian subjects commissioned by adversaries of Savonarola.[8]

61

Considering that Botticelli's "Savonarolan style" is quite distinct from Fra Bartolomeo's "Savonarolan style," and that both, in turn, are decidedly in contrast to Michelangelo's "Savonarolan style" and so on, the entire problem of Savonarola and style becomes generally diffuse, unrevealing, and even moot. At best it is of speculative interest.[9]

PART THREE

SAVONAROLAN ICONOGRAPHY

CHAPTER 11

INTRODUCTION TO PART THREE

If we examine what constituted, for past historians, an "influence" of Savonarola on an artist, we find that their conclusions rested on evidence supposedly demonstrating that an artist was an adherent of the *frate*. Their argument was that if the artist were a follower of Savonarola, then his works were Savonarolan, that they somehow reflected the general religious convictions of Savonarola. However, evidence clearly revealing contact between the artist and the preacher or the personal beliefs of the artist is extremely scarce. Furthermore, such an argument is implicitly based on the invalid assumption that the artist at the turn of the fifteenth century was always free to choose the subject matter of his paintings or to interpret a given subject according to the dictates of his own particular beliefs.

Historians have also believed in their ability to identify Savonarola's influence on art by pointing out that some works of art reflect his intense religious feeling. Of course this depends wholly upon one's definition of "intensity" and interpretation of the work. To state, five hundred years after the fact, that one painting of a Madonna, for example, is more religious or spiritual than another in its expression is presumptuous. Even if such a determination could actually be made, then one would have to prove that it is more religious or more spiritual because of Savonarola. Such a statement unnecessarily assumes that Savonarola was the only religious stimulus in Florence at the turn of the fifteenth century, and that all religious patrons and artists as a matter of course had to be his partisans. A basic fault with both approaches is that they limit the area of inquiry to artists who were mature during the six years of Savonarola's activity in Florence and

65

who had personal contact with him. On the other hand, an attempt to discover instances of Savonarolan iconography does not falsely limit the area of inquiry. Consideration of Savonarola's (almost twenty) volumes of sermons, treatises, and poetry as possible iconographic sources rather expands the possible range of Savonarola's "influence" both geographically and temporally. In addition it has the virtue of possibly yielding specific demonstrable results to a degree not possible when one is dependent upon vague interpretations of the artist's and patron's characters, motivations, or personal beliefs as they may or may not be revealed in the scarce available documents, not to mention the depth and duration of those beliefs. The definition of a Savonarolan work of art adopted here depends upon the fact that although a work of art may have been commissioned in response to Savonarola's character, activities, and preaching, that which makes the work Savonarolan can only be that which at the same time distinguishes it somehow from all other versions of the same subject while these same distinctions unite the work with Savonarola and only Savonarola.

Savonarola's use of graphic imagery may easily have caught the imagination of artist and patron. However it appears that there are rather few instances of such Savonarolan iconography, even in the works of Fra Bartolomeo, an artist whose closeness to Savonarola is to some degree documentable. The reason for this may be twofold. Firstly, the standard repertory of religious subjects in the visual arts apparently was sufficient in most cases to express religious sentiment, even the kind of sentiment inspired by Savonarola; there was no general demand for a new religious imagery among the host of Savonarola's adherents. Secondly, Savonarola's rather complicated imagery was often dependent upon a large number of objects, depiction of which would have been contrary to his own stated ideas of what good painting should be. Savonarola called for iconographically straightforward paintings such as those showing the Virgin and Child, the Inferno and Paradise, the saints and incidents from their lives: if paintings were the Bibles of children and the illiterate, they had to be easily readable. The richness of imagery, to be found, for example, in his treatise *Il Trionfo della Croce*, served beautifully for verbal explication; as a painting it would have been burdensomely complex, both for the painter and for a viewer who did not have Savonarola's text at hand.

The following paraphrase from Savonarola's sermon on Job will serve to indicate the prolixity of his imagery as well as the fact that,

because of his interest in graphic images and the visual arts, he apparently studied paintings, for the image he presented is directly dependent upon the traditional pictorial theme of the eternal heavenly communion of the saints with the Madonna and her Child, known commonly as the *Sacra Conversazione*.

On the Vigil of the Annunciation (March 24, 1495),[1] Savonarola chose the throne of Solomon as his text, and began by declaring that he would place the Virgin in the throne of Solomon because in her was located the throne and seat of God who rested in her womb nine months and many more times in her arms. He then described the throne and the meaning of all its parts. Made of ivory and decorated throughout with the purest gold, the throne has two hands holding up the seat, at the sides of which are two lions; rising up to the throne are six stairs with lions at each side; a rotunda crowns the whole. The pure ivory of the throne signifies the great purity of the Virgin; its gold sheathing signifies her great charity, and the rotunda above reflects her divinity because the only thing without beginning or end is God; the grandeur and height of the throne represent the grandeur and height of the idea (i.e., *concetto*) of the Virgin, and her knowledge and intelligence of God; the two hands and two lions which hold the seat of the throne represent the firmness of all the Virgin's virtues. Thus the throne itself represents the Virgin. Later in the sermon, these parts of the throne were given further symbolic meanings: the seat symbolizes the humility of Mary, and is also the seat of Humility and Wisdom; the right hand supporting the throne represents knowledge of God, the left, knowledge of oneself, the two necessities for remaining firm in one's humility; the lions symbolize fortitude of the soul and fortitude in tribulations and are also related to the Virgin. The six stairs leading up to the throne represent the six ages; and the twelve lions on the stairs represent the twelve ancient fathers who have explicated all the mysteries of the church, six on one side are from the Old Testament, and six on the other side are from the New Testament. The throne is placed on the grass in a meadow and, as we climb the first stair, we encounter Joseph, who is the custodian of the throne because he was the husband of the Virgin. On the first stair we find on one side Saints Elizabeth and Zachariah and on the other side Saints Anne and Joachim, the mother and father of the Virgin. They hold sweet violets in their hands. On the second stair are, on either side, Saints Catherine Martyr and Catherine of Siena with crowns of white roses. On the third stair are the two bishop saints of Florence, Antonino and Zenobio, with crowns of lilies (*fioralisi*, the

emblematic flower of Florence). The fourth stair supports Saints Sebastian and Stephen, one at each side, who have crowns of red roses. On the next to the last stair are, at either side, Saints John the Evangelist and Mark with crowns of pink roses. On the topmost stair are David and Saint John the Baptist with crowns of palms. Above all these is the royal throne where the Virgin sits with the infant Jesus in her arms circled by angels and archangels: first Gabriel, then Raphael, then Michael, all with many flowers that are unknown to man. All are filled with the greatest happiness and exultation.

The sermon on the next day contained an amplification of this image, but the scribe reported that he was so taken by the sweetness of the preacher's words that he could not write.

This variation of the *sacra conversazione* theme presented verbally by Savonarola could, with little difficulty, have been transferred into the visual medium. The basic format, for example, of Fra Bartolomeo's Gran Consiglio altarpiece would have served the purpose.[2] But the large number of forms a painter would have needed, even just for an accurate rendering of the throne, would have been contrary not only to Savonarola's own professed ideals of visually simple and straightforward religious images, but to the stylistic tendencies of early sixteenth-century Florentine artists as well. Would, however, such an image as Savonarola described have actually been necessary? The symbolism of the Virgin in the throne of Solomon and all it implied was traditionally implicit in images of the Madonna enthroned.[3] Savonarola's image, with all its details and his particular selection of saints, in substance did not institute any major change in the interpretation of the subject. The usual paintings of the Madonna and Child enthroned with various saints served the purpose well enough.

Instead of the invention of all new compositional formats to represent specific Savonarolan images, established compositions and subject-types were adapted by artists to represent, for the most part, not specific images borrowed from single passages in the sermons but rather fundamental and important themes which were prevalent throughout the sermons and which were identifiably and uniquely Savonarolan. With their compositions standardly recognizable types, these Savonarolan paintings could also on a simple level serve as religious imagery for those unfamiliar with Savonarola's messages. Indeed, this mostly was their fate, for while Savonarola's influence has been searched for in the personalities of the artists and the style of their paintings, his messages remain to be discovered in their iconography.

68

CHAPTER 12

BOTTICELLI

Sandro Botticelli's personal feelings toward Savonarola are at best elusive, but some of his paintings nonetheless reveal Savonarolan iconography. And this iconography, we should keep in mind, may not at all reflect the artist's own personal views.

We shall first consider the so-called *Mystic Crucifixion* in the Fogg Museum, Cambridge (Fig. 1). The provenance of the painting is not known, and when it was first published by Horne, he doubted that it was totally by the hand of Botticelli, although it was certainly in his style.[1] Indeed, it is with a greater security that we can attribute the work to the master's style than we can to the master himself. Nevertheless, we shall consider the work here, for if the picture is not Botticelli then certainly it is by someone who worked closely with him.[2] Horne's date of around 1500 will serve.

The composition is a simple one. At the center is a crucified Christ. Mary Magdalen lies across the left foreground embracing the foot of the crucifix, and a standing angel to the right appears to be in the act of striking an animal, which he holds in the air by its hind leg, with a rod of some kind. Behind him are flames and dark clouds. To the left is a view of Florence seen against a light, clear sky. At the upper corner is a circle of light within which is seated God the Father, holding an open book and blessing. To the right, in the sky just below Him, are white shields painted with red crosses.

There is total agreement in the literature as to the basic meaning of the painting and its relation to Savonarola; however, the painting has been read variously as an interpretation of one of Savonarola's visions as recorded in his *Compendio delle Rivelazioni*, or as an interpretation of a passage from one of his sermons. Both the vision and

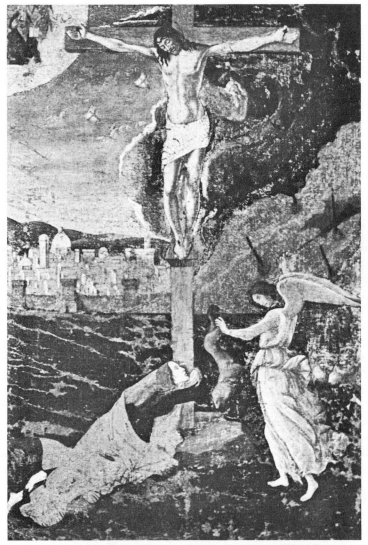

FIGURE 1. Sandro Botticelli (attribution), *Mystic Crucifixion*, Fogg Museum, Cambridge, Massachusetts. Courtesy of the Fogg Art Museum, Harvard University.

the sermon contain the same kind of imagery, hence the confusion. Horne was the first to associate the painting with Savonarola's vision of the *Crux irae Dei*.[3] This vision is described in the *Compendio* as follows:

> While preaching in San Lorenzo during Lent of 1492, I saw, on the night of Holy Friday, two crosses. The first was black and in the middle of Rome; its top touched the heavens and its arms extended over all the land, and above it was written these words: CRUX IRAE DEI. Immediately that this appeared the weather became disturbed; clouds came flying through the air bringing winds, and hurling lightning and arrows, and it rained hail, fire and swords, and killed a great number of people so that few remained on earth. After this came a time of serenity and clear skys and another cross was seen. This was golden, as high as the first, and was above Jerusalem. It was so resplendent that it lit all the world, and above it was written: CRUX MISERICORDIAE DEI, and all the generations of men and women from all parts of the world came and adored it and embraced it.[4]

For Horne, the painting illustrated the appearance of the first cross. However Florence replaced Rome, the city of the vision. The Magdalen represented the repentant soul clutching the crucifix to escape God's wrath. The animal struck by the angel Horne identified as a fox which represents vice, and he referred to the fox that destroys the vineyard from the Song of Solomon (2:15) for this interpretation.

This explanation of the painting has been generally accepted with slight variations or additions. For example, Bode identified the animal held by the angel as a lion, the *Marzocco* of Florence. He interpreted its castigation as symbolizing the castigation of Florence for its sins (the martyrdom of Savonarola, according to him, was also intended by Botticelli to be numbered among the sins of Florence), while to the left the repentant Magdalen represented the repentant city after its divine cleansing.[5] Other authors saw the painting as representing God protecting Florence from the tribulations being meted out to the rest of the world, and as the triumph of religion over the pagan licentiousness prevalent at the time.[6]

It should be recognized that whereas Horne believed the imagery of the painting to be based on a particular descriptive passage from Savonarola, later authors, although they basically followed Horne's account, began to interpret the painting not as the rendering of a specific Savonarolan image, but rather as symbolizing a general and constant message that runs through the preacher's sermons. In other words, the painting came to be seen no longer as a rendition of a

particular verbal image, but rather as that of a general idea for the expression of which a visual image had to be invented by the artist. It was apparently with this later view in mind that Ferrara, in 1932, offered a new interpretation. Ferrara argued that Horne's interpretation should be set aside for although the mood of castigation obviously reflected in the painting is similar to that expressed in Savonarola's *Crux irae Dei* nothing else is. The artist hardly needed to include the prominent figures of the angel with the animal, the Magdalen, the city of Florence, and the shields to render into the visual medium the vision of Savonarola which had its own different and equally expressive content. Obviously, their inclusion in the painting produced a different image which must be based upon other sources.

Ferrara first described the painting in great detail, noting that: a wolf can be seen emerging from the folds of the draped figure who embraces the crucifix; the angel holds a lion and a rod which he shakes at the animal; behind him, flames flicker over a fissure in the ground; God, surrounded by a nimbus of angels, with a gesture of His hand marshals the angels, who with swords and shields marked by crucifixes fly toward the tempest at the right, which appears to be driven back by the heavenly militia; and, in the middle of the rents in the dark clouds devils shake and hurl feeble fires to the earth.[7] Ferrara believed that "Botticelli developed this painting from the repeated statements of divine threats pronounced [by Savonarola] and, above all, from his frequent announcements of the renovation of the Church which was to be preceded by the punishment of Florence and Italy."[8] To substantiate this, Ferrara cited a passage from Savonarola's sermon of August 15, 1496, in which a battle between Satan and the angels is referred to, and also noted that this is one of many similar passages in his sermons.[9] He further observed that, in accord with this passage, heavenly wrath can be seen arousing itself and the angel can be seen at the right in the act of beating the Florentine *Marzocco*, which Ferrara had no doubt was the true identification of the animal. In this regard, he cited Savonarola's reference to Florence with the vocative "*Leone*" in his sermon of March 13, 1496.[10]

Ferrara continued his interpretation of the painting by indicating that at the left renovated Florence can be seen in the "dawn of a paradisal light" with all heaven rejoicing and the angels defending the city. Furthermore, the church, redeemed in the grace of its repentance, fastens itself to the foot of the cross as its supreme salvation. He concluded that in consequence of this spiritual regeneration, the wolf, a

Dantesque and Savonarolan symbol of the corrupt clergy, exits cautiously and snarlingly from the papal mantle where it formerly was protected.[11]

Salvini, in 1958, interpreted the painting as having been inspired by Savonarola's sermon of January 13, 1496, which dealt, as did so many other of his sermons, with the renovation of the church. The passage Salvini quoted is practically the same vision of the *Crux irae Dei* related by Savonarola in his *Compendio delle Rivelazioni.*[12] According to Salvini, the painter synthesized the two passages into one, and at the right depicted the tempestuous cloud in which devils throw burning swords to earth. There is, however, no reference in the vision to such devils; the swords merely rained down along with hail, fire, and arrows. To the left, Salvini continued, appears Florence in sunlight with God sending white angels, holding shields with red crosses on them. The angels, he noted, are so rubbed that they have been left unmentioned by many commentators on the painting. For this motif, he referred to a later passage in the same sermon in which Savonarola spoke of the shaking sword he saw above Italy, and of the angels who came with red crosses *in their hands.* This passage, although from the same sermon, is from another of Savonarola's visions and cannot really be applied to the Fogg painting, since it has red crosses *on shields.* No shields are mentioned in the vision and the crosses in the vision are kissed by the angels while they hold white stoles in their other hands.[13] Furthermore, if the angels are rubbed, as Salvini noted, then why are the presumably more thinly painted clouds around the shields still readily apparent? In fact not even "rubbed" angels are discernible. Salvini concluded that the painting was intended as an allegory of the purification of Florence and the church which repent after their tribulations. These tribulations are seen in the clouds and swords, which the angels of God push far back from the city, and the lion of vice is chastised, while the wolf of corruption flees "the womb of the Church."[14]

The prime fault with the interpretations of Horne and Salvini is their insistence on reading the painting as the artist's free interpretation of Savonarola's vision when the differences between the two are greater than the similarities. Ferrara, while not strictly following this reading, saw in the painting rather more than is actually there and incorporated this into his interpretation: for example, God's marshalling of the angelic militia, and its battle with the demons, the paradisal light over Florence, the rejoicing heavens, and the Magdalen's

73

repentant and imploring gaze at the angel. Nor does Savonarola ever mention, in the passages referred to, the crucified Christ. He spoke only of crosses, one black and the other gold, as symbolic forms, not as part of the Passion of Christ. When on other occasions Savonarola referred to the crucified Christ he did so explicitly and for specific meaning.

The interpretation proposed here instead is dependent upon one of Savonarola's most emphasized and oft-repeated themes and the metaphors he constantly used in presenting this theme. The painting represents the theme reduced to its fundamental elements for the sake of visual clarity in order to represent an easily readable, timeless, didactic image, not a scene in a narrative of a miracle.[15]

Basically, the painting represents Savonarola's theme of the imminent and inevitable dark cloud of tribulation which approaches Florence at the will of God the Father. The angel, on the side with the clouds, is in the act of purging the sinful city, symbolized by the Florentine *Marzocco*, with the *bastonata* (other *bastonate* are visible in the dark clouds) while the wolf, Savonarola's usual symbol for corruption, leaves the purged penitent, who has turned to the crucified Christ for salvation in the threat of the tribulations and embraces the cross as Savonarola exclaimed people must in a reaffirmed faith.

Specific sources for this interpretation can be found on numerous occasions in the course of Savonarola's sermons. To begin with, tribulations are pictured as a dark advancing cloud so often in Savonarola's sermons that a dark cloud becomes synonymous with tribulation and even symbolically represents it. These tribulations, for Savonarola, are necessary to purge evil. They should, in fact, be welcomed as an instrument of God to improve mankind, and, as Savonarola pointed out, were constantly used as such by God as reported in the Old Testament. In the course of such tribulations, those whose faith is firm will not suffer, and those who wholeheartedly repent their sins by turning to Christ as their only salvation from such terrors will be saved.[16] Thus, in the painting are the necessary images of Christ crucified for man's salvation and of God the Father in heaven whose will is being revealed on earth. These prophecies of tribulation were forecast for all of Italy, but particularly for Florence because that city was, according to Savonarola, the new chosen city, the city from which all the new political, religious, and moral reforms would spread; and as such it most necessarily had to be chastened and purged.[17] The chastising and cleansing of Florence is symbolically represented by

the angel holding an animal which we believe to be a lion, as did Bode, Ferrara, and Salvini. (Its small proportions result from obvious compositional necessities but even they cannot hide its lithe, feline form.) Ferrara pointed out that Savonarola referred to Florence with the vocative *Leone*. But Savonarola also on numerous occasions throughout his sermons referred to the city as *Marzocco* as well as *Leone*, used the appelations interchangeably, and also referred to Florence as the *Marzocco* sick with sin that must be cured and revived with medicine administered by Christ. In one of his many sermons addressed to Florence on its imminent chastisement and purification through tribulation, he exclaimed: "O *Marzocco*, I will tell you of that time and how you will fare." He then went on to describe the *Marzocco* flayed, and with its tail and ears cut off, attacked by lesser animals and dying. The Lord, he continued, will then appear and offer to revive the *Marzocco* with a medicine that will send all its attackers back to their lairs. He further told the *Marzocco* of the sin of Adam and of God becoming flesh to save mankind. The medicine offered to the beast is that of humility to purge its sin of *superbia*. Then Savonarola interpreted the phrase *et lacrimatus est Iesus* as signifying the lamenting of those who saw the *Marzocco* so terribly treated during the tribulations, but when the tribulations passed they cried sweetly, praising the Lord and saying, "O Lord, you have liberated us!"[18] Also throughout this passage *Marzocco*, the lion, and Florence are variously interchanged, and in an earlier series of sermons Savonarola similarly spoke of Christ as a doctor who will come to sick Florence with medicine.[19] Elsewhere, he asked, "How often does the pulse of this *Marzocco* have to be taken?"[20] In the sermons on Ezechiel, Florence and the church are symbolized by an evil lion which Christ will fight and conquer.[21] On several occasions the lion symbolizes *superbia*,[22] the sensual nature of man,[23] the heads of the Florentine government,[24] and those who do not have faith in Christ and who will tremble during the tribulations.[25] Thus, in the painting, against the background of dark clouds of tribulations, the angel, as God's instrument, beats the evil lion with the "*flagello*," "*bastonata*," "*bastoncello*," or the new "*virga del ferro*" of Moses, as Savonarola referred to the instrument of purification brought by the tribulations.[26]

On the side of the painting toward which Christ's head is inclined is a depiction of Florence; the fire and clouds of tribulation only pass the crucifix at one small point at the wall of the city. In his sermons of March 16 and 17, 1497, Savonarola, in speaking of the divinely

75

ordained tribulations coming to Florence, said that God has raised his hand above Florence as he did over Egypt when it was purged.[27] This image fits the depiction of God above the city of Florence in the painting, but since this is a standard depiction of God the Father as well, the source need not have been in this passage from the sermon. After this, Savonarola stated that God, as a consequence of the purging tribulations, will make Florence into a most beautiful city.[28] In the same sermons he spoke of the "*flagello*" above Florence, called upon the city to repent,[29] and told the Florentines that they will "cry at the foot of the crucifix."[30] The Magdalen at the foot of the cross probably has the general meaning, typical for that saint, of the repentant sinner who embraces the cross for salvation. She is also interpreted by Savonarola in this fashion.[31] In fact, according to him, the repentent and purged sinner is especially regarded by Christ. Thus, to the right side of the painting Florence is castigated by the instrument of God against a background of the dark clouds of tribulation interspersed with *bastoncelli*, while to the left the way of its salvation is indicated by the Magdalen's abandonment of herself to the crucified Christ. Furthermore, Savonarola always pointed out that those who are firm in their faith will not be tortured by the tribulation; therefore the Magdalen may represent, on the unperturbed side of the painting, the faithful who will not suffer because of their belief in Christ. The wolf noted by Ferrara as creeping out from the robes of Mary Magdalen has been interpreted by him, and others after him, as representing the cleansing of the church after the tribulations. For Savonarola, the wolf represented various sins. In one passage from a sermon dealing with the sins of Florence he spoke both of the "lion of *superbia*" and the "rapacious wolf"[32] (both of which are represented in the painting); and in a later sermon in the same series he stated that both the lion and the wolf will be destroyed by the tribulations.[33] His many references to the clergy as "wolves in sheeps' clothing" and as the animals chased away by the rod of Moses which "are not shepherds, but wolves, I tell you,"[34] would also suggest that the repentant sinner at the foot of the cross from whose garment the wolf exits represents the cleansed church as well as a cleansed and repentant sinner in general.

Although there are references in the sermons and *Compendio* to red crosses, none are ever mentioned as an emblem on a shield. Instead, red crosses and white garments are held in the hands of angels who descend from heaven and are offered to men, some of whom accept the garment and cross while others refuse them.[35] In another instance,

red crosses are marked on the foreheads of those who become drunk in the blood of the crucified Christ.[36] It is, however, clear from all these passages that the red cross is the sign assumed by those who follow Christ.[37] The location of the cross on the shield, and the apparent movement and direction of the shields from God the Father toward the dark cloud of tribulation, may then imply that God sends to man, during this tribulation, a shielding counterforce in the sign of the cross.

The second painting by Botticelli associated with Savonarola is the so-called *Mystic Nativity* in the National Gallery, London (Fig. 2). The iconography of this painting is far more complex than that of the Fogg *Mystic Crucifixion*, and some of its components can, with some degree of security, be associated with Savonarola's sermons, while others clearly cannot, or at best have only general and vague parallels in the sermons.

The earliest known provenance of the painting is the Villa Aldo-brandini in Rome.[38] Salvini suggested that the painting may originally have been in the possession of the Florentine branch of the Aldobrandini family.[39] Indeed, if this is the case, then there is at the very beginning an association of the painting with Savonarola, for no less than three (and perhaps four) members of that family were signatories of the petition to Pope Alexander VI requesting the removal of Savonarola's excommunication.[40] Further evidence associates that family with Savonarola. The *Vita latina* recorded that Arcangela Aldobrandini, a nun in the Florentine convent of Santa Lucia, at the beginning of the sixteenth century, along with several other nuns, was cured of a sickness by a miracle wrought by relics of Savonarola.[41] Schnitzer related that the Aldobrandini were always partisans of Savonarola, and that in the latter part of the sixteenth century both Cardinal Ippolito Aldobrandini and his mother, who wrote a defense of Savonarola in reply to an anti-Savonarolan treatise, still adhered strongly to Savonarola's cause.[42] It is not implausible, therefore, to propose that the *Mystic Nativity* may have been commissioned by a member of this devotedly Savona-rolan family. However, there is still no certainty in ascribing the painting's iconography to Savonarola.

Davies, in his entry for the painting in the National Gallery catalogue, carefully described the painting and reviewed the arguments for associating the work with Savonarola. We are in full agreement with Davies and thus will only summarize his analysis and conclusions below.[43]

The Greek inscription at the top was translated by Davies, as follows:

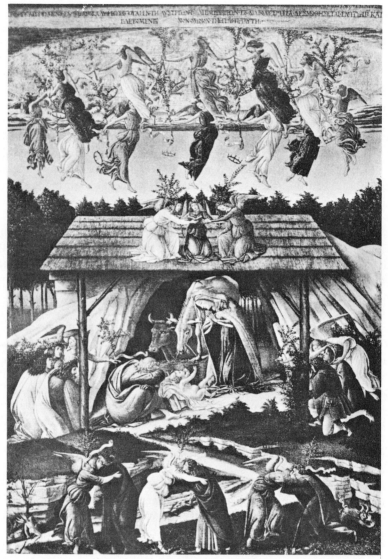

FIGURE 2. Sandro Botticelli, *Mystic Nativity*, National Gallery, London. Reproduced by courtesy of the Trustees, The National Gallery, London.

78

I Sandro painted this picture at the end of the year 1500 (?) in the troubles of Italy in the half time after the time according to the 11th chapter of S. John in the second woe of the Apocalypse in the loosing of the devil for three and a half years then he will be chained in the 12th chapter and we shall see clearly (?) . . . as in the picture.

The words following "we shall see clearly" are illegible owing to damage. According to the inscription the devil is chained in the 12th chapter of Revelation; but it is actually in the 20th chapter of that book in which he is chained, and there is no chained devil in the painting. The date of 1500 is clear. In the middle of 1499, Cesare Borgia invaded Romagna and King Louis XII invaded North Italy and "Botticelli may have been thinking of these troubles or perhaps of something different." After maybe two years (or maybe not), the inscription implies that a Reign of Peace was to occur. The exact durations are problematic because of the difficulty in determining the meaning of "a time" and a "half time." The inscription has also been interpreted as referring to Savonarola's execution in May, 1498. The 11th chapter of Revelation tells of two witnesses due to be killed by the beast from the bottomless pit. Savonarola was executed along with two other *frati*, one of whom was a minor figure. Thus Savonarola and the more important of the two *frati* are identified with the two witnesses in Revelation. This is certainly not a very cogent argument, and no contemporary source associated Savonarola and his cohort with the two witnesses of Revelation. Indeed, the inscription makes no mention of these witnesses either.

Furthermore, the inscription seems to prophesy a Reign of Peace. But Savonarola always maintained that such peace cannot come without a period of penitence. It would thus appear that the prophecy of the inscription is not in accord with Savonarola's beliefs. (We should mention here that for Savonarola a Reign of Peace, as Davies described it, can also follow a period of purging or divine chastisement, and this necessary previous chastisement may be implied by the words at the beginning of the inscription which refer to a time of "troubles.")

Nevertheless, Davies is correct in believing that any association of Savonarola with the words or interpretation of the inscription are, at best, vague and totally hypothetical.

The inscriptions on the scrolls held by angels and entwined around olive branches are difficult to read. The following is legible: NIVS DEI (presumably *Ecce Agnus Dei*); SACRARIVM.I(N BETHL?); MATER DE(I); VIRGO.VIRGINVM; SPŌSA.DEI.PATRIS.ADMIRĀDA;

VE () FECHVNDA; SPERAN (); REGINA.SOPRA.TVT(?); RE-
GINA. SOLA.MV̄DI; GLORIA. IN EXELSIS.DEO OMINIBVUS.
BO . . . ; ET INTERA . . . : OMINIBVS.BONE. VOLVNTATIS.
Some other inscribed scrolls are totally illegible. The last four inscrip-
tions are from Saint Luke 2:14, *Gloria in altissimis Deo, et in terra pax
hominimus bonae voluntatis*. The other inscriptions appear to come
from some litany in praise of the Virgin at the Nativity, but the source
has not been identified.

The closest parallel, as Davies indicated, between the basic subject
of the painting, the Nativity, and Savonarola's sermons, is his sermon
of Advent, 1493.[44] But this sermon on the Nativity is in actuality quite
different from the Nativity represented in the painting in its imagery
and implications. And given the inherent graphic potentiality of
Savonarola's description, it is surprising, if the sermon were in fact the
inspiration for the painting, that the painting has only such negligible
similarities to the sermon.[45]

An *Adoration of the Magi* in the Uffizi, Florence, attributed to Botti-
celli, supposedly contains a portrait of Savonarola, immediately to
the left of the figure of Joseph, pointing to the Madonna and Child.[46]
The work is partially unfinished and reveals the hands of different
artists,[47] particularly in the head of the Madonna which is of a type
and modeling derived from Leonardo da Vinci or Correggio. Although
it is not difficult to identify the gesticulating monk as Savonarola (and
the figure to whom he turns as Lorenzo de' Medici),[48] there is sufficient
reason to hesitate in attributing the work wholly to the hand of Botti-
celli. Savonarola may be present, but the iconography is not Savona-
rolan, nor is the presence of the *frate* here sufficient reason to describe
the artist, whoever he may have been, as Savonarola's adherent.

Vasari recorded that Botticelli engraved Savonarola's treatise *Il
Trionfo della Fede*.[49] He may have meant the *Trionfo della Croce*;
however, this engraving is not known today. Ferrara identified this
print with that of the woodcut of men washing in the river of blood
flowing from the crucified Christ, which has views of Florence, Rome,
and Jerusalem in the background.[50] But there is nothing in the style
of the woodcut which would associate the work with Botticelli. Nor
is the subject derived in any way from the *Trionfo*; it is an illustration
from Benivieni's *Trattato in defensione e probazione della dottrina e
profezie predicate da frate Ieronimo da Ferrara nella città di Firenze*,
published in Florence in 1496. Savonarola's *Trionfo* first appeared
fully one year after this *trattato*, in late 1497.

80

A final painting by Botticelli associated with Savonarola is the so-called *La Derelitta* in the Pallavicini Collection in Rome.[51] In 1933 Franz Landsberger interpreted the painting as a representation of Justice weeping because of the unjust execution of Savonarola.[52] The painting was thus seen as a definite sign of the artist's feelings for the preacher. However, Edgar Wind clearly demonstrated that the painting represents a biblical subject, the weeping of Mordecai, and convincingly argued that it was originally destined for a *cassone*.[53] Finally, the concensus on the date of the painting, c. 1480,[54] obviates any connection with Savonarola.

CHAPTER 13

FRA BARTOLOMEO DELLA PORTA

As a painting monk in San Marco it was Fra Bartolomeo della Porta's job to produce on commission works of religious art; obviously most of them were done for convents or churches belonging to the Dominican order and thus feature the Dominican saints, Dominic, Thomas Aquinas, Mary Magdalen, Peter Martyr, Antoninus, and Catherine of Siena. But for a few exceptions their formal and iconographic contents differ in no distinctive fashion from that to be found in the works of Fra Bartolomeo's uncloistered colleagues.

However, three paintings by Fra Bartolomeo have their origin in Savonarola's sermons and treatises; each depends upon Savonarola in different ways. The first of these, the *Mater Misericordia* in the Lucca Pinacoteca (Fig. 3), is based upon a traditional subject which has been adapted to illustrate visually a particularly important message from Savonarola's sermons. The second painting, a large altarpiece with God the Father, Saint Catherine of Siena, and Saint Mary Magdalen, also in the Lucca Pinacoteca (Fig. 4), represents the illustration of a fundamental Savonarolan concept. But it is more complex in that it is achieved not through a traditional subject, but rather through the use of a traditional pictorial formula found in Christian paintings of the more standard subjects. The third painting, the *Madonna and Child with Saint Anne and Other Saints*, in the San Marco Museum, Florence (Fig. 5), is a common subject type which has been given a new role by some minor formal changes. The inclusion of certain figures and especially the context for which the painting was produced, a large iconographic scheme dependent upon Savonarola's religio-political beliefs embodied in the Sala del Gran Consiglio and its decoration, give the painting a particular Florentine meaning.

82

The *Mater Misericordia* (Fig. 3), signed by the artist and dated 1515, was produced for the Dominican church of San Romano in Lucca on the commission of Fra Sebastiano de' Montecatini, probably with the advice of Fra Sante Pagnini, who had twice been prior of San Marco and was, from 1513 to 1515, prior of San Romano.[1] On the dado below the Madonna appears the Montecatini arms and the initials "F.S.O.P.," standing for *Frater Sebastianus Ordinis Praedicatorum.*[2]

The painting shows a large number of figures grouped around a central throne upon which the Virgin stands. Her right arm is raised upward and with her lowered left arm she gestures toward the crowd. At the lower right is a Dominican saint, represented by a portrait of Fra Sebastiano, indicating the Virgin to two men. Seen in profile with similar faces which are distinct from those of the other figures, they are two members of the Montecatini family.[3] Another physiognomically distinctive and formally stressed head, picked out by highlight and the hands of the Virgin above it and the Dominican below it (on the picture-plane these hands point to that head), may be a self-portrait of Fra Bartolomeo looking out to the viewer. There is a similar self-portrait in the Gran Consiglio altarpiece. Above the Virgin, whose mantle is held out over the crowd by flying angels, appears Christ with outstretched arms, drapery billowing out from His sides. Below Christ, supported by angels, is a plaque reading MISEREOR SUP[ER] TURBAM. A second inscription on the dado below the Virgin reads: M[ATE]R PIETATIS ET MI[SERICORDIA]E. Behind the Virgin a dark cloud fills the background, becoming lighter toward the top of the painting. With the exception of the figure of Christ, the inscription below Him, and the dark cloud, the painting clearly falls within the tradition of *mater-misericordia* imagery and can be interpreted in accordance with this tradition, as it has been in the literature.[4] It is the inclusion of the dark cloud, the resemblance of the form of Christ to a large-winged bird (which cannot be considered fortuitous), and the inscription below Him that set the painting apart from every other version of the Madonna of Mercy and associate it directly with Savonarola. No other representation of the theme has been found to include such additions.

The inscription MISEREOR SUP[ER] TURBAM is from Saint Mark 8:2. This statement of Christ's "compassion for the multitudes" aptly fits the meaning of the painting; it also extends and augments this meaning by showing the profundity of the deity's compassion for mankind through *both* Christ and the Virgin. No other example of this subject contains both figures. This increase of mercy, or the possi-

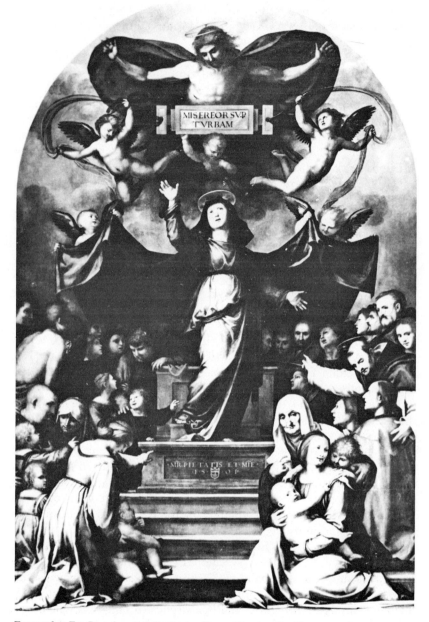

FIGURE 3. Fra Bartolomeo della Porta, *Mater Misericordia*, Pinacoteca, Lucca.

bility of mercy, reflects the greater threat symbolized by the dark cloud filling the background of the painting and separated from the people by the Virgin and Christ; such a cloud is also unique in a painting of this subject.

One of Savonarola's favorite, oft-referred to, and quoted psalms, number 91, reads as follows: "He will cover you with his pinions, and under his wings you will find refuge; his faithfulness is a shield and buckler. You will not fear the terror of the night, nor the arrow that flies by day, nor the pestilence that stalks in darkness, nor the destruction that wastes at noonday."[5] Chapter 23, verse 37 of the Gospel of Saint Matthew, also a favorite of Savonarola, offers a similar image: "O Jerusalem, Jerusalem, thou that killest the prophets and stonest them which are sent unto thee, how often would I have gathered thy children together, even as a hen gathereth her chickens under her wings, and ye would not."[6] Two elements are commonly used when Savonarola spoke of the imminent tribulations of Italy; they are likened to a dark cloud, and the tribulations forecast by the Old-Testament prophets are quoted with Rome, Florence, and Italy substituted for Jerusalem, the locus of the original prophecies.[7] The dark cloud, one of Savonarola's most constantly repeated metaphors, is God-ordained, necessary, and therefore welcome; those who remain steadfast in their faith despite the trials, and who seek the protection of Christ's compassion and the Virgin's mercy, will remain safe from the dark cloud and be among the elect. Since the Virgin is closest to God, the steadfast always turn to her in their tribulations.[8] Although none of the images or inscriptions in the painting has its original source in Savonarola's sermons, it cannot be merely coincidental that their combination into a total and cohesive image has a close parallel in the imagery and quotations used by Savonarola over and over again to express one of his primary homiletic subjects. This, in conjunction with the completely Dominican origin and provenance of the painting, makes it more than a mere similarity; and considering that there are no other preceding or coetaneous renderings of the *Mater Misericordia* containing such a combination of elements, it is clear that the painting has its origins in Savonarola's sermons.

The painting, basically of a traditional Christian subject, has had, by the addition of several unique elements, its meaning both amplified and made more specific to express a particular contemporary idea. In the next painting, a traditional composition in use for images of standard religious subjects was adapted to portray a Christian concept never before presented visually.

85

Fra Bartolomeo's large altarpiece (3,60 x 2,34 m.), representing *God the Father, Saint Mary Magdalen, and Saint Catherine of Siena* (Fig. 4), inscribed with the date 1509 and ORATE PRO PICTORE, was given by Sante Pagnini to the Dominicans in Lucca.[9] Because of its size, lack of decoration, and concentration on only the essential elements of its subject, it is a painting easily comprehensible by the ordinary churchgoer. However, for learned Christians, particularly for the members of the Dominican order for whom it was painted by a Dominican artist, this quiet and austere scene of the two holy women elevated on clouds in the presence of the deity becomes through their contemplation of it an introduction to divine mysteries: as they interpret step by step each of the painting's elements and their harmonious interdependence, they become progressively more elevated to the divine presence.[10]

The deity, the two saints, and the three inscriptions from the Old and New Testaments and an early commentator on the mystical nature of man's relation to God, along with the essential meaning of their relationships manifested by the composition, would also be recognized by these Dominicans as revealing themes expounded by their beloved and controversial brother, Girolamo Savonarola, whose execution was still of very recent memory.[11]

Indeed the basic divine role of such an image was also promulgated by Savonarola:

> Love is like a painter, and a good painter if he paints well, greatly delights men with his paintings. In contemplation of the painting men remain suspended and at times appear to be in ecstasy and outside themselves and seem to forget themselves [as corporeal beings].[12]

And an analysis of the iconography of the Lucca painting demonstrates its origins in the sermons and treatises of Savonarola.

Saint Mary Magdalen at the left is easily identifiable by the prominence given her attribute, the ointment jar; Saint Catherine of Siena at the right is identified by her black and white robes of the Dominican Order of Penance and by the book and lily on the floor beneath her.[13] Above them, encircled by wreath-bearing angels, two of whom suspend a rosary between them, God the Father, blessing and holding an open book revealing the letters *Alpha* and *Omega*, is seated on clouds. An arc of cherub heads, barely discernable in the clouds, fills the upper background.[14] The saints are located in a loggia-like architecture, through which a distant landscape can be seen. To the right of the Magdalen's head a small inscription in gold letters reads: NOSTRA CONVERSATIO IN COELIS EST. An inscription, also

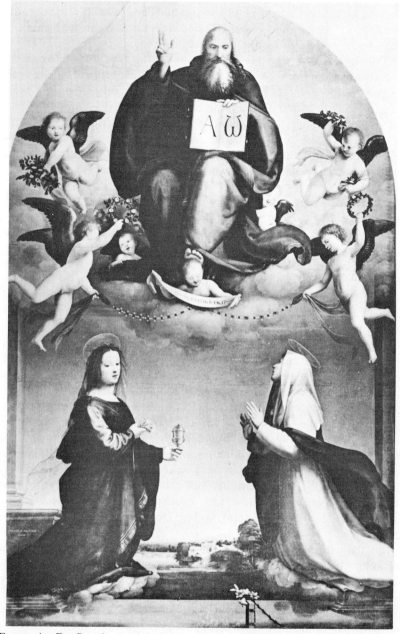

FIGURE 4. Fra Bartolomeo della Porta, *God the Father, Saint Mary Magdalen, and Saint Catherine of Siena*, Pinacoteca, Lucca.

in gold, to the left of Saint Catherine and level with her eyes reads: AMORE LANGUEO. A larger inscription contained on the banderole held open by an angel just below the figure of God declares: DIVINUS AMOR EXTASIM FACIT.[15] So far as we have been able to ascertain, these inscriptions occur in no other painting either alone or collectively, nor have we been able to locate any other painting with the combination of motifs found here.

The fundamental composition, a triangle composed of saints to the lower left and right with the diety centered above them, all appearing on clouds, has been adapted by Fra Bartolomeo from representations of other subjects in which it is not uncommon, such as the Trinity, the Coronation of the Virgin, and the Madonna in Glory.[16] This thematic type of a cloud-elevated triad is used here by Fra Bartolomeo for a new and unique purpose.

On a primary level of meaning, the position of both saints elevated above the ground in the presence of God can be associated with their legends. As a penitent recluse, Saint Mary Magdalen was raised up to the heavens by angels seven times a day for seven years; however, in most depictions of this event she is shown as an old, wizened women clothed in rags. Saint Catherine of Siena, the popular early biographies of her relate, was so constantly occupied with divine contemplation that her soul was often strongly drawn up to heaven. Her spirit was so vehement at such times that her body would be elevated as well and suspended in air.[17] Thus the painting may be read as a generalized representation of a salient theme from the lives of the two saints: their contemplation and adoration of the Eternal Father.

Considering the vocation of Saint Catherine as a Dominican and the special veneration of the Magdalen by the Dominican order, the image becomes particularly Dominican. The feast days of both saints were celebrated by that order, and Mary Magdalen, their unofficial protectress, had many convents dedicated to her in Florence and throughout Tuscany.[18] There are also many paintings executed by Dominicans and by lay painters for Dominicans showing the two saints together.

But the painting by Fra Bartolomeo expresses a still more profound meaning. It will become apparent that none of the individual concepts expressed in the painting is original with Savonarola, as they are basic tenets of Christian theology and Platonic thought. However, it is the peculiar combination of these ideas and the stress given them as a related totality by Savonarola that is new, and upon which the painting is based.

In practically every one of his daily sermons, Savonarola referred to God as the beginning and end, the first cause and prime mover, the first truth and ultimate purpose.[19] This meaning of God has been traditionally abbreviated by the symbolic letters *Alpha* and *Omega* represented on an open book referring to the statement *Ego sum Alpha et Omega* of the Book of Revelation 1.8, 21.6, and 22.13. These qualities of the deity are formalized and aptly depicted by Fra Bartolomeo. Hieratically frontal, the figure of God is the largest and most commanding form in the painting. His drapery, flowing well out to the sides of His volumetric figure, amplifies His size by expanding His silhouette, which is composed of simple broadly curving shapes. His form, wider at the base than at the top, with a low center of gravity, altogether suggests stability and composure, qualities necessary for the image of the eternal, immutable God.[20]

A constantly, even urgently, repeated theme in Savonarola's sermons is that the prime and ultimate end of man is contemplation of the meaning of *Ego sum Alpha et Omega*, and that this contemplation should produce a union of man with God.[21] Furthermore, Savonarola said that this contemplation has an effect of raising man outside of the world as he moves toward union with God. Man, according to Savonarola, becomes elevated above the earth through contemplation. Man rises, as he phrased it in one sermon, to the middle regions of the air. Savonarola also characterized heaven not as a specific place but as a condition, a communion of those "raised up" through divine contemplation.[22]

The condition favorable for contemplation and the ultimate union with God is a denial of earthly matters. As Savonarola stated, the less one is immersed in matter the more easily he can be contemplative, and the more contemplative he is the less tendency he has for immersion in the mundane and thus can rise higher still toward the vision of God.[23] Savonarola realized that this is difficult for man, who is situated between the spiritual above and the corporal below. Because of this, and because the soul is joined to the flesh, life for man is a constant battle.[24] Basically, man is of the earth, his love is for the earth, its riches, its activities. In short, his converse is mundane. As Savonarola said, his conversation is on the earth, and this conversation should be turned toward heaven; those who scorn the riches of the world, their conversation will be in heaven. He asked, "Where is your conversation, on earth or in heaven, among those whose sole purpose is in the contemplation of God?" He stated: "As Saint Paul said, *Nostra conversatio in Coelis est*, our conversation is in heaven

89

although we live on earth.[25] These words from Saint Paul's Epistle to the Philippians, 3:20, can be found, as noted earlier, next to the figure of Mary Magdalen.

The theme of the heavenly conversation appears constantly in the sermons; no other preacher or writer at the turn of the fifteenth century was as concerned with this Pauline theme. Eleven quotations of this passage can be found in the sermons from March, 1495, to February, 1498,[26] and there are numerous other instances in which the theme is referred to, paraphrased, used to form a metaphor, or extrapolated from other biblical passages. For example, Savonarola stated in one sermon that the root of man is in the earth, but his intellect is in the heavens conversing with the Virgin, angels, and so on; elsewhere the earth is compared to a vineyard into which the pig (symbolizing for Savonarola the vice of *luxuria*) has entered, destroying the growth of heavenly conversation; and in interpreting Leviticus, 6:11, in which vestments are carried out of a "*castello*" (as he interpreted the passage) to a most clean place, Savonarola stated that this means conversation should be outside the filthy world and in the most clean place, heaven.[27]

The location of the inscription NOSTRA CONVERSATIO IN COELIS EST next to Saint Mary Magdalen is appropriate; she represents a repentent sinner whose conversation, until her conversion, was very much on the earth. In fact, Savonarola instructed his congregation to "Go, look at Mary Magdalen who immediately [upon her conversion] had divine contemplation."[28] In other words, the turning of her conversation from earth to heaven enabled her to contemplate the deity, to approach her ultimate purpose and cause, and to gain a proper happiness in this vision of God and her proximity to Him. These, incidentally, are the words Savonarola used in describing what happens to a repentent sinner.[29] He also said: "the elect of God, elevated through contemplation and love of the divine, leave earthly things and trample evil desires which remain below."[30]

The inscription alongside Saint Catherine of Siena should be read in conjunction with the Magdalen's inscription. AMORE LANGUEO is a quotation from two parts of the Song of Songs, 2:5 and 5:8. Obviously, it is divine love for which Saint Catherine languishes. Savonarola preached that Christians are unique in their power of a vehement love for God, and that divine contemplation and heavenly conversation will be achieved in proportion to the degree with which one loves one's end and desires union with this end, which is God.[31]

90

In his earliest sermons (those for Advent, 1493), he bemoaned the lack of spiritual love at the time, stating that nobody languishes for this love.[32] In his next series of sermons, and in those following until his death, the theme is developed and made more explicit. The passage from the Song of Songs is quoted directly, referred to, or passionately paraphrased as, for example:

> O my Lord, O my chosen one, O my amorous one, my soul languishes for your love, it is enamored of you, it is drunk and maddened for you. I languish, I burn of love. Take, take away my soul from this world. I do not desire to remain here longer. My soul desires to be in the atrium of the Lord, because my soul is no longer in me, but outside of me.[33]

In another sermon the Virgin speaks, saying: "I am consumed, I am liquified, I languish for Love." Savonarola then went on to relate how the Virgin then fell into a state of "sweet ecstasy" because of her "suave contemplation" of God.[34] Thus, the theme of languishing for God's love was related by Savonarola to the concept of divine contemplation as well as to the theme of a removal from earth and a heavenly contemplation. In a similar fashion, the themes are related in the painting by the composition and the two inscriptions.

The message of the inscription AMORE LANGUEO has a particular meaning in relation to Saint Catherine of Siena, whose pose also aptly portrays its sentiments. The earliest, almost contemporary biographies of the saint report that she was gifted with a powerful soul, "vehement" love for God, and great ability at divine contemplation.[35] In a passage on the Song of Songs, Savonarola advised his listeners to read the biographies of the saints to see how, through their absorption in contemplation, they were torn outside themselves and became ecstatic. He observed that Saint Catherine of Siena was outstanding for this as well as for the remarkable vehemence of her spirit which allowed it.[36] Thus the inscriptions associated with both saints, although they have their foundation in their respective biographies, had been specifically related to them by Savonarola in his sermons; the inscriptions also reflect, as we have noted, major Savonarolan themes.

The final and largest inscription, DIVINUS AMOR EXTASIM FACIT, combines in its meaning all the elements of divine contemplation, love, ecstasy, and transports outside oneself and outside the world, which aid in producing heavenly conversation. This inscription originates in the writing of Dionysius the Aeropagite,[37] whom Savo-

91

narola called one of the greatest authorities on divine matters, refer-
ring to him on many occasions and quoting passages from his works,
including this one.[38]

Savonarola found in the scriptures numerous citations of the ability
of fervent love to send one into intense transports, to take one out-
side oneself, as he usually phrased it. This constant theme was de-
livered in his sermons through direct quotations, interpretations, or
metaphor. For example, in a metaphor involving a well and pail (a
symbol for the soul or heart), he stated that one must take one's self
outside the world and oneself (symbolized by the deep dark well) with
the rope of desire.[39] As noted earlier, contemplation of God has, for
Savonarola, the same result. Both contemplation of the *Alpha* and
Omega and divine love combined remove one from the mundane
world and its personal and corporeal limitations. This theme occurs in
practically every sermon of his more than thirteen volumes of sermons.
Always the phrase *fuora da se* is used when he described the results
of such holy desires and pursuits.[40]

It will have been observed in the foregoing citations from Savona-
rola's sermons that he related the euphoric languishing for love and
the themes of divine contemplation and heavenly conversation with
feelings engendered by intoxication. Again this theme alone and in
combination with the others expressed in the painting, along with the
variations on them, is an integral part of the basic message of Savona-
rola's sermons and treatises, and many passages from the Old and New
Testaments are interpreted in their light. They also inspire many
metaphors on divine drunkenness. For example, besides quoting *Divinus
amor extasim facit* several times, in his paraphrase of the Song of
Songs he spoke of being "drunk with love." Elsewhere, he similarly
spoke of being drunk with the love of God; of the intoxication of di-
vine love; of the good prelates who make the assembly drunk with a
sermon on the love of God; of a fountain making one drunk with the
waters of divine love; of washing in the river of Christ's blood and
becoming drunk in it; or of intense love being as an intoxicant which
trahe l'huomo fuora da se. He said, furthermore, that ecstasy pro-
duced by divine love takes man outside himself to a degree equal to
that of the vehemence of his love; it elevates him to the heavens and
serves to unite him with God, his ultimate end. He then quoted an-
other passage from Dionysius: "Love is a virtue that unites."[41]

The inscription DIVINUS AMOR EXTASIM FACIT, revealed by
an agent of God at the center of the painting, links its heavenly and

earthly realms; it is thus the unifying pictorial and thematic element of the painting as well as the means through which God and heaven are approached. Unlike the other two smaller inscriptions whose meanings originate on the earth and are voiced by its creatures, the inscription DIVINUS AMOR EXTASIM FACIT is presented as a divine revelation which can unite man with the Ultimate Being.

The rosary by which the divine upper realm is carefully divided from the lower mundane section may appear at first to add a common liturgical note to an otherwise generalized theological concept. However, besides its close association with the Dominican order,[42] the rosary obviously and necessarily associates the Passion of Christ with the subject of the painting. There is no unique stress given to the rosary in Savonarola's sermons, although he often referred to the necessity of *Ave Marias* and *Pater Nosters*.[43] Savonarola did not write the iconographic program for the painting; it was extrapolated from his sermons a decade after his death, and it should therefore not be surprising to find elements in the painting which are not uniquely Savonarolan, but which, nevertheless, augment the basic iconography derived from Savonarola.[44] For example, the only specific instance in which Savonarola referred to wreaths of roses is in his image of the Madonna in the throne of Solomon surrounded by saints (an image which he made into a kind of later quattrocentesque *Sacra Conversazione*), where Saints Catherine Martyr and Catherine of Siena are described as crowned with white roses.[45] But the wreaths of roses in this painting of God the Father, some all white, some all red, and others consisting of these colors in alternation, have a well-established traditional symbolism which clearly augments the meaning of the painting. The wreath or crown of roses, worn by the pagans on festal occasions, was adapted by early doctors of the church to signify Christian joy, and it follows that divine love and paradise also came to be symbolized by the rose.[46] In conjunction with this, the red rose represented ardent charity, compassion, and the flesh conquered by the spirit; the white rose represented virtue and the passions purified.[47] All these symbolic values, inherent in the Christian use of this flower by the end of the fifteenth century, may be ascribed to the roses in the painting. Furthermore, these wreaths of white and red roses held by the angels present divine themes properly concentrated into one immediately discernible and comprehensible image located in the heavenly upper sphere of the painting, whereas their reflection in the mundane lower section requires many elements, including human figures

93

and words, for their expression. This is a Christian and Neoplatonic interpretation of divine symbolism and its function, which was quite in accord with Savonarola's thinking.[48]

There is one other element in the painting which may have its source in Savonarola's sermons, the Magdalen's ointment jar. Held in a very prominent position and silhouetted against the sky almost in the center of the painting, it is in a position so outstanding as to suggest for it a meaning beyond that of a mere identifying attribute of the saint. In his thirty-seventh sermon on Amos and Zachariah, Savonarola stated that the Magdalen's jar represents her heart which after her conversion became cold in her love for the earth. Furthermore, because alabaster (the material of the vessel) is a good insulator, it was able to conserve well her love for Christ and the unguent of contrition.[49] The jar as a symbol of the Magdalen's heart which became cold in mundane love, retained contrition for past sins, and kept warm her divine love augments the inscription at her side.

Before suggesting a further interpretation of the altarpiece which serves to summarize and deepen its meaning, we should note that the two saints may represent the active life (Saint Catherine) and the contemplative life (Saint Mary Magdalen).[50] Two distinct types are indeed represented by these figures. Saint Mary Magdalen, a converted pagan sinner and perhaps the earliest saint, is contrasted to Saint Catherine of Siena, a virgin who was always devoted both to God and good works and a saint of very recent origin (canonized in 1461). Mary, because of her formal composition and her downward glance, seems a heavier figure than the swooning, windblown, upwardly-curving Catherine, whose activity is visually enhanced by the strong color contrasts of her garment. Mary, the converted sinner, establishes close contact with the viewer's world. Catherine is less approachable by the viewer; her contact is with God only. This also suggests the ultimate level in the understanding of the painting.

At the top of a triad, God the Father with the blessing gesture of His right hand disseminates His grace. To His lower right Saint Mary Magdalen is the recipient of that grace; as such she humbly lowers her eyes and turns from the divine source, while stating that conversation should be spiritual and heavenly. At the other side Saint Catherine of Siena with her ecstatic pose and head turned toward God states that she languishes for the love of God, and thus by abandonment of the intellect and body through love returns divine grace to its source, effecting a union with that source by love for it.

94

This tripartite, cyclical concept of giving, receiving, and returning benefits, that is, the power of a god to exert his influence in a triadic rhythm, is an essential element of Platonic theology.[52] This basic and more universal meaning of the painting nevertheless still reflects similar concepts, both Christian and Platonic, expressed by Savonarola in his sermons and treatises.[53] It is the ultimate mystical revelation; the image breathes divine inspiration eternally joining man to his God.

The third work (Fig. 5) by Fra Bartolomeo with a Savonarolan iconography requires for its explication an account of Savonarola's influence on the construction and decoration of the Sala del Gran Consiglio in the Palazzo Vecchio in Florence. It was Savonarola who, with a blend of biblical exegesis, forceful preaching, and knowledge of Florentine politics and political motivations, formed not only a new government but, with his belief in the power of art and symbolism, shaped its new meeting place as well.[54]

For Savonarola the importance of the Palazzo Vecchio could not be exaggerated: in July, 1495, he urged that the work being done on the cathedral be halted so that more manpower and money could be devoted to the Sala del Gran Consiglio.[55] Others, when they saw that so large a building was completed in such a comparatively short time, were convinced that angels miraculously lent a hand.[56] Savonarola had fully convinced the populace of the importance of this structure. A new locus for God's operations on earth was needed, and they created it; the agency for man's salvation was now a government building, not a church. No longer was a place needed in which to demonstrate faith in salvation. Salvation was at hand, and the government of Florence was to be the instrument.[57]

The Florentine revolution of November 9, 1494, brought about the expulsion of the Medici and the institution of a kind of popular republican government vested in the *Gran Consiglio*.[58] On December 14, 1494, just over one month after the revolution, Savonarola began a series of sermons on the book of Haggai.[59] His choice of this prophet indicates that for himself and his followers the Florentine reforms were imbued with a particular symbolic content. Haggai's prophecies were provoked by Jerusalem's delay in reconstructing the Temple. This delay resulted in various punishments as a sign of God's disfavor, a disfavor which would not be removed until the city rebuilt His house as befitted it. Savonarola saw clearly that the circumstances in Haggai could be readily applied to the situation in Florence. He cast himself in the role of Haggai, with Florence as Jerusalem and its government

95

as the Temple in need of reconstruction. For example, in his first sermon on Haggai, Savonarola summarized Haggai's prophecy concerning the need to rebuild the Temple and then addressed his congregation with the words, "Thus I say to you, Florentines, it is time to build anew the house of the Lord and to renovate your city." He then called for the renovation of the city and its government together, and further constructed the parallel between the present situation in Florence and Haggai's demands for the rebuilding of the Temple in Jerusalem.[60] Later, the wood carried to rebuild the Temple (Haggai, 1:8) was compared by Savonarola to the bringing of good council to the Palazzo Vecchio to remake the government.[61] (In his later sermons, as we shall see, he became increasingly concerned with the physical construction of the *sala* which was to house the government.)

It should be noted that for Savonarola the reforms which were begun in Florence also signaled the beginning of renovation of the church. In his first sermon on Haggai he declared: "This morning there is a greater multitude of angels than of men in the church. There is also the Divine Majesty to whom I bow and say: I am a suppliant and I pray that this morning will be the beginning of the renovation of the church."[62] It is of importance for this discussion that Savonarola and his followers believed that Florence was a city divinely chosen to lead this renovation, that the Florentines were the chosen people and their city the new Jerusalem. Over and over again Savonarola preached that Christ loves Florence as He loved Jerusalem and has turned to Florence to build His house; and from Florence, as the heart of Italy (both geographically and symbolically), His light will flow to other cities.[63] As is not unusual for Savonarola, the characterization of Florence as a divinely chosen and favored city was borrowed from a traditional Florentine self-conception.[64] Savonarola gave it a new, forceful, and religiously-based pronouncement. Thus exposition of such an idea fell on fertile ground, affording it firmer acceptance and better growth.

The new government of the blessed city of Florence, then, is a gift of God; the *Consiglio* is in the hands of Christ and in it lies the salvation of the city and subsequently of the rest of Italy.[65] Savonarola provided further foundation for the new government by his assertions that God designated Christ as the king of Florence, the *capo* of the government body. This theme first appears in his last sermon on Haggai, on December 28, where it is referred to several times.[66] In his next series of sermons, on Job, delivered during March and April, 1495, Savona-

rola gave further substantiation to the concept of the kingship of Christ.[67] In the sermons following those on Job during the same year, the theme of Christ's kingship of Florence became more and more important.[68] In his next sermons, on Amos and Zachariah, delivered during February, March, and April, 1496, even more attention was devoted to the theme. The congregation was powerfully exhorted to "take Christ as their king" and the Virgin as their queen. They were given the choice of a tyrant or Christ as their king.[69] So moved was the congregation by these exhortations that the sermon was interrupted by cries from the congregation of "*Misericordia*" and "*Viva il nostro Re Iesu Cristo*," as noted by the scribe who recorded Savonarola's words from the pulpit.[70] This is confirmed by the contemporary diarist Luca Landucci in his entry for March 8, who also recorded that every weekday during this time there were around fifteen thousand people present to hear the sermons in stands erected in the cathedral,[71] and by Guicciardini, who marveled at the enthusiasm of the auditors in a city where no preacher could sustain an audience for more than three Lenten sermons.

At the end of his Palm Sunday sermon (March 28), Savonarola called for a procession through the city and then asked the congregation if they did not want Christ, who was the king of the universe, to become their king in particular as He wished to be. The sermon ended with cries of assent and "*Viva Cristo*."[72] The procession that followed, as Landucci related, was composed of "5,000 boys and a great number of girls" with olive wreaths and branches, who followed through the city a canopied tabernacle representing Christ's entry into Jerusalem, amid cries of "*Viva Cristo ch'e'l nostro Rei*."[73] Thus, Christ's assumption of the kingship of Florence was symbolized and likened to His triumphal entry into Jerusalem. Indeed, the author of an early sixteenth-century biography of Savonarola ended his description of the procession with the statement: "Certainly at that time Florence was happy and blessed and seemed a new Jerusalem."[74] Savonarola continued stressing this theme in his sermons on Ruth and Micah (May through November, 1496),[75] and his poem on this subject was set to the music of a popular song.[76]

Florence was the divinely chosen city, its government was divinely inspired, and Christ was its king. Thus conceived and armed, it was destined to renovate the world and the church. All this, for Savonarola and his adherents, needed some kind of symbolic embodiment: this was to be the Sala itself.

The first reference to the Sala del Gran Consiglio by Savonarola was in his sermon of May 1, 1495: "I tell you that this *Consiglio* is your salvation, and that you should build the Sala."[77] Ten days later, the *Signoria* ruled that building should begin.[78] Shortly afterwards, on July 5, Savonarola became more emphatic about the construction of the room, stating that the Sala del Consiglio should be built so that no one could try to destroy the *Consiglio* (assuming here, as he did later, that the government would be more secure once it had its chamber). He urged that the *maestri* of the cathedral should work on the Sala, because this was more necessary than work on the cathedral. Furthermore, he asked that other people who had no work in hand work on the Sala as well.[79] On July 12, he again urged that the construction go quickly so that the government would be more quickly reconfirmed (by the completion of its physical embodiment), and that the work on the cathedral be left temporarily as there was a greater need to do the work on the Sala than on that building.[80] The same theme of speed in building and security of the government is strongly presented, and at greater length, in his sermon of July 28 (the feast day of San Vittorio), which he gave in the cathedral for the members of the *Signoria*.[81] Then, in October, in answer to his rhetorical question on what the people should do in relation to the new government, he replied: "First, finish the great room which is being made for the *Consiglio*."[82] It was early in that month that the substructure of the Sala was completed; the ceiling was under construction by mid-1497.[83] It was then said that due to the surprisingly short period of construction the angels had had a role in building it.[84]

The full symbolic meaning of the Sala del Gran Consiglio was given by Savonarola in a sermon which he delivered, significantly, to the members of the *Signoria* at their request. In this sermon, the sixth in a series on Ezechiel begun November 27, 1496, he continued to express great concern with the divine role of Florence initiated by "Christ's gift of the *Consiglio*."[85] On the occasion of this sermon he chose justice as his theme, and used as his text not Ezechiel, but Psalm LXXXIV (LXXV, King James) which begins: "Lord thou hast been favorable to thy land: Thou hast forgiven the iniquity of thy people," an opening obviously applicable to the divinely inspired reformation of God's newly favored city, Florence. The sermon commenced with Savonarola praising Christ for His infinite goodness in taking flesh in the Virgin to save man, and for electing Florence to spread His light as He had previously done with Jerusalem, and for giving Florence its *Consiglio*.

Then after words about the good commune of Solomon and the good commune of the Florentines, which, he stated, is their specialty and which they love more than anything, Savonarola began on his theme of justice.[86] Its climax was reached with Savonarola quoting the eleventh verse of the Psalm: *Veritas de terra orta est et iustitia de coelo prospexit.*

> Truth, says our psalm is born on the earth, and Justice looks down from Heaven. See how good Truth is, although first in Heaven she wants to come to earth and take flesh in the Virgin. This Truth then emerges from earth, that is, takes human flesh. The truth has come now another time, it is born on the earth, that is, it emerges from the holy scriptures which are expounded and preached. *Et iustitia de coelo prospexit*: Justice stays up there and looks down here to earth. Justice, what are you doing? What do you look at? Come down here, Justice. She replies: "I want to come, but I look to see what I will receive, and I don't find a place prepared for me." People, do you want this Justice? Make a beautiful room. Do this so that she may come and not be impeded. *Consoli delle Arte*, do you want this Justice? *Magistrati* of Florence. *Signori Otto*, who among you wants to receive this Justice? Nobody responds. Magnificent *Signori*, it is your concern, you are expected to receive her: your *Signorie* should receive her. Make the room, prepare the street, so that she may come.[87]

Savonarola concluded the sermon by asking the people and all the officers of the *Signorie* to prepare the way of the Lord so that their king and their Jesus will come, with Justice before Him as His minister (according to the psalm), to give them His grace.

Clearly, for Savonarola, the center of civic activity became the center for religious activity as well, since they both were the inseparable instrument for the manifestation of God's will on earth. It is also clear that for Savonarola symbols and metaphors, both verbal and visual, were absolutely necessary for man's understanding of God and His designs. Indeed, the symbol takes on a kind of mystical power and can, in a moment and totally, represent something too vast to be comprehended and too complex and profound to be followed if literally expounded.[88] Therefore, the extraordinary importance of the *Gran Consiglio* had also to have a symbolic representation; as the cross symbolized a new theology or the Palazzo Vecchio symbolized Florence, the Sala was to symbolize and house the *Gran Consiglio* as the body houses the soul and becomes its instrument.

The divine gift of the *Consiglio* to Florence was spelled out clearly in inscribed plaques set, according to Landucci, in the still unfinished

Sala in February, 1495.[89] One of these in Latin stated: "This council is from God, and ill will befall anyone who tries to destroy it." This is practically word for word Savonarola's oft-repeated warning to the Florentines that can be found in his sermons from mid-1495.[90] The other inscription, according to Landucci, a verse in Italian, stated: "Whoever wishes to have a *parlamento*, wishes to take the government away from the people."[91] In his sermon of July 28, 1495, to the *Signorie* in which, as related above, Savonarola asked them to build the Sala quickly, he also warned them twice, in the words of the inscription, about the dangers of a *parlamento*.[92] On October 11 of the same year Savonarola advised his auditors to repeat to their children so that they would remember it (like a catechism) the verse, "whoever wishes to make a *parlamento* takes the government out of the hands of the people."[93] Finally, on October 28, he advised the people that they should, to aid their Lord Christ, first build the Sala and then place a tablet in the Sala with the verse, which he had told them many times before: "*chi vuole fare parlamento, vuole torre di mano del populo el reggimento.*"[94]

Since the profound theological basis given the government was expressed in the construction of its seat, it might be expected that a similar symbolism would be expressed in the interior of the Sala, particularly in its altarpiece (Fig. 5). This was commissioned by the *Signorie* in 1510 when Pier Soderini, a staunch supporter of Savonarola, was *gonfaloniere*, an office to which he was elected in 1502.[95] The artist was Fra Bartolomeo.[96]

In the painting, Saint Anne is seated on the upper section of a throne and the Madonna is seated below with the Christ child in her arms. Directly above the group, in the center of a circle surrounded by clouds and cherub heads, is an image of the Trinity in the form of three joined heads.[97] The central group in the painting is exceptional: there is no other representation of Saint Anne with the Madonna and Child in which Saint Anne is shown as such a disproportionately large figure turning her head and gazing upward with her arms extended and hands opened, altogether suggesting a mood of rapture directed at, or caused by, the Trinity.[98] Any image of the Madonna and Child with Saint Anne must suggest the holy lineage of Christ, the role of Anne as the corporeal source of Mary, whose existence made possible the incarnation of Christ.[99]

This image of the Virgin's sanctification in the womb of Anne (as the Dominicans after Saint Thomas Aquinas viewed her conception),[100] and her resultant purity, which made possible her consequent

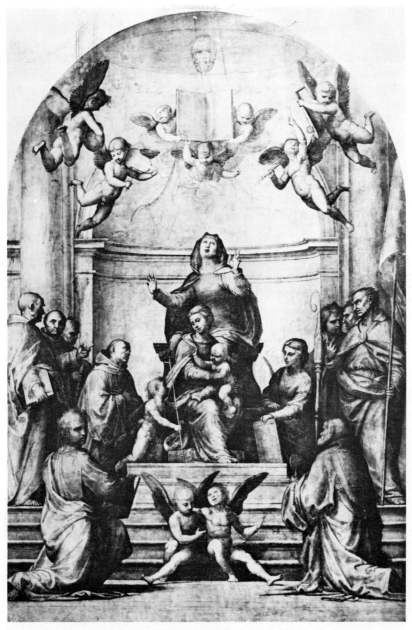

FIGURE 5. Fra Bartolomeo della Porta, *Madonna and Child with Saint Anne and Other Saints*, San Marco Museum, Florence.

101

sinless conception of Christ, may be related to Savonarola's metaphor of Justice refusing to descend to earth until a proper place is prepared for her to enter. If this is the case, then Justice's descent to the prepared Sala del Gran Consiglio from her heavenly dwelling can be analogous to the Son of God's descent to earth by His conception in the womb of the Virgin, which was made a pure place by her sanctification in Anne's womb.

Another of Savonarola's sermons strengthens this interpretation. During Advent, 1493, on the occasion of the celebration of the nativity of Christ, his text was the same psalm as that in the sermon to the *Signorie*. First, Savonarola associated the Virgin with David by her lineage through Jesse. Her holy parentage and lineage were necessary for his interpretation of the psalms. He then described the Christ child's *presepio* and declared that four venerable women are standing at each of its corners; they represent Mercy, Truth, Peace, and Justice (the four names, as he says, mentioned by David in the psalm), which are the four qualities brought to earth by the incarnation of Christ. Savonarola also described them, in the same sermon, as descending to earth from the bosom of the Eternal Father.[101] Thus Savonarola twice interpreted this psalm in a sense that can be applied to both the Sala and its altarpiece. The arrangement of the figures of Saint Anne, the Virgin, and the Child, and the pose of Saint Anne can, if the analogy between the sermons and the altarpiece is acceptable, also reflect Savonarola's interpretation. Saint Anne is placed directly between the Virgin and the Trinity, toward which she looks in rapture as a holy recipient. The Virgin is immediately below her and contained well within Anne's contour, as the Christ child is well within His mother's contour. The impression is that the figures represent a descent from a heavenly sphere filled with jubilant angels to the Christ child below.

Although this interpretation of the figures in the center of the painting can only be hypothetical, it nevertheless is not an impossibility. Both Soderini and Fra Bartolomeo were deeply attached to Savonarola. The *frate* had been intensely involved with the *Consiglio*. And although the painting was commissioned twelve years after Savonarola's death, the reputation of the *frate* was being revived at the time.[102]

There is another more explicit meaning to the painting based upon associations of Saint Anne with Florence. The saints in the painting have been described by Vasari as representing patron saints of Flor-

ence and those saints on whose name-days the city won military vic-
tories.[103] Aside from the youthful Saint John, the ten other saints are
difficult to identify. None of the saints' identities are noted in any of
the documents relative to the commission, and identification is made
all but impossible both because the painting is unfinished and because
only the heads of four of the ten saints can be seen.[104] Some identifi-
cations can be narrowed down by type; three bishop saints (at the
extreme left and right and one kneeling at the right) and two monks
(the second one from the left and one kneeling at the left behind
the Baptist) are discernible by their garments. Also present is a female
martyr, identifiable by her palm (to the right of the Virgin). By as-
certaining the dates of Florentine victories and determining on which
sainted monks', female martyrs', and bishops' days such victories
occurred, one may attempt, in this unfortunately circular fashion, to
complete the identification. However, one must allow for the peculiar-
ity of the Florentine calendar and changes in the recording dates as
well as the variations in recorded celebrations of saints' days.[105] The
result is that it is impossible to decipher an iconographic program
for the painting based on Vasari's statement, since none of the iden-
tifications in the painting is certain and each figure may be identified
as any one of several saints on whose name-days Florence won honor
in battle; thus, although Vasari may have been right, confirmation
and particularization of his general identifications cannot be achieved.

There is nevertheless one saint, Anne, whose identification is def-
inite, and she is the most important figure in the painting. As Giovan-
ni Villani recorded in his contemporary *Cronaca*, it was on her feast
day, July 26, that the tyrant duke of Athens was expelled by a popu-
lar insurrection in 1343.[106] This victory of the people, as it was inter-
preted at the time, was commemorated shortly afterwards by a paint-
ing representing Saint Anne enthroned at the side of the Palazzo
Vecchio, symbolizing the city's government, above which she extends
her hand in protection while she turns to kneeling soldiers whose
banners and uniforms bear the emblem of the Florentine people, the
red cross on a white ground and the *fioralisi* (Fig. 6).[107] The other
side of the composition shows the duke of Athens leaving his throne
with broken weapons at his feet. The expulsion of the duke was al-
ways significant for the Florentines. Machiavelli, in his *History of
Florence*, used the misrule of the tyrant and his expulsion by the peo-
ple as a kind of object lesson in government and popular power.[108]
In the early sixteenth century another historian of Florence, Cerretani,

103

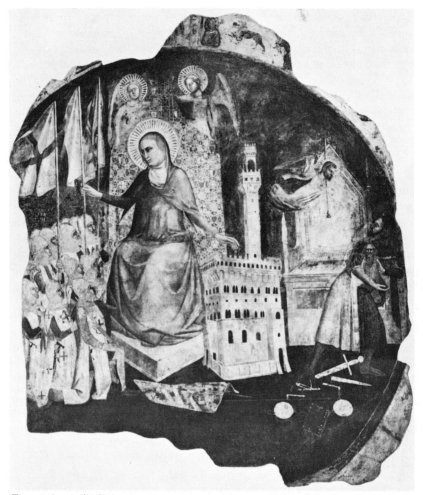

FIGURE 6. Artist Unknown, *Saint Anne and Florence Triumphant Over the Duke of Athens*, Palazzo Vecchio, Florence.

explicitly equated the overthrow of the Medici in 1494 with that of the duke of Athens in 1343.[109] During the revival of the *Consiglio* a painting was commissioned (c.1528) by the *Signoria* representing the *Madonna and Child with Saint Anne* for the convent of Saint Anne to which the *Signoria* would go, in solemn procession, annually on the saint's feast day in commemoration of the popular rebellion against the duke of Athens. At the same time, the altarpiece by Fra Bartolomeo, then in San Marco, was ordered restored to its original position in the Sala del Gran Consiglio.[110]

One may therefore assume that the stress given Saint Anne in the altarpiece commissioned for the room in which a new popular government, formed after the expulsion of the Medici, was to meet, and which indeed symbolized that government, purposefully was meant to draw a parallel between the popular struggles for freedom of 1343 and 1494.[111]

A further correlation between political events and functions and religious beliefs can be found in other works of art planned for the Sala. According to the documents a statue of the Savior was to be placed on an entablature above the seat of the *gonfaloniere* of justice. It was on the feast day of the Holy Savior, November 9, that the Medici were expelled, and a resolution of the newly formed *Signoria* of December 2 proclaimed that day a perpetual holiday.[112] Thus the two major expressions of the Florentine's desire for freedom, although almost a century and half apart, are symbolized in the Sala. The statue of the Savior is also related to Savonarola's declarations of Christ's kingship of Florence.[113] The location of the statue of Christ the Savior above the head of the secular chief of state clearly symbolizes, by its position, the leadership of Christ, the true *capo* of the government.

It should be apparent now that although the expeditious construction of the Sala del Gran Consiglio in the later 1490s, and the symbolic values with which it was invested, had their origins in Savonarola, the paintings and sculpture commissioned for the room between 1500 and 1512, while carrying through the basic conceptions of the *frate* had, by then, perhaps more general forces behind them. The rest of the decoration for the Sala is expressive of a far wider range of people and ideas, and much of it uses an iconography long associated in Florence (and other cities) with civil liberty and divinely guided government.[114]

CHAPTER 14

SAVONAROLA IN COMMEMORATIVE WORKS OF ART

The commemoration and glorification of Savonarola in the visual arts took several forms: at times, as in the cases of the Fra Bartolomeo and della Robbia portraits, works were produced by artists who had a personal commitment to Savonarola (although the works were done presumably for a specific commission); in other instances Savonarola was commemorated by artists such as Corniole and Pocetti, who apparently had no personal attachment to him whatsoever but merely carried out commissions by his partisans.

The simplest commemorative form was the portrait; the Fra Bartolomeo painting and the Corniole gem contain only profile portraits of Savonarola. On the former is an inscription reading HIERONYMI FERRARIENSIS A DEO MISSI PROPHETAE EFFIGIES (Fig. 7).[1] The medallions by the della Robbia contain only identifying inscriptions on the portrait sides, but on the reverse they all contain references to Savonarola's prophecies based on the passage GLADIUS DOMINI SUPER TERRAM CITO ET VELOCITER,[2] which is also inscribed on several of the medals. The images on the reverse are as follows: a hand issuing from a cloud holding a dagger above the city of Florence (this is the most common); a hand holding a sword, presumably above Rome, at the right side accompanied by the above inscription and at the left a dove with rays emerging from its mouth above another city, presumably Florence, accompanied by the inscription, SPIRITUS DOMINI SUPER TERRAM COPIOSE ET HABUNDANTER. If Florence and Rome are not respectively represented (as the chosen and the condemned cities),[3] then they represent the same city, first with the approach of the divine scourge and then in its redeemed state. One other medal shows the sword above

106

FIGURE 7. Fra Bartolomeo della Porta, *Portrait of Savonarola*, San Marco Museum, Florence.

Italy. Two of the medals show Savonarola looking at a crucifix which he holds in his hand; in one of these a book, lily, and a seraph head (referring to his prophetic nature) are added.[4]

Two other portraits honor Savonarola by depicting him in the guise of popular saints. The first portrays him (in profile) as Saint Peter Martyr,[5] a Dominican. The second, by Fra Paolino, shows three Dominican saints (Dominic, Aquinas, and a third whose inscribed halo is not legible) kneeling in the presence of the Virgin and Christ.[6] In this painting, the features of Saint Dominic, the most imposing of the three saints, are clearly those of Savonarola. Dominic-Savonarola points to the city of Florence and looks up at the Virgin, who kneels in supplication in the clouds. The image no doubt refers to the many passages in which Savonarola called upon the Virgin as the protector of the city and as its intercessor before Christ.[7] Savonarola is glorified as the person who intercedes with the Virgin for Florence and as a holy man among the many great and holy Dominicans.

If we compare these portraits to Lorenzo Lotto's painting *Saint Vincent Ferrer in Glory* (San Domenico, Recanati, c. 1513-1515), we see that even though Saint Vincent is in full-face, his features bear a striking similarity to those of Savonarola. It is quite possible, since the work was done for a Dominican church, that Lotto was given some kind of portrait of Savonarola to work from, possibly one of the della Robbia medals. The physiognomy of Lotto's Saint Vincent is not at all similar to other renderings of that saint.

The fresco by Pocetti, part of a series on the Dominican order and Saint Antonine, in the cloister of San Marco, dating from c. 1600, shows Saint Antonine's installation as bishop of the cathedral of Florence in the mid-fifteenth century. Standing to the right is a prominent, full-length figure, a portrait of Savonarola. The obvious anachronism is unimportant compared to the honorific association of the two great Dominicans. Certainly at this time it would have still been impossible to honor Savonarola himself by such a fresco. Thus his inclusion here in a large cycle glorifying the Dominican order in San Marco was relevant and important to his brethren of a later generation.

One other portrait of Savonarola by an unknown, but contemporary artist (Fig. 8), represents a kind of sanctification of the *frate* complete with halo, instrument of martyrdom, and passages from his most important prophecies.[8]

At the turn of the fifteenth century profile portraits were archaic,

FIGURE 8. Artist Unknown, *Savonarola as a Martyred Saint*, Location unknown.

as three-quarter or full-face renderings were then in style. The use of the older type for Savonarola's portraits probably had the honorific effect of removing his image from everyday experience from the immediate and approachable—which was the desired effect of the newer portraiture.[9] The large painting of c. 1500 depicting the execution of Savonarola and his brethren in the Piazza Signoria exists in three versions, in San Marco, in the Galleria Corsini, Florence (Fig. 9), and in the Palazzo Schifanoia in Ferrara. They are all exact replicas except that the Ferrara and Corsini paintings show a banderole held across the top by angels, and in the Ferrara version the banderole is inscribed with a statement glorifying Savonarola as a prophet, martyr, and saint.

FIGURE 9. Artist Unknown, *The Execution of Savonarola*, Galleria Corsini, Florence.

CHAPTER 15

CONCLUSION

In his book entitled *The Idea of History*, R. G. Collingwood argued that in history writing no achievement is final, that available evidence and the principles for interpreting it change with every historian's methodology. "Historical thought," he stated, "is a river into which none can step twice." By no means was Collingwood denying the value of history writing; rather he was calling for an awareness of the "history of history," a recognition that "the historian himself, together with the here-and-now which forms the total body of evidence available to him, is a part of the process he is studying, has his own place in that process, and can see it only from the point of view which at this present moment he occupies within it."[1] Historical consciousness, then, implies self-consciousness on the historian's part. The picture the historian creates may use the symbols of the past, but its form and color come from the present. He must be sensitive to the blend.

From the late eighteenth through the nineteenth centuries, Savonarola was seen in the light of historians' special interests and aims. The information they discovered, the documents, names, and dates, and the incidents recorded by contemporaries were all interpreted to fit these needs. The picture that emerged was a well-focused, consistent, forcefully stated construction, although it was more dependent upon their special interpretation of the data they gathered than it was upon the data itself. And in that last element lay the fault: the difference between the here-and-now and the there-in-the-past was unrecognized. However, the construction had a completeness: motivations were recognizable and real and because they reflected those familiar to the writer and his audience, they seemed rational. Scenes of reli-

113

gious torment, condemnation, and exoneration, and passionate strug-
gles against inexorable evil, all naturally aided in the simple human
appeal of the story. Inevitably it found its way into popular litera-
ture, scholarly articles (even those not specifically dealing with Savo-
narola), college textbooks, and classroom lectures. By dint of constant
repetition it became, but for the very occasional, iconoclastic (and
generally disregarded) exceptions, an integral part of our "knowledge"
of the Renaissance, even though the historical situations that gave
birth to the construction no longer applied, nor for the most part are
even remembered today.

The degree to which modern concepts of Renaissance art are con-
ditioned by the aims and prejudices of past historians is perhaps no-
where else more in evidence than in our interpretation of the period
immediately after Savonarola. For art historians the period of Savo-
narola has generally been seen as part of the last phase of quat-
trocentesque naïveté in art, which was to be followed by the advent
of the more "sophisticated," "grandly scaled," classicizing achievements
of the so-called High Renaissance in the early sixteenth century.
As investigation into the origins of our conception of Savonarola's
relation to Florentine art revealed its dependence upon eighteenth-
and nineteenth-century ideas, similarly an investigation of the
historiographic construction of the High Renaissance would demon-
strate its origins in the growth of classicizing art academies, their
theories of art practice, and interpretations of past art, especially in
the eighteenth century, and the development of theories of linear
evolution. The use of the term "High Renaissance" today is as mis-
leading as was the search for and belief in a general and pervasive
influence of Savonarola on Florentine art. The term and all its impli-
cations wrongfully condition our view of the period preceding it, that
of Savonarola, and our estimation of its art; in no way describe the
variety of artistic styles and functions of the early sixteenth century
(whether within the work of one artist such as Raphael, or within a
whole city such as Florence or Rome); and obviously falsely prede-
termine our approach to the art of the later sixteenth century. Further
study of this "High Renaissance" should first have its basis in a
study of its history as an idea. Nor is it the only art historical concept
in need of such an approach. The investigation of Savonarola and
Renaissance art contained in this book would have yielded little with-
out first determining what the *historiographic* situation was—for that
is the historical situation we are best equipped to know.

114

NOTES AND BIBLIOGRAPHY

NOTES

CHAPTER 1

1. *The Dictionary Historical and Critical of Mr. Peter Bayle*, 5 vols. (London, 1738), V: 71.

2. P. Villari, *Life and Times of Girolamo Savonarola*, 2 vols., 1st ed. 1859-61 (London, 1889), II: 421-22.

3. Bayle, *Dictionary*, V: 62; Villari, *Savonarola*, I: 246 ff. On the importance of Bayle's *Dictionary* and its popularity, see Wallace K. Ferguson, *The Renaissance in Historical Thought, Five Centuries of Interpretation* (Cambridge, Mass., 1948), pp. 70 ff.

4. Bayle, *Dictionary*, V: 61-62.

5. See Introduction in D. Weinstein, *Savonarola and Florence, Prophecy and Patriotism in the Renaissance* (Princeton, 1970), and Villari, *Savonarola*, I: liv.

6. Villari, *Savonarola*, II: 145.

7. See Chapter 4. Before Rio, writers were not interested in Savonarola's attitude toward art or in the possibility of his having influenced it. Bayle has nothing to say about Savonarola in this regard.

8. Weinstein, *Savonarola and Florence*, pp. 3 ff.

9. See Chapter 5.

CHAPTER 2

1. P. Ginori, ed., *La Vita del Beato Ieronimo Savonarola* (Florence, 1937), pp. 129ff. This early biography, generally referred to as the *Vita latina*, was attributed to the Dominican Fra Pacifico Burlamacchi. See Ginori's introduction for a review of this attribution and the dating of the manuscript. Luca Landucci, *A Florentine Diary from 1450 to 1516* (London and New York, 1927), pp. 130-31.

2. Ginori, *La Vita*, pp. 130.

3. *Ibid*, pp. 130-31.

4. Fra Girolamo Savonarola, *Preaiche sopra Aggeo con il trattato circa il reggimento e governo della città di Firenze* (Rome, 1965), pp. 19-21. Since references to Savonarola's sermons and treatises will form the bulk of the notes, in order to avoid repetition, after the initial full citation of each volume, they will be referred to in abbreviated form, e.g., *Aggeo*, p. 30; *Amos e Zaccaria*, II: 40, and so forth.

5. P. Villari, *Life and Times of Girolamo Savonarola*, 2 vols. (London, 1889), I: 508 ff.

6. Joseph Schnitzer, *Savonarola*, 2 vols. (Milan, 1931), I: 442-45; II: 391.

7. See Chapter 5.

CHAPTER 3

1. This was the so-called Nazarene school (discussed in Chapter 4).

2. P. Ginori, ed., *La Vita del Beato Ieronimo Savonarola* (Florence, 1937), pp. 201-49.

3. *Ibid.*, p. 52.

4. See Chapter 8.

5. Padre V. Marchese, *Memorie dei più insigni pittori, scultori, e architetti domenicani*, 2 vols. (Florence, 1854), I: 392-93. Marchese misunderstood Savonarola's conception of art and the status of artists. See, for example, his statements on pp. 30f, 54-58, 60, 65, 117, 142 f.

6. P. Villari, *Life and Times of Girolamo Savonarola*, 2 vols. (London, 1889), I: 519.

7. John A. Symonds, *Renaissance in Italy*, 2 vols. (New York, n.d.,), I: 279.

8. Joseph Schnitzer, *Savonarola*, 2 vols. (Milan, 1931), II: 391.

9. Mario Ferrara, *Savonarola, Prediche e scritti commentati e collegati da un racconto biografico, l'influenza del Savonarola sulla letteratura e l'arte del Quattrocento — Bibliografia ragionata* (Florence, 1952), p. 46.

10. André Chastel, *Art et humanisme à Florence* (Paris, 1959), p. 400. Chastel referred the reader to the list of Dominican artists in San Marco compiled by Marchese.

11. Marchese, *Memorie*, I: 149-56, 161-69.

12. *Ibid.*, p. 156.

13. *Ibid.*, pp. 185 ff, 314-32.

14. *Ibid.*, p. 149.

15. *Ibid.*, pp. 151-52.

16. *Ibid.*, pp. 395-96.

17. *Ibid.*, pp. 286 f.

18. *Ibid.*, p. 252.

19. *Ibid.*, pp. 253-54 cites this passage in the *Vita latina*.

20. *Ibid.*, pp. 254-55 has nothing to say about the works of Fra Benedetto or Fra Filippo Lapaccini; Marchese noted that there are no known works by these miniaturists. Nor have we been able to find out anything more about them. On Fra Eustachio, see *Ibid.*, pp. 258-65; Mirella L. D'Ancona, *Miniatura e miniatori a Firenze dal XIV al XVI secolo* (Florence, 1962), pp. 246-47; U. Thieme and F. Becke, *Allgemeines Lexikon der bildenden Künstler* (Leipzig, 1915), XI: 90.

21. Marchese, *Memorie*, I: 395.

22. *Ibid.*, p. 396; A. Marquand, *The Brothers of Giovanni della Robbia* (Princeton, 1928), p. 43.

23. Marquand, *della Robbia*, p. 45, and pp. 46-63 for a catalogue of Fra Ambrogio's works.

24. Professor Ulrich Middeldorf has told us that he does not credit the attributions of the medals to the della Robbias.

25. Marchese, *Memorie*, I: 395-96.

26. *Ibid.*, II: 273.

27. *Ibid.*, II: 204-24.

28. Ginori, *La Vita*, pp. 156, 163, 188, 201-203.

29. Giorgio Vasari, *Le Vite de più eccelènti architetti, pittori, et scultori italiani* (Florence, 1550 ed.), II: 709-12; 1568 ed., II: 126-29.

30. *Ibid.*, 1568, II: 36.

31. In the first edition (II: 712), Vasari stated that Lorenzo di Credi, a partisan to the cause of Savonarola, lived and continually behaved with propriety. In the second edition (II: 132), he wrote that "Lorenzo was very partial to the sect of Savonarola; he lived an upright life and was very courteous on every occasion."

32. Vasari, *Le Vite*, 1550, II: 668.

33. *Ibid.*, 1568, II: 100.

34. *Ibid.*, 1568, I: 266. (Not mentioned in the first edition.)

35. Marquand, *della Robbia*, pp. 3, 43. For a discussion of the medals, see Chapter 14.

36. Vasari, *Le Vite*, 1568, II: 287.

37. *Ibid.*, 1550, I: 645-46; 1568, II: 71.

38. See our discussion in Chapter 4.

39. Marchese, *Memorie*, I: 381; Schnitzer, *Savonarola*, II: 396.

40. Marchese, *Memorie*, I: 381-82.

41. Georgio Vasari, *Le Vite de più eccelènti architetti, pittori, et scultori italiani*, ed. G. Milanese, 9 vols. (Florence, 1879-1906), IV: 396.

42. Villari, *Savonarola*, I: 519. See also L. Hirsch, *San Marco in Florenz, das Kloster Savonarolas* (Stuttgart, 1908), pp. 38-39 ff; V. Schultze, *Das Kloster San Marco in Florenz* (Leipzig, 1888), pp. 61 ff; and our discussion of Michelangelo and Savonarola.

43. Hirsch, *San Marco*, p. 39.

44. Ludwig F. von Pastor, *The History of the Popes*, 40 vols. (London, 1923), V: 200-01. Pastor used Wilhelm Bode's "Gruppe der Beweinung Christi von Giovanni della Robbia in Florenz," *Jahrbuch der Königlich Preussischen Kunstsammlungen*, VIII (1887): 217-30, for his information on Perugino. The number of *Pietà*s executed by Perugino in the latter part of his career forms neither the majority nor even a large portion.

45. Schnitzer, *Savonarola*, II: 392-93, 403 (the della Robbia); p. 393 (Corniole); pp. 393-94 (Fra Bartolomeo); p. 397 (Lorenzo di Credi); pp. 403-11 (Botticelli); pp. 402-03 (Baccio da Montelupo).

46. *Ibid.*, pp. 394, 397 (Perugino); p. 398 (Francia); pp. 403-11 (Michelangelo).

47. *Ibid.*, pp. 394, 396.

48. Roberto Ridolfi, *Vita di Girolamo Savonarola* (Rome, 1952), II: 34-35. See also Ferrara, *Prediche e scritti*. One artist, Alesso Baldovinetti, it should be noted, was recorded in the documents of the investigation of the struggle at San Marco as having been present among the defenders of the convent. In the *Cronaca* of Botticelli's brother Simone (published in P. Villari and E. Casanova, *Scelta di prediche e scritti di Fra Girolamo Savonarola con nuovi documenti intorno alla sua vita* [Florence, 1898], p. 515, immediately preceding Simone's signature to the petition to the pope requesting the removal of Savonarola's excommunication, the signature Alesso di Fran. Baldovinetti appears. Of all the variations of Baldovinetti's name appearing in documents, there is none that is similar to the signature on the petition; nor, however, are there any other members of the family during the 1490s who are known to have had such a name. The name as presented in the proceedings of the San Marco investigation, merely Alesso Baldovinetti, was most commonly used by the artist in the documents. The only way the Francesco could have come into the artist's name in the petition, if the signature is in fact the artist's, is through the Francesco which was part of his father's name, and it was common usage in Italy to include the father's given name.
At any rate, there are no known works of Baldovinetti of the 1490s which can be

related to Savonarola; during these years, he was at work repairing the mosaics in the Baptistry and in completing a series of frescoes, no longer extant, in the Gianfigliazzi Chapel of Santa Trinità, which were begun long before; he died in August, 1499.

The documents are published in Marquand, *della Robbia*, p. 69; Villari, *Savonarola*, II: CCL. Ruth W. Kennedy, *Alesso Baldovinetti* (New Haven and London, 1938), although substantiating Vasari's account of the artist's pious life (p. 196) with documentation (pp. 251-52), does not mention the appearance of his name in the documents on the San Marco incident.

49. Villari, *Savonarola*, I: 522-23. See also Marchese, *Memorie*, I: 381 ff. Wallace K. Ferguson, *The Renaissance in Historical Thought* (Cambridge, Mass., 1948), pp. 179ff. Also see G. P. Gooch, *History and Historians in the Nineteenth Century* (London, 1913).

50. See Schnitzer, *Savonarola*, II: 379ff, and Pastor, *Popes*, V: 194-202. Particularly revealing is J. A. de Gobineau's *La Renaissance, scènes historiques* (Paris, 1877), in which the section on Savonarola is preceded by dozens of scene-setting pages outlining the decadence, worldliness, and un-Christian character of the Renaissance.

51. There is no need to present here a detailed argument proving that the Renaissance was not "pagan." The reader is referred to Rudolf Wittkower, *Architectural Principles in the Age of Humanism* (New York, 1965), pp. 2-3 ff; E. Panofsky, *Renaissance and Renascences in Western Art* (Stockholm, 1960), pp. 170 ff; and Edgar Wind, *Pagan Mysteries in the Renaissance* (New Haven, 1958), which, in various ways, refute these older interpretations.

CHAPTER 4

1. Herman Ulmann, *Sandro Botticelli* (Munich, 1893); E. Steinmann, *Sandro Botticelli* (Bielefeld and Leipzig, 1897); J. B. Supino, *Sandro Botticelli* (Florence, 1900); Julia Cartwright, *The Life and Art of Sandro Botticelli* (London, 1904); Herbert P. Horne, *Alessandro Filipepi Commonly Called Sandro Botticelli* (London, 1908).

2. Lionello Venturi, *Sandro Botticelli* (London, 1961), p. 23.

3. Charles Seymour, *Michaelangelo's David* (Pittsburgh, 1967), p. 61. There are, however, two noteworthy and widely disregarded exceptions to this prevailing view. Early in the twentieth century N. Steinhauser in his essay "Savonarola's Einfluss auf die Kunst und Künstler," *Historisch-politische Blätter für das katholische Deutschland* 139 (1903): 423-24, took issue with the belief in Savonarola's profound influence on artists. More recently, Martin Davies, *The Earlier Italian Schools* (London, 1961), p. 105, in his discussion of Botticelli's *Mystic Nativity* also questioned this influence on Botticelli in relation to that painting, although D. Weinstein, *Savonarola and Florence, Prophecy and Patriotism in the Renaissance* (Princeton, 1970), in discussing the same painting (pp. 334 f), referred to Botticelli as a *Piagnone*.

4. The entire *Cronaca* was published in P. Villari and E. Casanova, *Scelte di prediche e scritti di Fra Girolamo Savonarola con nuovi documenti intorno alla sua vita* (Florence, 1898), pp. 453-518. The passage referred to is on p. 493.

5. Cartwright, *Botticelli*, p. 162.

6. As noted by Horne, *Botticelli*, p. 189.

7. *Ibid.*, p. 276.

8. *Ibid.*, p. 292. The conversation was also recorded in the *Giornate* of Lorenzo Violi, a friend of Simone and a partisan of Savonarola. The relevant passage may be found in *Ibid.*, pp. 291-92.

9. Horne, *Botticelli*, p. 291.

120

10. *Ibid.*, pp. 291-93; Cartwright, *Botticelli*, p. 168. For an analysis of the *Mystic Nativity* and an account of some of its decidedly *anti*-Savonarolan characteristics, see Davies, *Italian Schools*, pp. 103-08, and our discussion in Chapter 12. The so-called *Derelitta* by Botticelli has also been related to the Spini-Botticelli conversation and interpreted as a representation of Justice weeping for Savonarola's unjust execution. This argument, advanced by F. Landsberger, "Trauer um den tod Savonarola, zur deutung des Derelitta-Bilder," *Zeitschrift für Kunstgeschichte* 2 (1933): 275-78, has been refuted by Edgar Wind, "The Subject of Botticelli's 'Derelitta'," *Journal of the Warburg and Courtauld Instutes* 4 (1940-1941): 28-117, who convincingly demonstrated that the painting represents the weeping of Mordecai and was originally intended as a *cassone* panel. The consensus on the date of the painting, c. 1480, also obviates any connection with Savonarola. For the date, see Roberto Salvini, *Tutta la pittura del Botticelli*, 2 vols. (Milan, 1958), II: 59-60. P. Zeri, in his note to the painting in *La Galleria Pallavicini* (Florence, 1959), p. 151, n. 271, even cast doubt on Botticelli's authorship of the painting, ascribing it instead to Filippino Lippi. Cartwright, *Botticelli*, pp. 162-63, interpreted Botticelli's *Calumny of Apelles* much as Landsberger interpreted the *Derelitta*, as Botticelli's personal memorial to Savonarola.

11. Venturi, *Botticelli*, p. 23.

12. On the friendship between Botticelli and Lorenzo or, more accurately, for the evidence attesting, at the least, to an association between the two men, see Salvini, *Botticelli*, II: 36, 56-57; Horne, *Botticelli*, pp. 183 f; Wilhelm Bode, *Sandro Botticelli*, original ed. 1910 (New York, 1925), pp. 50 f.

13. Horne, *Botticelli*, p. 275.

14. *Ibid.*, *loc. cit.*, and p. 189. Bode, *Botticelli*, p. 145, concurs with Horne.

15. Horne, *Botticelli*, pp. 188-89; N. Rubinstein, *The Government of Florence Under the Medici, 1434-1494* (Oxford, 1966), p. 231. Ernst Breisach, *Caterina Sforza* (Chicago and London, 1967), pp. 205-06, 255, 344-45; G. F. Young, *The Medici* (New York, 1933), p. 505.

16. Horne, *Botticelli*, p. 282.

17. Giorgio Vasari, *Le Vite de più eccelènti architetti, pittori, et scultori italiani* (Florence, 1568), II: 472-73.

18. See Young, *Medici*, pp. 290-91, on Lorenzo, duke of Urbino.

19. Vasari, *Le Vite*, p. 470.

20. Vasari wrote within what might be called the tradition of exemplary historical biography; he added historically plausible incidents to his *Vite* not just to fill obvious gaps, but to supply his readers with proper cause and effect relationships, and to make the *Vite* more cohesive and readable, and most important, to make particular points when necessary for his readers' and patrons' view of history and their role in it. Thucydides' statement, in relation to his "quotation" of Pericles' funeral oration, that it was not his intention to report what Pericles said, but what he ideally should have said, was probably known to Renaissance historians. E. F. Jacob, in his introduction to *Italian Renaissance Studies* (London, 1960), pp. 30 ff., discussed the various approaches and ideals in history writing during the Renaissance and demonstrated in several examples how biographies were rewritten for new purposes. Such rewriting of the past was especially close to Vasari in his painting for Cosimo I of the *Foundation of Florence* as explicated by N. Rubinstein, "Vasari's Painting of *The Foundation of Florence* in the Palazzo Vecchio," in *Essays in the History of Architecture. Presented to Rudolf Wittkower*, ed. Douglas Fraser, Howard Hibbard, and Milton J. Lewine (London, 1969), pp. 64-73. It is informative to read Rubinstein's study in conjunction with Hans Baron's "A New View of Roman History and of the Florentine Past," the third chapter in his book *The Crisis of the Early Renaissance* (Princeton, 1955). Donald

Wilcox, *The Development of Florentine Humanist Historiography in the Fifteenth Century* (Cambridge, Mass., 1969), and Felix Gilbert, *Machiavelli and Guicciardini, Politics and History in Sixteenth-Century Florence* (Princeton, 1965), especially his fifth chapter "The Theory and Practice of History in the Fifteenth Century," offer basic summations on the subject. This attitude is summed up best by Vasari himself at the beginning of his *Vita* of Raphael: Vasari, *op. cit.,*: "Most artists have hitherto displayed something of folly and savagery, which, in addition to rendering them eccentric and fantastical, has also displayed itself in the darkness of vice and not in the splendour of those virtues which render men immortal."

21. For example, see Cartwright, *Botticelli*, pp. 171 ff., and Bode, *Botticelli*, p. 122.

22. Horne, *Botticelli*, pp. 303-04.

23. See Salvini's list, *Botticelli*, II: 45 ff, of Botticelli's paintings for these years. Cited in the list are the attributions and dates given by other authors as well as Salvini's own.

24. Horne, *Botticelli*, p. 302.

25. See Joseph Schnitzer, *Savonarola*, 2 vols. (Milan, 1931), II: 462 ff.

26. The quotations are from Salvini, *Botticelli*, II: 29 and Bode, *Botticelli*, p. 30.

27. See the compilation cited in Salvini, *Botticelli*, II: 45 ff.

28. Compare, for example, the following late works of varied subjects and sizes: the Munich *Pietà*, ᵌhe *Saint Zenobius* panels (London, New York, and Dresden), the *Lucrezia* and *Virginia* panels (Bergamo and Boston), the Glasgow *Annunciation*, and the London *Mystic Nativity*.

29. See our discussion in Chapter 10.

30. For example, the *Virginia* and *Lucrezia* panels commissioned by Guidantonio Vespucci. See Salvini, *Botticelli*, I: 63 ff.

31. See Francesco Guicciardini, *The History of Italy* (New York and London, 1969), pp. 80 ff, for this record of Vespucci's opposition to Paolo Antonio Soderini's advocacy of Savonarola's popular republican government.

32. For the year 1499, Guicciardini, *Ibid.*, pp. 150-51, from the viewpoint of a man experiencing the events, declared that Italy was "shaken by so many perturbations": the incursion of the Turks, the invasions of King Louis XII, the armed threats of Cesare Borgia which were sponsored by his father the pope, all contributed to the year ending in great turmoil.

33. Bode, *Botticelli*, p. 122.

34. On Wackenroder's influence, see Camillo von Klenze, "The Growth of Interest in the Early Italian Masters," *Modern Philology* 4 (1906): 240 ff. In von Klenze's lengthy (67pp.) article the particular bias of his period for the early Italian painters as opposed to the later masters, particularly those of the Baroque, was unrecognized by him, but reflected in his statement "Even Pietro da Cortona, to our taste an empty rhetorician, was for a time regarded as a painter of the first rank," (pp. 208-09). On Wackenroder, also see Wallace K. Ferguson, *The Renaissance in Historical Thought* (Cambridge, Mass., 1948), p. 138.

35. Klenze, "Growth," p. 240, discussed at length the implications of this difference for German Romanticism in general. For a full discussion of Wackenroder's intellectual milieu, see Walter Silz, *Early German Romanticism, Its Founders and Heinrich von Kleist* (Cambridge, Mass., 1929). It is not our purpose here to review or summarize the Romantic movement in general but rather to trace a particular thread within it.

36. W. H. Wackenroder, *Herzensergiessungen eines kunstliebenden Klosterbruders* (Berlin, 1797), p. 136.

37. *Ibid.*, pp. 158-61.

38. *Ibid.*, pp. 224-25.

39. *Ibid.*, pp. 220-21.

40. See, for example, Dieter Honisch, *Anton Raphael Mengs und die Bildform des Frühklassizismus* (Recklinghausen, 1965), pp. 11 ff; Sir Joshua Reynolds, *Discourses delivered to the students of the Royal Academy* (London, 1905), and the influential book of Charles Cochin, *Voyage d'Italie* (Paris, 1758).

41. Wackenroder, *Herzensergiessungen*, pp. 15 ff. What Wackenroder did here was to interpolate a divine element into Raphael's well-known letter to Castiglione of 1516 in which Raphael stated that in order to paint a beautiful woman he made use of a "certain idea" that came into his head. For a more accurate interpretation of the letter, see Erwin Panofsky, *Idea* (Columbia, South Carolina, 1968), pp. 59-60.

42. Friedrich von Schlegel, *The Aesthetic and Miscellaneous Works* (London, 1889), p. 45. Schlegel (p. 53) reflected Wackenroder's *kunstgefühl-kunstverstand* opposition, and did so specifically in relation to classical style by stating: "I am decidedly of opinion that Italian masters, even of the modern school, possibly far more from correct impulse and true feeling than from classical study, have so truly embodied the expression of ancient life and faith"

43. *Ibid.*, p. 49.

44. *Ibid..*, p. 47. Schlegel, as did Ruskin later in the century (see text below), considered the Vatican *stanze* to be quite distinct from the earlier purer, more personal Raphael of the Florentine Madonnas.

45. *Ibid.*, pp. 148, 289.

46. *Ibid.*, p. 48. For a general discussion of the role of Schlegel and Wackenroder in German art historiography, see Wilhelm Waetzoldt, *Deutsche Kunsthistoriker* (Berlin, 1965), pp. 215-72. Also of interest is Maria Deetz, *Anschauungen von italianische Kunst in der deutschen Literatur von Winkelmann bis zur Romantik* (Wiesbaden, 1967), a reprint of the original 1930 edition published in Berlin.

47. See Ferguson, *Renaissance*, especially Chapters 4 through 7. This belief is inherent in the thesis of Alexis Rio, which became crucial for the association by later writers of Savonarola and Botticelli (see below). Rio's contemporary in the field of general history, Jacob Burckhardt, also promoted the thesis of a pagan Renaissance. See the discussion of Burckhardt in Ferguson, *Ibid.*, Chapters 7 and 8.

48. François-René de Chateaubriand, *Oeuvres Complètes de*; Vol. 2, *Génie du christianisme* (Paris, 1859), p. 285. For the history of this concept and its representation in the art of the later eighteenth and nineteenth centuries, see Robert Rosenbloom, "Origin of Painting: A Problem in the Iconography of Romantic Classicism," *Art Bulletin* 39 (1957): 279-90.

49. Chateaubriand, *Oeuvres*, pp. 287-88. On the same theme, see Schlegel's essay of 1819, *Works*, pp. 306 ff.

50. On the Brotherhood of Saint Luke, its development and aims, see Keith Andrews, *The Nazarenes, A Brotherhood of German Painters in Rome* (Oxford, 1964). Schlegel, *Works*, p. 289, referred to this group of artists when he compared this "new impulse" that has stirred Germany to the old barren theories and doctrines of art founded by Winkelmann and Mengs.

51. For illustrations of these paintings, see Andrews, *Nazarenes*, Plates 67, 68a, and 3, respectively. Wackenroder recorded his vision in his *Herzensergiessungen*, pp. 106-07.

52. The citations of A. F. Rio are from the English edition of *The Poetry of Christian Art* (London, 1854), which combines into one both of Rio's separate volumes.

The translator noted that the daily increasing taste and appreciation for Italian art promoted his translation of Rio's most important works, which were as yet little known in England, and he referred the reader to Mrs. Jameson's *Sacred and Legendary Art* (London, 1848) for her high opinion of Rio and her many quotations from his books.

53. Rio, *Christian Art*, pp. 236 ff. Wallace K. Ferguson noted that the age of the Medici was regarded by the Romantics with a "kind of fascinated horror." See his essay "The Reinterpretation of the Renaissance," pp. 1-18, in *Facets of the Renaissance* (New York, Evanston, and London, 1959).

54. Franz Kugler's book and H. Thode's *Franz von Assisi und die Anfänge der Kunst der Renaissance in Italien* (Berlin, 1885) are both discussed by Ferguson, *Renaissance*, pp. 147, 298 ff.

55. Rio, *Christian Art*, pp. 232 f, 249 f.

56. *Ibid.*, pp. 275 ff. On the probable non-existence of the Medicean school, see André Chastel, "Vasari et la légende medicéene," *Studi vasariani* (1952): 159-67.

57. Rio, *Christian Art*, pp. 259 ff.

58. *Ibid.*, pp. 299 ff.

59. See, for example, Mario Ferrara, *Savonarola, Prediche e scritti commentati e collegati da un racconto biografico—l'Influenza del Savonarola sulla letteratura e l'arte del Quattrocento—Bibliografia ragionata* (Florence, 1952).

60. Lord Lindsay, *Sketches of the History of Christian Art*, 4 vols. (London, 1847), III: 151.

61. *Ibid.*, p. 141.

62. *Ibid.*, p. 423.

63. On Newman and the Oxford movement in general, see S. L. Ollard, *A Short History of the Oxford Movement* (London, 1963), and Desmond Bowen, *The Idea of the Victorian Church* (Montreal, 1968).

64. Aside from the writings of Ruskin the reader is referred to the account of the Pre-Raphaelite movement by William Gaunt, *The Pre-Raphaelite Dream* (New York, 1966).

65. Michael Levey, "Botticelli and Nineteenth-Century England," *Journal of the Warburg and Courtauld Institutes* 23 (1960): 294, referred to these and other judgments on Botticelli in the early nineteenth century. In this article Levey was not at all concerned with Botticelli in relation to Savonarola or Christian art, but rather carefully traced the development of English taste for Botticelli and the collecting of his works.

66. John A. Symonds, *Renaissance in Italy*, 2 vols. first published 1875-86 (New York, n.d.), I: 294. Walter Pater, in 1870, also remarked on this developing interest in Botticelli; see his book *The Renaissance* (New York, n.d.), p. 41.

67. Rio, *Christian Art*, pp. 260 f. Levey, "Botticelli," p. 295, also associated Rio with the new interest in Botticelli.

68. Rio, *Christian Art*, p. 260. Vasari recorded (*Le Vite*, 1568, I: 472-73) that Botticelli engraved Savonarola's *Trionfo della Fede*. He may have meant Savonarola's treatise *Il Trionfo della Croce*; however, this engraving is not known today. Ferrara (*Prediche e scritti*, p. 57) identified this print with that of a woodcut depicting men washing in the river of blood flowing from the crucified Christ; views of Florence, Rome, and Jerusalem fill the background of the print. But there is nothing in the style of the woodcut which would associate the work with Botticelli. The subject is actually derived from Benivieni's *Trattato in defensione e probazione della dottrina e profezie predicate da frate Ieronimo da Ferrara nella città di Firenze* (Florence, 1496), for which it served as an illustration. Savonarola's *Trionfo* first appeared fully one year after Benivieni's *Trattato*.

124

69. Rio, *Christian Art*, p. 260.

70. See Levey, "Botticelli," pp. 291 ff.

71. E. Frantz, *Fra Bartolomeo della Porta* (Regensberg, 1879). Frantz (pp. 91-96) reiterated Rio and Marchese's claims about the important role of Savonarola and his profound and powerful effect on artists, but provided no more specific information or evidence than they had to offer.

72. For an annotated bibliography of nineteenth-century literature on Savonarola in which the ever-growing increase and diversity can be measured, see Mario Ferrara, *Bibliografia savonaroliana* (Florence, 1958).

73. Gustave Gruyer, *Les Illustrations des écrits de Jérôme Savonarole publiés en Italie au XVè au XVIè siècle et les paroles de Savonarole sur l'art* (Paris, 1879). Gruyer failed to take into account Savonarola's dependence upon traditional and well-known concepts as well as his rather eclectic manner of formulating "new" ideas. Gruyer also confused Savonarola's comments on beauty with his comments on art. For Savonarola, beauty was solely a metaphysical attribute of God, and thus could not possibly be manufactured by man, and certainly had no part in his considerations on art.

74. See the study of the "Savonarolan movement" in the second half of the nineteenth century by Giovanni Gentile, *Gino Capponi e la cultura toscana nel secolo decimonono* (Florence, 1922).

75. Schlegel, *Works*, p. 199; Bode, *Botticelli*, p. 167.

76. Ferguson, *Renaissance*, p. 121, saw this idea of a longed-for return to a Golden Age as implicit in the Romantic approach to the Middle Ages. Savonarola himself often commented that "there once were priests of gold and chalices of wood, now it is the reverse of those ancient days and there are priests of wood and chalices of gold." See, for example, his *Prediche sopra Giobbe* (Rome, 1957), II: 135, and his *E'Libri della semplicità della vita cristiana* (Rome, 1959), p. 226. On the concept in the Renaissance of a past Golden Age, see Harry Levin, *The Myth of the Golden Age in the Renaissance* (Bloomington and London, 1969).

CHAPTER 5

1. Giorgio Vasari, *Le Vite de più eccelènti architetti, pittori, et scultori italiani*, 2 vols. (Florence, 1550), II: 602.

2. *Ibid.*, 2 vols. (Florence, 1568), II: 36.

3. *Ibid.*

4. *Ibid.*

5. See Chapter 1.

6. Girolamo Savonarola, *Prediche sopra Ezechiele*, 2 vols. (Rome, 1955), II: 262, 272.

7. Joseph Schnitzer, *Savonarola*, 2 vols. (Milan, 1931), I: 465.

8. G. Savonarola, *Prediche sopra l'Esodo*, 2 vols. (Rome, 1955), I, Sermons 1-4, given on February 11, 18, 25, 28, pp. 1-121.

9. *Aggeo*, pp. 19-21.

10. Vasari, *Le Vite*, 1568, II: 36.

11. *Ibid.* For an account of the attack on San Marco, see Schnitzer, *Savonarola*, II: 83 ff.

12. Vasari, *Le Vite*, 1550, II, p. 602; *Ibid.*, 1568, II: 36.

13. The documents of the interviews were transcribed by P. Villari, *Life and Times of Girolamo Savonarola*, 2 vols. (London, 1889), II: CXLVI-CCLXXXVII, and A. Marquand, *The Brothers of Giovanni della Robbia* (Princeton, 1928), pp. 67-70.

14. See Marquand, *della Robbia*, pp. 67-70 and our chapter 3.

15. Vasari, *Le Vite*, 1550, II: 602; *Ibid.*, 1568, II: 36.

16. Vasari, *Le Vite*, 1550, II: 603; *Ibid.*, 1568, II: 37.

17. Padre Vincenzo Marchese, *Memorie dei più insigni pittori, scultori, e architetti domenicani*, 2 vols. (Florence, 1854), II: 28-29.

18. Vasari, *Le Vite*, 1550, II: 604; *Ibid.*, 1568, II: 37.

19. Felix Gilbert, "The Renaissance Interest in History," in *Art, Science, and History in the Renaissance*, ed. C. Singleton (Baltimore, 1967), p. 377. See also our discussion of the life of Botticelli in Chapter 4.

20. Vasari, *Le Vite*, 1550, II: 601; *Ibid.*, 1568, II: 35.

21. Vasari, *Le Vite*, 1550, II: 601; *Ibid.*, 1568, II: 35.

22. Vasari, *Le Vite*, 1550, II: 37-38.

23. Marchese, *Memorie*, II: 31.

24. *Ibid.*, II: 24.

25. *Ibid.*, II: 39, and pp. 360-63 for a transcription of the documents of the dispute.

26. *Ibid.*, II: 13.

27. *Ibid.*, p. 14.

28. *Ibid.*, pp. 25-29. Marchese (*Ibid.*, p. 27) listed other artists whom he believed gave up painting because of Savonarola and referred to Vasari as his source for this information. Of these several artists only two are so cited by Vasari. On the belief of the nineteenth century in the "corruptness" of the Renaissance, see Chapter 4 on Botticelli.

29. *Ibid.*, pp. 36-37.

30. *Ibid.*, I: 29.

31. H. von der Gabelentz, *Fra Bartolomeo und die florentiner Renaissance*, 2 vols. (Leipzig, 1922), I: 23.

32. *Ibid*, p. 36.

33. *Ibid.*, p. 23.

34. In addition to Gabelentz and Knapp, see E. Frantz, *Fra Bartolomeo della Porta* (Regensberg, 1879), pp. 92-96.

CHAPTER 6

1. Joseph Schnitzer, *Savonarola*, 2 vols. (Milan, 1931), II: 409-10.

2. Erwin Panofsky, *Studies in Iconology* (New York, 1962), pp. 171, 182.

3. In his study of Michelangelo's Florentine *Pietà* ("Metaphors of Love and Birth in Michelangelo's Pietas," in *Studies in Erotic Art*, ed. C. Christenson [New York, 1970]), Leo Steinberg, citing the passages from Savonarola's sermons to which we directed him, suggested Savonarola as the artist's major source for this work. We would maintain that these are parallels only; both Michelangelo and Savonarola knew the prime sources. Michelangelo did not need Savonarola for his iconography.

4. Ascanio Condivi, *The Life of Michelangelo*, trans. C. Holroyd (London and New York, 1911), p. 74. The original reads as follows: " . . . Con grande studio ed attenzione lette le sacre scritture si del Testamento Vecchio, come del Nuovo, e chi sopra di chio s'e affaticato, come gli scritti del Savonarola, al quale egli ha sempre avuta grande affezione, restandogli ancor nella mente la memoria della sua viva voce," (A. Condivi, *Vita di Michelangiolo* (Florence, 1938), p. 149.

5. Charles DeTolnay, *The Art and Thought of Michelangelo* (New York, 1964), p. 59.

6. Giorgio Vasari, *La Vita di Michelangelo nelle redazioni del 1550 e del 1568*, ed. P. Barocchi (Milan, 1962), p. 121.

7. Condivi, *Michelangelo*, p. 74.

8. Schnitzer, *Savonarola*, II: 409.

9. DeTolnay, *Michelangelo*, pp. 56-82.

10. *Ibid.*, pp. 56, 129-30, n. 1.

11. *Ibid.*, p. 129, n. 1; H. W. Beyer, *Die Religion Michelangelos* (Bonn, 1926), p. 145.

12. Beyer, *Religion, loc. cit.*

13. H. Thode, *Michelangelo*, 4 vols. (Berlin, 1908), II: 296.

14. Beyer, *Religion*, pp. 145-46.

15. DeTolnay, *Michelangelo*, pp. 60-61. DeTolnay's arguments for a powerful influence of Savonarola upon Michelangelo presented in his study *The Youth of Michelangelo*, 2 vols. (Princeton, 1953), I: 20-21, 22-23, 24, 27 ff, fall into the same doubtful category.

16. *Ibid.*, p. 62.

17. *Ibid.*, pp. 62-63.

18. One of these parallels exists in the case of Michelangelo's *David*.

CHAPTER 7

1. *Triumphus Crucis*, p. 357; *Esodo*, II: 213; *Ruth e Michea*, I: 105.

2. *Ruth e Michea*, II: 88. Savonarola did not believe that allegory was possible in poetry because allegory must have its origin in actuality. See, for example, Girolamo Savonarola, *Prediche italiane ai Fiorentini giorni festivi del 1495*, [Perugia and Venice, 1930], II: 40, 243, to be referred to as *Psalms*. On several occasions Savonarola condemned those who interpreted Dante's works as allegories, and introduced "from the pulpit the poetry of Dante and other frivolities," (*Aggeo*, p. 290). On the Renaissance discussions of Dante, allegory in poetry, and poetry as a vehicle for theological expression, see Ernst R. Curtius, *European Literature and the Latin Middle Ages* (New York, 1963), pp. 214-27, especially p. 226, and Bernard Weinberg, *A History of Literary Criticism in the Italian Renaissance*, 2 vols. (Chicago, 1961), I: 291. See also Edgar Wind, *Pagan Mysteries in the Renaissance* (New Haven, 1958), Chapter 1, pp. 24-30 on "Poetic Theology." For an interesting discussion of allegory and prophecy, see Michael Murrin, *The Veil of Allegory* (Chicago and London, 1969), pp. 21-53.

3. *Ezechiele*, I: 195-96.

4. P. Villari, *La storia di Girolamo Savonarola*, 2 vols. 1st. ed., 1859-61 (Florence, 1930), I: 152, n. 1. Joseph Schnitzer, *Savonarola*, 2 vols. (Milan, 1931), II: 249 also referred to Cerretani's account. See also Schnitzer, *Savonarola*, II: 227 ff for a survey of preaching in fifteenth-century Italy.

5. Schnitzer, *Savonarola*, II: 250.

6. *Ezechiele*, I: 219.

7. Villari, *La storia . . . Savonarola*, I: 143, n. 1. For Savonarola's justification of his extensive and exceptional use of imagery, see our discussion of Fra Bartolomeo's painting of God the Father with Saint Mary Magdalen and Saint Catherine of Siena in Chapter 13.

FRA GIROLAMO SAVONAROLA

CHAPTER 8

1. *Ruth e Michea*, I: 143.

2. Gustave Gruyer, *Les Illustrations des écrites de Jérôme Savonarole publiés en Italie au XVè et XVIè siècle et les paroles sur l'art* (Paris, 1879).

3. *Ezechiele*, I: 17-20, 166 ff; *Prediche quadragesimale del reve. P. F. Ieronimo Savonarola da Ferrara, sopra Amos propheta, & sopra Zaccaria* (Venice, 1544), p. 157v; *Psalms*, II: 40. Numerous other passages refer to the same concepts. In many of the statements Savonarola was paraphrasing Saint Thomas Aquinas' *Summa* Ia,q.1, a.9.r. One may assume that Savonarola was also familiar with similar statements in Saint Augustine's *De doctrina christiana* and in Gregory's explication of Job, a work to which Savonarola referred many times in his extensive sermons on Job.

4. *Triumphus Crucis*, pp. 293-96, 355 f; *Ezechiele*, I: 18, 166. On the use of the image of triumphs in pagan and Christian literature, see Werner Weisbach, *Trionfi* (Berlin, 1919), pp. 93 ff, and Ernst R. Curtius, *European Literature and the Latin Middle Ages* (New York, 1963), pp. 120 ff.

5. G. Savonarola, *Prediche . . . sopra il Salmo Quam Bonus Israel Deus* (Venice, 1539), pp. 164v-65. For Savonarola the "good painter" in this passage, furthermore, became a figure for grace and faith, which have the same effect on man as that of a good painting. This ability of a visual image to take one outside oneself into a state of ecstacy through one's contemplation of the image is a basic Neoplatonic idea. See E. H. Gombrich, "Icones Symbolicae, the Visual Image in Neo-Platonic Thought," *Journal of the Warburg and Courtauld Institutes* 11 (1948): 167, 174 ff. In general Savonarola's conception of the role of an image, verbal or visual, reflected the tradition of systematic interpretation of the symbol's Christian function and usage which became an integral part of later fifteenth-century Neoplatonic philosophy. Gombrich, *ibid.*, pp. 167-68, indicated that the basis for this use of symbols was Dionysius the Aeropagite's *Celestial Hierarchy*. Dionysius was one of Savonarola's favorite authorities (see text below).

6. *Ezechiele*, I: 343. A builder also builds, as Savonarola put it, according to his own image (*Amos e Zaccaria*, pp. 66v-67; all references to this sermon cited solely by page number refer to the Venetian edition of the sermon); and the house is made well when it conforms to the intellect of the builder and when his intellect is subject to and conforms with that of God (*Ezechiele*, I: 126). The use of the figure of the builder and the idea of the house for analogy has a long pedigree going back to Aristotle and Plotinus. It also occurred in Philo and other late antique writers and was constantly repeated in the Middle Ages by Saint Thomas Aquinas, among others. See Erwin Panofsky, *Idea* (Columbia, South Carolina, 1968), pp. 13 ff, and p. 78, no. 50.

7. *Amos e Zaccaria*, p. 281. See also the similar passage in the following sermons of Savonarola: *Ezechiele*, I: 150; *Psalms*, II: 146; *Amos e Zaccaria*, pp. 280v-81.

8. *Quam Bonus*, pp. 200-200v; *Amos e Zaccaria*, pp. 336v, 358v-59 377v-78; *Esodo*, I: 17.

9. *Ruth e Michea* I: 250.

10. *Ibid*, II: 80.

11. For a summation of these associations in the fifteenth century, see Rensselaer Lee, *Ut Pictora Poesis: The Humanistic Theory of Painting* (New York, 1967), pp. 25 f. Also see Curtius, *Literature*, p. 77.

12. Paul O. Kristeller, *Renaissance Thought II* (New York and London, 1965), pp. 174-75. Savonarola referred mainly to painting, hardly ever to sculpture, and to architecture only in its more practical sense, i.e., the proper joining of stone or the need for good foundations. The word "building" is used in place of "architecture" and "builder" instead of "architect." See, for example, *Ezechiele*, I: 126.

128

13. *Amos e Zaccaria*, pp. 380v-81; *Ezechiele*, I: 327.

14. *Amos e Zaccaria*, pp. 359, 380v-81.

15. *Ezechiele*, I: 327; *Amos e Zaccaria*, p. 463.

16. Kristeller, *Renaissance Thought*, p. 186.

17. The great and exceptional emphasis Botticelli gave his self-portrait (at the extreme right foreground) in his *Adoration of the Magi* in the Uffizi, dated in the later 1470s is exactly the kind of thing Savonarola would oppose. Botticelli was saying· here, in effect, "I am the artist, here I am, this is my work, and I cannot be separated from it," in direct contradiction of those who traditionally maintained that the work produced was praiseworthy but the artist, being a mere manual laborer, was worthy only of disdain. This was a dichotomy which the artists of the Renaissance strove to eliminate. On the matter of the professional enhancement of the artist in the fifteenth century, see M. and R. Wittkower, *Born Under Saturn* (New York, 1963), pp. 14ff.

18. *Ezechiele*, I: 91.

19. *Psalms*, II: 162.

20. Joseph Schnitzer, *Savonarola*, 2 vols. (Milan, 1931), II: 379.

21. *Quam Bonus*, p. 118v; *Ezechiele* I: 357-58, 365; II: 272, 276-77; *Ruth e Michea* I: 134; II: 277, 372; *Amos e Zaccaria* I: 127.

22. *Amos e Zaccaria* I: 127, (183-83v).

23. *Ibid.*, p. 391.

24. *Ezechiele* I: 358. Similarly, in antique works on rhetoric there occurred the injunction that the perfect orator must be a morally good man. (See Curtius, *Literature*, p. 67 and Bernard Weinberg, *A History of Literary Criticism in the Italian Renaissance*, 2 vols. [Chicago, 1961], I: 27.) Throughout the preceding pages it will have been apparent that for Savonarola art should be instructive. He strongly desired, it would seem, to oppose the antique idea, prevalent during the Renaissance, that art should delight as well as instruct. For a discussion of these purposes of art maintained in the theoretical literature of the period, see Lee, *Poesis*, pp. 32 ff; also see Weinberg, *Criticism*, I: 140 f. In his discussion of this matter, Lee (p. 33) put forth his belief, which he did not substantiate, that Savonarola would allow art neither of these functions for he vehemently "denounced the arts as hostile to the Christian way of life."

25. These and other examples can be found repeated constantly throughout the sermons. It is sufficient to cite the following: *Quam Bonus*, pp. 154 ff; *Psalms*, II: 162, 346; *Ezechiele*, I: 372; II: 184, 192; *Giobbe*, II: 129, 442; *Ruth e Michea*, II: 469; *Aggeo*, pp. 115, 163; *Esodo*, II: 370; *Amos e Zaccaria*, I: 281.

CHAPTER 9

1. Anthony Blunt, *Artistic Theory in Italy, 1450-1600* (Oxford, 1956), pp. 45-47.

2. A. F. Rio, *The Poetry of Christian Art* (London, 1854), pp. 405-63, 465-551; Joseph Schnitzer, *Savonarola*, 2 vols. (Milan, 1931), II: 379-90; P. Villari, *Savonarola*, 2 vols. (London, 1889), I: 519-26.

3. *Amos e Zaccaria* III: 5-6 and *Ezechiele* I: 374-75 contain concise discussions by Savonarola of his concept of beauty. On conceptions of beauty in the Renaissance, see Paul O. Kristeller, *Renaissance Thought II* (New York, 1965), pp. 166-68; Edgar Wind, *Pagan Mysteries in the Renaissance* (New Haven, 1958), pp. 88-89; and Erwin Panofsky, *Idea* (Berlin, 1960), pp. 35 ff.

4. N. Robb, *Neoplatonism of the Italian Renaissance* (London, 1935), p. 227. Savonarola, it appears, argued against Pico's belief that simple beauty cannot exist because

beauty is produced by the harmony of discordant parts and therefore must be composite; this means that beauty could not be an attribute of God for He is in essence simple (see Wind, *Pagan Mysteries*, p. 88). This may also be the reason for Savonarola's comment in 1494, at the end of one of his sermons (p. 104), that, through the prayers of the *frati*, Pico was in Purgatory.

5. Kristeller, *Renaissance Thought*, pp. 176-78.

6. Rensselaer Lee, *Ut Pictora Poesis: The Humanistic Theory of Painting* (New York, 1967), p. 13, indicated that toward the end of the sixteenth century Lomazzo in his treatise *Idea del tempio della pittura* reverted to the consideration of beauty as having its source in God and not in nature, and that this idea of beauty which is God, emanates into the painter's mind from God. Savonarola always urged a contemplation of the beauty which is God, but never associated this beauty, which is totally and solely divine, with any objects of man's manufacture.

7. Schnitzer, *Savonarola*, II: 380.

8. See especially the *Proemis* of the treatise, pp. 142-49.

9. *Quam Bonus*, pp. 136v-37, 233v; *Aggeo*, pp. 20, 115; *Giobbe*, II: 129, 131, 442, 450; *Salmi*; pp. 77, 162, 346; *Ezechiele*, I: 91.

10. *Giobbe*, II: 135; *Della semplicità, loc cit.*, and p. 226. There are close to one hundred references in the sermons to such objects of *superbia* in which many of these things, in various combinations, are listed. Savonarola also marveled at the value attached to objects of personal, household, and church decorations over and over again, exclaiming in one instance that he was even shown a volume of Petrarch valued at fifty ducats (*Amos e Zaccaria*, p. 413).

11. *Ruth e Michea*, I: 122-24.

12. *Quam Bonus*, p. 162.

13. Throughout this passage Savonarola used the word "*peccato*" as, for example, in the second sentence: "*nella natura e peccato*." Given the context of the word here we have translated it as "error" except in the last sentence where we have translated it as "sin," because it is clear from Savonarola's usage there, as well as from the point he finally made, that this translation is warranted.

14. *Amos e Zaccaria*, pp. 335v-36v. Similar ideas are expressed in many other passages; for example, see *Giobbe*, II: 282-83.

15. *Amos e Zaccaria*, p. 463. See also, *Ruth e Michea*, II: 265-66.

16. *Ezechiele*, II: 51-52. This analogy of the real grapes and the grapes depicted by the painter which appear natural was a favorite of Savonarola, occurring many times in his sermons. For example, *Psalms*, II: 146; *Amos e Zaccaria* II: 98-99. This and similar analogies also occurred in the literature of art since Pliny. See Lee, *Poesis*, p. 10.; Panofsky, *Idea*, p. 49.

17. Panofsky, *Idea*, pp. 47 ff; 89, n. 95; 109, n. 210.

18. For examples from the sermons, see the references cited above and in Chapter 13, on Fra Bartolomeo's painting of God the Father.

19. It is unnecessary to consider the "theoretical" ideas on art expressed by Savonarola as "influencing" later writers. He is not a source to whom these theoreticians would have normally referred, instead of the better-known and more germane sources on art theory.

CHAPTER 10

1. S. J. Freedberg. *Painting of the High Renaissance in Rome and Florence*, 2 vols. (Cambridge, Mass., 1961) I: 23-24.

2. *Ibid.*, pp. 54, 193 ff.

3. Heinrich Wölfflin, *The Art of the Italian Renaissance* (New York, 1966), p. 143.

4. Compare the works of those older painters mentioned above with Fra Bartolomeo's *God the Father with Saint Mary Magdalen and Saint Catherine of Siena* (1509), *Madonna and Child and Saints* (1509), the Gran Consiglio altarpiece (1510), *Salvator Mundi and the Evangelists* (1516).

5. The quotations are from Roberto Salvini, *Tutta la pittura del Botticelli*, 2 vols. (Milan, 1958), II: 29, and Wilhelm von Bode, *Sandro Botticelli* (New York, 1910), p. 30.

6. See Salvini, *Botticelli*, II: 29.

7. Compare, for example, the Munich *Pietà*, a large (110 x 207 cm.) composition with large, well-modeled figures in static positions, with the *St. Zenobius* panels (66.5 x 149.5 cm., from the *Vocation of St. Zenobius*, with other panels approximately the same dimensions); the *Lucrezia* and *Virginia* panels (approximately 85 x 160 cm.) with the Glasgow *Annunciation*, a smaller panel (49.5 x 58.5 cm.) but with a much clearer rendering of figures and comparatively monumental architecture.

8. See Chapter 8 of this study.

9. The belief, expressed by André Chastel in his book *The Flowering of the Italian Renaissance* (New York, 1965), pp. 270 f., that "Savonarola's reforms had the effect of bringing the Florentine artists back for a moment to the canons of the Dominican tradition" cannot be substantiated by his immediately subsequent statement, "Filippino Lippi even painted, for a *Piagnone*, a Crucifixion with a golden background," particularly when he goes on to enumerate other examples of archaisms at the end of the fifteenth century which cannot be related at all to Savonarola. It is doubtful, but not impossible, that it would have occurred to a *piagnone* commissioning a painting to have interpreted Savonarola's demand for a return to the simplicity of the early church into a painting containing an older element such as the gold background. There are several examples of such backgrounds in paintings in Florence (and certainly in paintings in Siena and elsewhere) toward the end of the fifteenth century. The inclusion of this gold, in itself, indicates little. Alfred Scharf also saw an association between Savonarola and Lippi in regard to his painting of the *Crucifixion*. See *Filippino Lippi* (Vienna, 1935), pp. 55-56. Scharf referred to Julius Meyer, "Zur Geschichte der florentinischen Malerei des XV Jahrhunderts," *Jahrbuch der Königlich Preussichen Kunstsammlungen* 11 (1890): 3-35, for the general reasons which associate the gold ground with Savonarola, but Meyer is not specific. The painting is reproduced in Scharf, Plate 65.

CHAPTER 11

1. *Giobbe*, I: 405-26. In this sermon the text which Savonarola cited (pp. 407-08) for the description of the throne is Regum: 3, 10.

2. Numerous other Savonarolan verbal images could easily have been adopted into existing formats in the visual medium, but few of them were. Also, particular symbols and metaphors used by Savonarola to represent compendiums of secular and sacred concepts could have been included in any number of ways into pictures, such as: trees without roots, (*Giobbe* II: 243); vases with holes, (*Aggeo*, pp. 28 ff); firm and leaning columns, (*Giobbe* I: 11); God as a strongly linked chain in a circular form; an evil city represented as a polymorph monster in which the animal parts composing it vary as to the kinds of vices with which the city is filled (*Psalms*, II: 347). Many of these, as well as others, are part of Savonarola's standard repertory of metaphors and are used throughout his sermons.

3. References to the throne of Solomon in depictions of the Virgin are not uncommon, since Christ had been linked by the Church fathers with this seat of wisdom. See

Adolf Katzenellenbogen, *The Sculptural Programs of Chartres Cathedral* (New York, 1964), pp. 15, 66, 68 f, and Erwin Panofsky, *Early Netherlandish Painting*, 2 vols. (Cambridge, Mass., 1953), I: 143 and 415, n. 1.

CHAPTER 12

1. Herbert Horne, *Alessandro Filipepi Commonly Called Sandro Botticelli* (London, 1908), p. 302. Also see Roberto Salvini, *Tutta la pittura del Botticelli*, 2 vols. (Milan, 1958), II: 66, for an outline of current assessments of the attribution.

2. Salvini, *Botticelli*, II: 66.

3. Horne, *Botticelli*, p. 302.

4. P. Villari and E. Casanova, *Scelta di prediche e scritti di Fra Girolamo Savonarola con nuovi documenti intorno alla sua vita* (Florence, 1898), pp. 366-77. This vision in the *Compendio* was also presented publicly by Savonarola as a separate sermon in his series on *Giobbe* (II: 78) early in 1495, as well as in his series on the *Psalms* (II: 45), January 13, 1495.

5. Salvini, *Botticelli*, II: 66-67.

6. These arguments are summarized in *Ibid*, p. 66.

7. Mario Ferrara, *Prediche e scritti commentati e collegati da un racconto biografico, l'influenza del Savonarola sulla letteratura e l'arte del Quattrocento—Bibliografia ragionata* (Florence, 1952), p. 55.

8. *Ibid.*, p. 56.

9. *Ibid.*

10. *Ibid.*, p. 56.

11. *Ibid.*, *loc. cit.*

12. As noted by Salvini, *Botticelli*, II: 66-67.

13. *Psalms*, II: 45. This does not appear in the *Compendio*.

14. Salvini, *Botticelli*, II: 67.

15. The most recent discussion of this painting can be found in D. Weinstein, *Savonarola and Florence, Prophecy and Patriotism in the Renaissance* (Princeton, 1970), pp. 336-38. Weinstein identified the "city" at the right as Rome, although only smoke and fire can be seen, and also erroneously read the painting as a sequential narrative.

16. In addition to the passages from the sermons cited in our discussion of Fra Bartolomeo's painting of the *Mater Misericordia* in Chapter 13, see *Aggeo*, p. 44; *Esodo*, II: 116.

17. See our discussion on the Sala del Gran Consiglio in chapter 13.

18. *Amos e Zaccaria*, pp. 322v-24. The same theme is presented in *Aggeo*, p. 339.

19. *Aggeo*, *loc. cit.*

20. *Ezechiele*, I: 277.

21. *Ibid.*, II: 206-07, 219 ff.

22. *Esodo*, I: 227; *Giobbe*, II: 181-82; *Amos e Zaccaria*, p. 323.

23. *Ruth e Michea*, II: 187.

24. *Ibid.*, I: 350.

25. *Ibid.*, II: 52. Just before this passage (p. 51), Savonarola used the image of a lion stalking the forest for its victims.

26. *Giobbe*, I: 203; *Ruth e Michea*, I: 340; II: 60, 140, 174, 297; *Aggeo*, p. 89; *Esodo*, I: 313.

27. *Ezechiele*, II: 261, 267.

28. *Ibid.*, p. 262.

29. *Ibid.*, p. 263.

30. *Ibid.*, p. 280.

31. For example, see *Quam Bonus*, p. 91v, and *Ezechiele*, I: 110. Also see nn. 28 and 29 in Chapter 13.

32. *Esodo*, I: 227.

33. *Ibid.*, II: 191.

34. *Ibid.*, I: 313.

35. *Psalms*, II: 45; (Villari and Casanova), *Savonarola*, p. 358.

36. *Amos e Zaccaria*, p. 462v.

37. *Esodo*, I: 149. See also Martin Davies, *The Earlier Italian Schools*, National Gallery Catalogue (London, 1961), p. 107, n. 19.

38. Davies, *Italian Schools*, p. 106.

39. Salvini, *Botticelli*, II: 65.

40. See Villari and Casanova, *Savonarola*, pp. 514-18. The members of the Aldobrandini family who signed the petition were: Piero di Salvatore Aldobrandini (p. 514); Aldobrandino di Brunetto di Aldobrandini (p. 515); Bernardo di Silvestro Aldobrandini (p. 517); Francesco di Giorgio Aldobrandini (p. 518).

41. P. Ginori, ed., *La Vita del Beato Ieronimo Savonarola* (*Vita latina*) (Florence, 1937), pp. 244-47. See also Joseph Schnitzer's report of this incident in *Savonarola*, 2 vols. (Milan, 1931), II: 484-85.

42. Schnitzer, *Savonarola*, II: 450, 489, 491.

43. The matter that follows in the text, except when otherwise noted, is from Davies, *Italian Schools*, pp. 103-08.

44. The sermon of Advent, 1493, is part of the series *Quam Bonus*, sermon 19, pp. 191v ff. The passage describing the presepio is on pp. 197v-98.

45. Weinstein, *Savonarola and Florence*, believing Botticelli to be a *piagnone* (p. 334), interpreted this painting as Savonarolan in content and meaning. He also credited Botticelli with a prophetic ability of his own, for if he painted the picture in early 1501 (as Weinstein interpreted the end of 1500, transposing the modern calendar for the Florentine), according to Weinstein's interpretation of the inscription, Botticelli referred to the newly reformed Florentine constitution of a year later (p. 335).

46. See the bibliography on this painting cited by Salvini, *Botticelli*, II: 53-54.

47. *Ibid.*

48. *Ibid.*, p. 53.

49. Giorgio Vasari, *Le Vite de più eccelènti architetti, pittori, et scultori italiani*, 3 vols. (Florence, 1568), I: 472-73.

50. Ferrara, *Prediche e scritti*, p. 57.

51. Illustrated in Salvini, *Botticelli*, II: tav. 3.

52. F. Landsberger, "Trauer um den tod Savonarolas, zur deutung des Derelitta-bilder," *Zeitschrift für Kunstgeschichte* 2 (1933): 275-78.

53. Edgar Wind, "The Subject of Botticelli's 'Derelitta'," *Journal of the Warburg and Courtauld Institutes* 4 (1940-1941): 28-117.

54. See Salvini, *Botticelli*, II: 59-60.

CHAPTER 13

1. Padre V. Marchese, *Memorie dei più insigni pittori, scultori, e architetti domenicani*, 2 vols. (Florence, 1854), II: 108-13; H. von der Gabelentz, *Fra Bartolomeo und der florentiner Renaissance*, 2 vols. (Leipzig, 1922), I: 147-49.

2. Marchese, *Memorie*, II: 111-12.

3. *Ibid.*

4. Louis Reau, *Iconographie de l'art chrétien*, 2 vols. (Paris, 1957), II: Part 2, pp. 112-19; Vera Sussmann, "Maria mit dem Schutzmantel," *Marburger Jahrbuch für Kunstwissenschaft* 5 (1929): 285-351.

5. *Psalms*, II: 299; *Esodo*, II: 53-81.

6. *Amos e Zaccaria*, p. 84v; *Esodo*, II: 53-81. In these passages, both the psalm and the quotation from Saint Matthew were also combined into one form by Savonarola.

7. *Ezechiele*, I: 234, 237, 368; *Aggeo*, p. 13; *Esodo*, I: 78; II: 63; *Psalms*, II: 299 ff; *Quam Bonus*, p. 14v; *Amos e Zaccaria*, pp. 84v, 393-393v, 407v, 410; *Ruth e Michea*, II: 91. Numerous other passages in the sermons could be cited.

8. *Psalms*, II: 242; *Esodo*, I: 106, 157, 180; II: 116, 173; *Ruth e Michea*, I: 155, 406; II: 31, 61, 72-83, 100, 267, 292, 294, 347, 354; *Amos e Zaccaria*, pp. 393-93v; *Aggeo*, p. 44. These are only a few of the numerous references made by Savonarola to these themes.

9. Gabelentz, *Fra Bartolomeo*, I: 147-49. On Sante Pagnini as the successor of Savonarola as prior of San Marco, see Edgar Wind, "Sante Pagnini and the Art of Michelangelo, A Study in the Succession of Savonarola," *Gazette des Beaux-Arts* 26 (1944): 210 ff. An analysis of this painting was originally published by the author in a slightly altered form as an article entitled "Fra Bartolomeo, Savonarola and a Divine Image," in the *Mitteilungen des kunsthistorishchen Institutes in Florenz* 18(1974): 319-28.

10. Divine simplicity and austerity, combined with the traditional levels of meaning and interpretation, which are God's gift to man for the comprehension and expression of the ineffable, were concepts particularly emphasized by Savonarola and associated by him with verbal and pictorial imagery, as discussed earlier.

11. On the "cult" of Savonarola after his death, see Joseph Schnitzer, *Savonarola*, 2 vols. (Milan, 1931), II: 463 ff.

12. *Quam Bonus*, pp. 164-65. Savonarola's conception of this function of a visual image reflected the tradition of systematic interpretation of the image's, or symbol's, Christian function and meaning which became an integral part of later fifteenth-century Neoplatonic philosophy. E. H. Gombrich, "Icones Symbolicae, the Visual Image in Neo-Platonic Thought," *Journal of the Warburg and Courtland Institutes* 11 (1948): 167 ff, indicated that the basis for this use of symbols was Dionysius the Aeropagite's *Heavenly Hierarchy*; Dionysius was one of Savonarola's favorite authorities (see following discussion).

13. George Kaftal, *St. Catherine in Tuscan Painting* (Oxford, 1949), pp. 20 ff.

14. The image of angels circling God the Father (or the Madonna in Glory) in all probability has its origins in Dionysius the Aeropagite's *Heavenly Hierarchy*, Chapter 7, Part 4.

15. The inscriptions NOSTRA CONVERSATIO IN COELIS EST and AMORE LANGUEO were cited by Gabelentz, *Fra Bartolomeo*, I: 147-48; as NOSTRA CONSERVATIO IN COBERTIS and AMORE LANGUBO, which are meaningless. Gabelentz's error may have been due to his having transcribed the original error by Fritz Knapp, *Fra Bartolomeo della Porta und die Schule von San Marco* (Halle a.S., 1903), p. 259.

16. For example, the *Trinity* by Alleso Baldovinetti (1471, Academia, Florence); the *Coronation of the Virgin* by Piero del Pollaiuolo (1483, Collegiata, San Gemignano); the *Madonna in Glory* by Cosimo Rosseli (c. 1500, Louvre, Paris). The statues of the Virgin, donors, and their patron saints by Klaus Sluter in Dijon also appear to be standing on clouds and not on cushions as generally believed.

17. Kaftal, *St. Catherine*, p. 76.

18. See Reau, *Iconographie*, Part 2, p. 847; George Kaftal, *Iconography of the Saints in Tuscan Painting* (Florence, 1952), p. 719; A. A. King, *Liturgies of the Religious Orders* (London and New York, 1955), p. 369.

19. Of the over one hundred sixty explicit references to this theme in the sermons, it will be sufficient to cite the following: *Ruth e Michea*, I: 24, 184, 376; *Aggeo*, pp. 279, 332; *Ezechiele*, I: 57, 69-71, 131, 229, 341-42; II: 10, 197, 256; *Giobbe*, I: 97, 241, 351; II, 263, 405; *Quam Bonus*, pp. 26v, 265v-66. The theme also received much attention in the treatise *Il Trionfo della Croce* (see *Triumphus Crucis*, Chapters 7, 8 and 14).

20. Savonarola, in *Ruth e Michea*, II: 336, described God as seated because, as he related, this position symbolizes His stability and immutability. This passage is based upon Isaiah 6:1, Savonarola's text for his sermon that day.

21. The following are some examples: *Psalms*, II: 75; *Ezechiele*, I: 114, 115, 338; *Giobbe*, I: 335, II, 86; *Amos e Zaccaria*, pp. 186v, 218, 218v, 231v, 240v, 440v; *Quam Bonus*, pp. 265v-66; *Triumphus Crucis*, p. 339.

22. *Quam Bonus*, pp. 62, 90v; *Psalms*, II: 77, 100, 252; *Ezechiele*, I: 47, 155; *Giobbe*, I: 328; *Ruth e Michea*, II: 309.

23. *Ezechiele*, I: 47, 155, 175; *Giobbe*, I: 328, 405; II: 263; see also *Giobbe*, I: 180.

24. *Giobbe*, I: 328, 405; *Ruth e Michea*, I: 344; *Aggeo*, p. 1.

25. *Ezechiele*, II: 311.

26. *Ibid.* I: 347-48; II: 311; *Giobbe*, I: 42, 236; II: 323-24; *Ruth e Michea*, I: 311; II, 44, 193; *Esodo*, p. 352. Similar themes can be found in *Quam Bonus*, p. 78v, in which Savonarola preached on the necessity of holy conversation, and in *Aggeo*, p. 3, when he defined the fourth sign in the reign of heaven as conversation with the good. In *Aggeo*, p. 27, conversation with the good is contrasted with evil conversation, which is defined as the "antique customs in use today."

27. *Esodo*, I: 227, 239; II: 352; *Ezechiele*, II: 110-11, 248; *Quam Bonus*, p. 78v; *Aggeo*, pp. 3, 27.

28. *Ezechiele*, I: 110.

29. *Giobbe*, I: 180.

30. *Ibid.*, p. 236; *Amos e Zaccaria*, p. 2v. On a great number of occasions Savonarola also stated that the end of man is "*la visone di Dio a faccia a faccia*," as, for example, in his *Della semplicità*, p. 166, and *Giobbe*, I: 180.

31. *Amos e Zaccaria*, p. 272.

32. *Quam Bonus*, p. 151.

33. *Esodo*, II: 267.

34. *Quam Bonus*, pp. 165-65v.

35. Kaftal, *St. Catherine*, pp. 46, 76.

36. *Quam Bonus*, pp. 165-65v.

37. Dionysius the Aeropagite, *Divine Names*, Book 4. Marchese, *Memorie*, II: 55, identified this source but did not associate it or the painting with Savonarola, nor did he mention the other two inscriptions.

38. *Ezechiele*, I: 254, for Savonarola's reference to the authority of Dionysius. The passage from Dionysius was quoted explicitly in *Quam Bonus*, pp. 151v, 287-287v; it

135

was implicitly referred to in *Psalms*, p. 115; *Ezechiele*, I: 331; II: 5, 45; *Amos e Zaccaria*, pp. 272, 462v.

39. *Ezechiele*, II: 37.

40. See the relevant passages cited above. The concept of divine love producing ecstasy and taking one outside oneself in a divine furor was very much a part of contemporary Neoplatonic philosophy. See Gombrich, "Icones" p. 171; Edgar Wind, *Pagan Mysteries in the Renaissance* (New Haven, 1958), pp. 61 ff.

41. *Amos e Zaccaria*, p. 271v. The phrase occurred several times in Dionysius the Aeropagite. See, for example, his *Divine Names*, Chapter 4, Parts 12, 15.

42. S. Orlandi, *Libro del Rosario* (Rome, 1965), pp. 130-35, cited the statutes of the Fraternity of the Rosary of San Marco, Florence, of 1481-1485. In 1490 Pope Innocent VIII issued a bull allowing the formation of a confraternity of the rosary; see W. Kirsch, *Handbuch des Rosenkranzes* (Vienna, 1950), p. 115, on the rosary in the fifteenth century and the role of the rosary for Saint Antonine, Savonarola's precursor at San Marco.

43. *Psalms*, II: 13-14, 67-68, 310; *Ezechiele*, I: 384-85; II: 60, 73; *Giobbe*, I: 278; *Ruth e Michea*, I: 98, 437; II: 61; *Amos e Zaccaria*, pp. 46v, 104-04v, 400-400v.

44. There are, for example, many other paintings of the period containing angels circling an image of God the Father or the Madonna in Glory. That it occurs here as well may serve to associate the image with Savonarola, since its origins in all probability lie in Dionysius the Aeropagite's *Heavenly Hierarchy*, Chapter 7, Part 4.

45. *Giobbe*, I: 422. Saints bearing crowns of flowers, including roses, were described by Saints Augustine and Jerome among others. See Charles Joret, *La Rose dans l'antiquité et au moyen age. Histoire, legendes et symbolisme* (Paris, 1892), pp. 238 ff.

46. Barbara Seward, *The Symbolic Rose* (New York, 1960), pp. 18-20; Joret, *La Rose*, pp. 231-32.

47. Joret, *La Rose*, pp. 343-44, 346-47; Seward, *Symbolic Rose*, pp. 36, 43, found this symbolism particularly strong in Saint Bernard of Clairvaux and in Dante.

48. The painting under discussion, along with many other paintings of a similarly visionary nature and divided into two realms, may relate to Saint Bernard of Clairvaux's concept of the two stages of mystic contemplation, the first revealing the saints in glory and the second revealing God Himself. (Seward, *Symbolic Rose*, p. 37, noted the parallel between the dual vision in the last cantos of the *Divine Comedy* and this concept of Saint Bernard.)

49. *Amos e Zaccaria*, pp. 377v-78.

50. Wind, "Sante Pagnini," pp. 233-34, believed that the painting merely reflects Sante Pagnini's "simple mood of piety" which, presumably, stems from Savonarola. He mentioned the passage from Dionysius the Aeropagite inscribed in the painting but failed to note either one of the other two inscriptions.

51. See, for example, *Amos e Zaccaria*, pp. 315v-16.

52. Wind, *Pagan Mysteries*, pp. 24 ff.

53. Savonarola, citing Dionysius the Aeropagite, always associated union with God with triple elements, especially referring to Dionysius' description of the role of the three orders of angels to purge, illuminate, and perfect. (see *Ezechiele*, I: 279-80; *Amos e Zaccaria*, p. 88). There were also, for Savonarola, "three steps of grace and thankfulness: (*Giobbe*, II: 174); the "three graces of the Virgin" (*Ruth e Michea*, II: 73); the "three generations of man" in Christian life; the incipient, proficient, and perfect (*Ruth e Michea*, II: 240-41, also in *Giobbe*, I: 221, 325, and *Quam Bonus*, p. 159); these three stages were also represented in the persons of the three Marys looking for Christ at His tomb (*Giobbe*, II: 396), and so on. Such beliefs naturally called

for, in the sermons, discussions of Platonic philosophy and its "three essences, the formal, causal, and participative" (*Ezechiele*, I: 255, for example), and the nature of the Trinity as well (see especially *Triumphus Crucis*, pp. 414-22).

54. The origin, formation, and history of the Florentine republican government of 1494-1512 have been the subject of several recent studies. See, for example, N. Rubinstein, "Politics and Constitution in Florence at the Turn of the Fifteenth Century," in *Italian Renaissance Studies*, ed. E. F. Jacob (London, 1960), pp. 148-83; also see the latter part of the same author's book *The Government of Florence Under the Medici, 1434-1495* (Oxford, 1966); Felix Gilbert, *Machiavelli and Guicciardini, Politics and History in Sixteenth-Century Florence* (Princeton, 1965); Felix Gilbert, "The Venetian Constitution in Florentine Political Thought" in *Florentine Studies, Politics and Society in Renaissance Florence*, ed. N. Rubenstein (Evanston, 1968), pp. 463-500. J. Wilde, in his article "The Hall of the Great Council of Florence," *Journal of the Warburg and Courtauld Institutes* 7 (1944): 65-81, was seriously handicapped in his arguments by his use of only a single volume of limited selections from Savonarola's sermons (i.e., P. Villari and E. Casanova's *Scelti di prediche e scritti di Fra Giralomo Savonarola* of 1898) and thus barely touched upon the themes explored in the present study.

55. *Psalms*, II: 354 (July 5, 1495), 372 (July 12, 1495).

56. Wilde, "Great Council," p. 68.

57. This revolutionary idea, the total identification of civic government with religion by Savonarola, was one of the reasons for his condemnation in the late seventeenth and eighteenth centuries by proponents of a strict separation of church and state; on the other hand, Savonarola's desire to unite religion with republicanism was the basis for his being praised in the nineteenth century as a precursor of the *Risorgimento*.

58. On the revolution and the formation of the *Consiglio*, see Rubinstein, "Politics and Constitution," pp. 148 ff.

59. In the first of the sermons on Haggai, Savonarola strongly advocated the adoption by Florence of the Venetian form of government because of that system's stability and power. See *Aggeo*, pp. 226, 228. These passages were also cited by Rubinstein, "Politics and Constitution," p. 157, and Wilde, "Great Council," p. 67. Wilde gave the wrong date for the delivery of this sermon. For a thorough discussion of the Florentine interest in the Venetian form of government, see Gilbert, "Venetian Constitution," pp. 463 ff, and Rubinstein, "Politics and Constitution," pp. 155 ff.

60. *Aggeo*, pp. 231-32.

61. *Ibid.*, p. 303.

62. *Ibid.*, p. 214.

63. *Psalms*, II: 324, 366; *Aggeo*, pp. 166-67. On the Florence-Jerusalem parallel, see *Ezechiele*, I: 78; *Amos e Zaccaria*, pp. 35v-36; *Ruth e Michea*, I: 106-07. For other references to Florence in this context, see *Aggeo*, pp. 187-88, 213, 232, 258, 374, 413; *Psalms*, II: 189, 288, 302, 324, 366, 409, 413, 433, 434, 436; *Ruth e Michea*, I: 107, 350, 358-59, 459; II: 85; *Ezechiele*, I: 1, 16, 46, 78, 90, 234, 303; II: 8; *Amos e Zaccaria*, pp. 404-04v, 461-61v, 463 ff.

64. On the Florentines' conception of their generally noble role, see F. Gilbert, "Florentine Political Assumptions in the Period of Savonarola and Soderini," *Journal of the Warburg and Courtauld Institutes* 20 (1957): 210 ff, and D. Weinstein, *Savonarola and Florence, Prophecy and Patriotism in the Renaissance* (Princeton, 1970), Chapter 1, "The Myth of Florence." See also Chapter 4 on Florence as Jerusalem.

65. *Psalms*, II: 135, 221, 287-88, 372, 426; *Ezechiele*, I: 81, 96; II: 8, 266; *Ruth e Michea*, II: 121, 408; *Amos e Zaccaria*, pp. 94, 495.

66. *Aggeo*, pp. 422, 423, 426.

67. *Giobbe*, II: 362; *Ruth e Michea*, I: 101, 145. The same theme occurred even in his first sermons which were given one year before the revolution. In these Savonarola related an inscription on the Temple of Solomon, and a similar inscription from the Apocalypse, and stated that these are his sources. See *Quam Bonus*, pp. 245v, 278v, 292v.

68. *Psalms*, II: 287, 288, 324, 354, 401-02, 405, 409, 413, 418, 423, 427, 436, 437, 442, 444.

69. *Amos e Zaccaria*, p. 93v. In the forty-eighth sermon of this series, the theme of Christ as the king of Florence was presented on twenty-four separate occasions. See, for example, pp. 16v, 35v, 46v, 71.

70. See *Amos e Zaccaria*, p. 1, and the end of the sermon of March 8 of the same series, p. 216v. On several occasions Savonarola himself called for such exclamations from his audience at the conclusions of his sermons in this series; see, for example, p. 407v (March 27).

71. Luca Landucci, *A Florentine Diary from 1450 to 1516*, trans. A. de R. Jervis (London and New York, 1927), p. 127.

72. *Amos e Zaccaria*, p. 216v. In his sermon of February 4 (same series), Savonarola advised children to cry out "*Viva Cristo*" on the morning of Palm Sunday (p. 46v).

73. Landucci, *Diary*, p. 128.

74. P. Ginori, ed., *La vita del Beato Ieronimo Savonarola* (Florence, 1937), pp. 129.

75. *Ruth e Michea*, I: 96, 100, 101, 106, 122, 406, 413, 414; II: 55, 56, 57, 58, 137. It was not until the restoration of the republic (it collapsed in 1512) and the reinstitution of the *Gran Consiglio* in 1527 that Christ was actually, by a solemn decree, elected king of Florence. See Cecil Roth, *The Last Florentine Republic* (London, 1925), pp. 76-77, 82-83, n. 109, and Wilde, "Great Council," p. 78. In June, 1528, an inscription commemorating this event was placed above the facade entrance of the Palazzo Vecchio. See Alfredo Lensi, *Palazzo Vecchio* (Milan and Rome, 1929), pp. 110, 116. At present, in this location on the facade, is a plaque with the following inscription: REX REGUM ET DOMINUS DOMINANTIUM, which was set in place by Duke Cosimo I, who, as Roth (*Republic*, pp. 76-77) remarked, hardly dared to abolish the inscription completely and thus replaced it with one which expressed a more remote lordship over Florence. However, ironically, the phrase "King of Kings and Lord of Lords" was also used by Savonarola in relation to the founding of the republic and Christ's kingship over it. He even stated that these words were placed over the entrance to the sanctuary in King Solomon's palace and identified his rule with the reign of God (*Quam Bonus*, p. 245v), which, in turn, was related to the new government of Florence. Also see his other references to this inscription in *Quam Bonus*, pp. 278v, 292v; *Giobbe*, II: 362; *Ruth e Michea*, I: 101; II: 55; *Ezechiele*, I: 72, 180; II: 234. A marble plaque containing the above inscription, now in the National Gallery, Washington, D.C. (catalog number A125), and dating from the turn of the fifteenth century, may be the plaque originally carved for the *palazzo*. Its dimensions, 2' 10" X 4' 8", certainly indicate an architectural setting. The inscription presently above the entrance to the *palazzo* is not much larger.

76. Transcribed in Girolamo Savonarola, *Poesie* (Rome, 1968), pp. 45-46. The editor of this volume, M. Martelli, cast some doubts on the authenticity of this verse; see pp. 57ff.

77. *Psalms*, II: 135.

78. Wilde, "Great Council," p. 67.

79. *Psalms*, II: 354.

80. *Ibid.*, p. 372.

81. *Ibid.*, p. 391. This passage is cited by Wilde, "Great Council," p. 68. However,

he did not mention Savonarola's references in this passage to the security of the government gaining with the completion of the *sala*. Wilde did refer to Landucci's remarks about Savonarola's continually calling for the completion of the room. Landucci constantly recorded the progress of the construction; see, for example, *Diary*, pp. 114, 131.

82. *Psalms*, II: 427.

83. Wilde, "Great Council," pp. 68, 76.

84. *Ibid.*, p. 68.

85. *Ezechiele*, I: 1, 46, 51, 78, 81, 96 (November 30 to December 13, 1496). This series continued until May, 1497.

86. *Ezechiele*, I: 69 ff.

87. *Ibid.*, pp. 100-01.

88. *Ibid.*, pp. 17-20, 166ff; *Amos e Zaccaria*, p. 157v; *Psalms*, II: 40; *Quam Bonus*, pp. 164v-165; *Triumphus Crucis*, pp. 293-96, 355f.

89. Landucci, *Diary*, p. 126. Wilde, "Great Council," p. 74, concluded that this and another plaque (see n. 42) were set up according to a resolution of May 22, 1498. He referred to Lensi, *Palazzo Vecchio*, pp. 81 and p. 115, n. 77 for this date.

90. *Psalms*, II: 302 (June 14, 1495), 309-10, 418, 426; *Amos e Zaccaria*, pp. 495, 301v, 505 (April 10, 1496), *Ezechiele*, I: 51 (December 8, 1496), 96 (December 13, 1496); II: 114-15 (March 7, 1497). Wilde, in "Great Council," p. 74, stated that the inscription was a "monumental extract" from Savonarola's sermons, when actually it was word for word in accord with the *frate*'s phrases and its use followed his specific directions.

91. Landucci, *Diary*, p. 126.

92. *Psalms*, II: 391-92.

93. *Ibid.*, p. 410.

94. *Ibid.*, p. 427.

95. Wind, "Sante Pagnini," pp. 235-36; Gilbert, *Machiavelli*, pp. 76 ff; Rubinstein, "Politics and Constitution," p. 181; Wilde, "Great Council," pp. 76-77.

96. See Gabelentz, *Fra Bartolomeo*, I: 147-49.

97. In his treatise *Il Trionfo della Croce*, (see *Triumphus Crucis*, p. 296), Savonarola described the Trinity as "A light from the sun that has three faces," although his precursor at San Marco, Saint Antonine, condemned such representations of the Trinity. See, Creighton Gilbert, "The Archbishop on the Painters of Florence, 1450," *Art Bulletin* 45 (1959): 76. Wind, "Sante Pagnini," p. 236, also noted the passage in Savonarola's treatise.

98. See, for examples, the illustrations in B. Kleinschmidt, *Die Heilige Anna* (Düsseldorf, 1930).

99. Mirella L. D'Ancona, *The Iconography of the Immaculate Conception in the Middle Ages and the Early Renaissance* (New York, 1957), pp. 39 ff.

100. *Ibid.*, p. 37.

101. *Quam Bonus*, pp. 194v-98.

102. On Savonarola's fame in the early sixteenth century, see Schnitzer, *Savonarola*, II: 463 ff.

103. Giorgio Vasari, *Le Vite de più eccel'ente architetti, pittori, et scultori italiani*, 3 vols. (Florence, 1568), III: 39-40.

104. Various attempts have been made to identify the saints. Marchese, *Memorie*, II: 133, identified six of the saints: Giovanni Gualberto, Reparata, Zenobius, Barbara, Vito, and Antonio. The identification of Saints Reparata and Barbara is surprising, since there is obviously only one female saint present aside from the Virgin and Saint

Anne. Gabelentz, *Fra Bartolomeo*, p. 167, identified the figure at the lower left holding a book as Saint John the Evangelist, the female saint as Reparta, and the bishop at the lower right as Zenobius. Wilde, "Great Council," p. 77, and Wind, "Sante Pagnini," p. 239, followed Vasari's generalized identification of the saints, and the former noted that along with the Saint John the Baptist the painting contains the two other patron saints of Florence, Bernardo and Zenobio, and also Saint Vittoria.

105. Of the two bishop saints at the right only one holds a recognizable attribute, a banner. The only bishop saint with such an attribute is Saint Constantius of Perugia whose feast day is, according to the modern calendar, January 29 (see, Kaftal, *Saints*, pp. 288-89). The only Florentine victory that occurred at the end of January, the defeat of Pistoia in 1378, was on the 28th day of that month (Kaftal, *Saints*, p. 1257). There are, in all, five bishop saints upon whose days Florence was victorious, but only one bishop in the painting. If Vasari was correct, this figure must represent Saint Zenobius, one of the patrons of the city. Any one of the three bishops in the painting may (or may not) represent any one of these six bishops. Similarly, any one of the nine holy monks on whose feast days Florence won honor may be represented by either of the two monks in the painting. The one female saint should represent Saint Reparata, another important patron of Florence, but none of her usual attributes are present. There are three other virgin martyrs who were important for Florence, but their customary attributes are also lacking in the painting.

106. Giovanni Villani, *Cronica*, 4 vols. (Florence, 1845), IV: 31. On the duke of Athens and his reign, see Marvin B. Becker, *Florence in Transition*, Vol. I, *The Decline of the Commune* (Baltimore, 1967), pp. 123 ff; Gene A. Brucker, *Florentine Politics and Society, 1348-1378* (Princeton, 1962), p. 7 f.

107. Lensi, *Palazzo Vecchio*, p. 28. The frescoes of Domenico Ghirlandaio in the Sala dei Gigli of the Palazzo Vecchio, dating from 1481-85, as well as many other monuments in Florence of a political significance, also show the red crosses on a white ground, the traditional badge of the *capitano del popolo*. The painting with Saint Anne was originally in the Carceri degli Stinche, but was later moved to the Palazzo Vecchio, (*Ibid.*, p. 33).

108. Niccolò Machiavelli, *History of Florence and the Affairs of Italy* (New York and London, 1901), pp. 90-107. Particularly significant for the meaning of this event to Machiavelli is the (apocryphal) address transcribed by him, which was presented to the duke by a delegation of citizens demanding liberty for Florence (*Ibid.*, p. 91). Gilbert, in *Machiavelli*, p. 238, stated that the episode of the duke of Athens contained, for Machiavelli, a very important historical lesson.

109. Gilbert, *Machiavelli*, p. 232.

110. On the painting for the convent of Saint Anne, see Frederick M. Clapp, *Jacopo Carucci da Pontormo* (New Haven and London, 1916), p. 168. On the moving of the *Consiglio* painting, see Roth, *Republic*, pp. 106-07, who merely recorded the event.

111. This symbolism may have been known to Vasari. As Clapp, *Pontormo*, p. 168, noted, Vasari knew that the Pontormo painting was commissioned for the convent of Saint Anne by the *Signoria*. Vasari thus may have transferred the meaning of Saint Anne to the other saints as well in the Fra Bartolomeo painting.

112. Wilde, "Great Council," pp. 77-78.

113. *Ibid.*, p. 78, referred to this declaration in Savonarola's sermons of "a few months after the revolution" when actually it was voiced by Savonarola much sooner.

114. The Simone Martini *Maestà* and the Ambrogio Lorenzetti frescoes in the Sala della Pace, both in the Palazzo Pubblico, Siena, and the Ghirlandaio frescoes in the Palazzo Vecchio, are examples of this kind of symbolic painting in government chambers. In one of his sermons in the *Ruth e Michea* series (II: 144-45), while discoursing on the subject of justice, Savonarola remarked that the Lord says "do justice!," which means

acts of justice, and that He does not want so many paintings of justice, but deeds of justice. The Sala del Gran Consiglio, known today as the Sala del Cinquecento, ironically has an iconography of the later sixteenth century commemorating Duke Cosimo I.

CHAPTER 14

1. On the Fra Bartolomeo portrait, see H. Von Der Gabelentz, *Fra Bartolomeo und die florentiner Renaissance*, 2 vols. (Leipzig, 1922); on the Corniole gem, see Joseph Schnitzer, *Savonarola*, 2 vols. (Milan, 1931), II: illustration at p. 208.

2. See A Marquand, *The Brothers of Giovanni della Robbia* (Princeton, 1928), pp. 6-7, 46-48.

3. See Chapter 13.

4. Marquand, *della Robbia*, pp. 46-48.

5. See Gabelentz, *Fra Bartolomeo*, I: 145-46.

6. The painting is in the Campetti Collection, Lucca.

7. See Chapter 13 on Fra Bartolomeo's *Madonna della Misericordia* in Lucca for Savonarola's reference to the Virgin as the intercessor for Florence before Christ.

8. The illustration is from Schnitzer, *Savonarola*, II: 464. Schnitzer did not give the location, medium, or size of the work, and we have been able to find no other references to it.

9. Giorgio Vasari, *Le Vite de più eccelènte architetti, pittori, et scultori italiani*, 3 vols. (Florence, 1568), II: 7, cited a portrait of Savonarola among the Doctors of the Church in Raphael's *Disputà*. Of all the figures in that portion of the painting, it is most probable that Vasari was referring to the one seen in full-face, his head cowled. The large nose, deepset eyes, and somber expression of this head could suggest the features and, perhaps, the character of Savonarola.

CHAPTER 15

1. R.G. Collingwood, *The Idea of History* (New York, 1956), p. 248.

BIBLIOGRAPHY

Andrews, Keith. *The Nazarenes, A Brotherhood of German Painters in Rome.* Oxford: The Clarendon Press, 1964.

Augustine, Saint. *On Christian Doctrine.* Translated by D. W. Robertson. New York: Liberal Arts Press, 1958.

Baron, Hans. *The Crisis of the Early Italian Renaissance.* Princeton: Princeton University Press, 1955.

Bayle, Peter. *The Dictionary Historical and Critical of Peter Bayle.* London: J. J. and P. Knapton, 1738.

Becker, Marvin B. *Florence in Transition.* Vol. 1, *The Decline of the Commune.* Baltimore: The Johns Hopkins Press, 1967.

Benivieni, G. *Trattato in defensione e probazione della dottrina e profezie predicate da frate Ieronimo da Ferrara nella città di Firenze.* Florence, 1496.

Beyer, H. W. *Die Religion Michelangelos.* Bonn, 1926.

Blunt, Anthony. *Artistic Theory in Italy, 1450-1600.* Oxford: Clarendon Press, 1956.

Bode, Wilhelm von. "Gruppe der Beweinung Christi von Giovanni della Robbia und der Einfluss des Savonarola auf die Entwickelung der Kunst in Florenz." *Jahrbuch der Königlich Preussischen Kunstsammlungen* 8 (1887): 217-30.

————. *Sandro Botticelli.* New York: E. P. Dutton & Co., 1910.

Bowen, Desmond. *The Idea of the Victorian Church.* Montreal: McGill University Press, 1968.

Breisach, Ernst. *Caterina Sforza.* Chicago and London: University of Chicago Press, 1967.

Brucker, Gene A. *Florentine Politics and Society, 1348-1378.* Princeton: Princeton University Press, 1962.

Burlamacchi, P. (attributed to). *La Vita del Beato Ieronimo Savonarola* (*Vita latina*). Edited by P. Ginori. Florence: Olschki, 1937.

Cartwright, Julia. *The Life and Art of Sandro Botticelli.* New York and London: E. P. Dutton & Co. and Duckworth & Co., 1904.

Chastel, André. *Art et humanisme à Florence.* Paris: Presses Universitaires de France, 1959.

————. *The Flowering of the Italian Renaissance.* New York: The Odyssey Press, 1965.

142

————. "Vasari et la legende medicéene: L'École du jardin de Saint Marc." *Studi Vasariani* (1952): 159-67.

Chateaubriand, François-René. de., *Oeuvres complètes*. Vol. 2, *Génie du christianisme*. Paris: Garnier Frères, 1859.

Clapp, Frederick M. *Jacopo Carucci da Pontormo*. New Haven and London: Yale University Press and Oxford University Press, 1916.

Cochin, Charles. *Voyage d'Italie*. Paris: C. A. Jombert, 1758.

Collingwood, R. G. *The Idea of History*. New York: Oxford University Press, 1956.

Condivi, Ascanio. *Michelangelo Buonarroti*. Translated by C. Holroyd. London and New York: Duckworth and Co. and Charles Scribner's Sons, 1911.

————. *Vita di Michelangiolo*. Florence: Rinascimento del Libro, 1938.

Curtius, Ernst Robert. *European Literature and the Latin Middle Ages*. New York: Harper Torchbooks, 1963.

D'Ancona, Mirella L. *The Iconography of the Immaculate Conception in the Middle Ages and the Early Renaissance*, College Art Association of America and the Art Bulletin, 1957.

————. *Miniatura e miniaturi a Firenze dal XIV al XVI secolo*. Florence: Olschki, 1962.

Davies, Martin. *The Earlier Italian Schools*. London: National Gallery Catalogue, 1961.

Deetz, Maria. *Anschauungen von italianische Kunst in der deutschen Literatur von Winkelmann bis zur Romantik*. Wiesbaden, 1967.

DeTolnay, Charles. *The Art and Thought of Michelangelo*. New York: Pantheon Books, 1964.

————. *The Youth of Michelangelo*. 2 vols. Princeton: Princeton University Press, 1953.

Dionysius the Areopagite. *Works*. Translated by Rev. J. Parker. London: James Parker and Co., 1897.

Ferguson, George W. *Signs and Symbols in Christian Art*. New York: Oxford University Press, 1955.

Ferguson, Wallace K. "The Reinterpretation of the Renaissance." *Facets of the Renaissance*. Edited by W. H. Werkmeister. New York, Evanston, and London: Harper Torchbooks, 1959.

————. *The Renaissance in Historical Thought, Five Centuries of Interpretation*. Cambridge, Mass.: Houghton Mifflin Co., 1948.

Ferrara, Mario. "Una tela del Botticelli d'ispirazione savonaroliana." *Rivista del R. Istituto d'Archeologia e Storia dell'Arte* 4 (1932): 82-90.

————. *Savonarola, Prediche e scritti commentati e collegati da un racconto biografico, l'influenza del Savonarola sulla letteratura e l'arte del Quattrocento—Bibliografia ragionata*. Florence: Leo S. Olschki, 1952.

————. *Bibliografia savonaroliana*. Florence: Leo S. Olschki, 1958.

Frantz, E. *Fra Bartolomeo della Porta*. Regensberg: G. J. Manz, 1879.

Freedberg, S. J. *Painting of the High Renaissance in Rome and Florence*. 2 vols. Cambridge, Mass.: Harvard University Press, 1961.

Gabelentz, H. von der. *Fra Bartolomeo und die florentiner Renaissance*. 2 vols. Leipzig: Karl W. Hiersemann, 1922.

Gaunt, William. *The Pre-Raphaelite Dream.* New York: Schocken Books, 1966.

Gentile, G. *Gino Capponi e la cultura toscana nel secolo decimonono.* Florence: Vallecchi, 1922.

Gilbert, Creighton. "The Archbishop on the Painters of Florence, 1450." *Art Bulletin* 45 (1959): 74-78.

Gilbert, Felix. "Florentine Political Assumptions in the Period of Savonarola and Soderini." *Journal of the Warburg and Courtauld Institutes* 20 (1957): 187-218.

————. *Machiavelli and Guicciardini, Politics and History in Sixteenth-Century Florence.* Princeton: Princeton University Press, 1965.

————. "The Renaissance Interest in History." In *Art, Science, and History in the Renaissance.* Edited by C. Singleton. Baltimore: The John Hopkins Press, 1967.

————. "The Venetian Constitution in Florentine Political Thought." In *Florentine Studies, Politics and Society in Renaissance Florence.* Edited by N. Rubinstein. Evanston: Northwestern University Press, 1968.

Ginori, P., ed., *La vita del Beato Ieronimo Savonarola.* Florence: Leo S. Olschki, 1937.

Gobineau, J. A. de. *La Renaissance, scènes historiques.* Paris: Plon, 1877.

Gombrich, E. H. "Icones Symbolicae, the Visual Image in Neo-Platonic Thought." *Journal of the Warburg and Courtauld Institutes* 11 (1948): 163-92.

Gooch, G. P. *History and Historians in the Nineteenth Century.* London: Longmans, Green & Co., 1913.

Gruyer, Gustave. *Les Illustrations des écrits de Jérôme Savonarole publiés en Italie au XVe au XVIe siècle et les paroles de Savonarole sur l'art.* Paris: Firmin-Didot, 1879.

Guicciardini, Francesco. *The History of Italy.* Translated by S. Alexander. New York and London: The Macmillan Company and Collier-Mcmillan, 1969.

Hirsch, L. *San Marco in Florenz, das Kloster Savonarolas,* Stuttgart, 1908.

Honisch, Dieter. *Anton Raphael Mengs und die Bildform des Frühklassizismus,* Recklinghausen: Bongers, 1965.

Horne, Herbert P. *Alessandro Filipepi Commonly Called Sandro Botticelli.* London: G. Bell & Sons, 1908.

Jacob, E. F., ed. "Introduction: An Approach to the Renaissance." *Italian Renaissance Studies.* London: Faber & Faber, 1960.

Jameson, Mrs. *Sacred and Legendary Art.* London, 1848.

Joret, Charles. *La Rose dans l'antiquité et au moyen âge.* Paris: Emile Bouillon, 1892.

Kaftal, George. *Iconography of the Saints in Tuscan Painting.* Florence: C. G. Sansoni, 1952.

————. *St. Catherine in Tuscan Painting.* Oxford: Blackfriars, 1949.

Katzenellenbogen, Adolf. *The Sculptural Programs of Chartres Cathedral.* New York: The Norton Library, 1964.

Kennedy, Ruth W. *Alesso Baldovinetti.* New Haven and London: Yale University Press and Oxford University Press, 1938.

BIBLIOGRAPHY

King, A. A. *Liturgies of the Religious Orders*. London and New York: Longmans Green, 1955.

Kirsch, W. *Handbuch des Rosenkranzes*. Vienna: Wiener-Dom, 1950.

Kleinschmidt, B. *Die Heilige Anna*. Düsseldorf: L. Schwann, 1930.

Klenze, Camillo von. "The Growth of Interest in the Italian Masters." *Modern Philology* 4 (1906): 240 ff.

Knapp, Fritz. *Fra Bartolomeo della Porta und die Schule von San Marco*. Halle a.S.: Wilhelm Knapp, 1903.

Kristeller, Paul, O. *Renaissance Thought II*. New York: Harper Torchbooks, 1965.

Kugler, Franz. *Handbuch der Geschichte der Maleri*. Berlin: Duncker & Humblot, 1837.

Landsberger, F. "Trauer um den tod Savonarolas, zur Deutung des Derelitta-Bildes." *Zeitschrift für kunstgeschichte* 2 (1933): 275-78.

Landucci, Luca. *A Florentine Diary from 1450 to 1516*. Translated by A. de R. Jervis. London and New York: N. J. Dent & Sons and E. P. Dutton, 1927.

Lee, Rensselaer W. *Ut Pictura Poesis: The Humanistic Theory of Painting*. New York: The Norton Library, 1967.

Lensi, Alfredo. *Palazzo Vecchio*, Milan and Rome: Bestetti & Tumminelli, 1929.

Levey, M. "Botticelli and Nineteenth Century England." *Journal of the Warburg and Courtauld Institutes* 23 (1960): 291-306.

Levin, Harry. *The Myth of the Golden Age in the Renaissance*. Bloomington and London: Indiana University Press, 1969.

Lindsay, Lord. *Sketches of the History of Christian Art*. 4 vols. London: J. Murray, 1847.

Machiavelli, Niccolò. *History of Florence and the Affairs of Italy*. New York and London: M. W. Dunne, 1901.

Marchese, Padre Vincenzo. *Memorie dei più insigni pittori, scultori, e architetti domenicani*. 2 vols. Florence: Felice le Monnier, 1854.

Marquand, A. *The Brothers of Giovanni della Robbia*. Princeton: Princeton University Press, 1928.

Meyer, Julius. "Zur Geschichte der florentinischen Malerei des XV Jahrhunderts" *Jahrbuch der Königlich Preussischen Kunstammlungen* 11 (1890): 3-35.

Murrin, Michael. *The Veil of Allegory*. Chicago and London: University of Chicago Press, 1969.

Neilson, Katherine B. *Filippino Lippi*. Cambridge, Mass.: Harvard University Press, 1938.

Ollard, S. L. *A Short History of the Oxford Movement*. London: Faith Press Reprints, 1963.

Orlandi, S. *Libro del Rosario*. Rome: Centro Internazionale Domenicano Rosariano, 1965.

Panofsky, Erwin. *Early Netherlandish Painting*. 2 vols. Cambridge, Mass.: Harvard University Press, 1953.

———. *Renaissance and Renascences in Western Art*. Stockholm: Almqvist & Wikfell, 1960.

————. *Idea, A Concept in Art Theory*. Columbia, South Carolina: University of South Carolina Press, 1968.

————. *Studies in Iconology, Humanistic Themes in the Art of the Renaissance*. New York: Harper Torchbooks, 1962.

Pastor, Ludwig, F. von. *The History of the Popes*. Vol. 5. London: Kegan Paul, Trench, Trubner & Co., 1923.

Pater, Walter. *The Renaissance*. New York: Modern Library, n.d.

Reau, Louis. *Iconographie de l'art chrétien*. 2 vols. Paris: Presses Universitaries de France, 1957.

Reynolds, Sir Joshua. *Discourses delivered to the students of the Royal Academy*. London: Seeley & Co., 1905.

Ridolfi, Roberto. *Vita di Girolamo Savonarola*. Rome: Angelo Belardetti, 1952.

Rio, A. F. *The Poetry of Christian Art*. London: T. Bosworth, 1854.

Robb, N. *Neoplatonism of the Italian Renaissance*. London: George Allen & Unwin Ltd., 1935.

Rosenbloom, Robert. "Origin of Painting: A Problem in the Iconography of Romantic Classicism." *Art Bulletin* 39 (1957): 279-90.

Roth, Cecil. *The Last Florentine Republic*. London: Methuen & Co., Ltd., 1925.

Rubinstein, N. "Vasari's Painting of the *Foundation of Florence* in the Palazzo Vecchio." In *Essays in the History of Architecture Presented to Rudolf Wittkower*. Edited by Douglas Fraser, Howard Hibbard, and Milton J. Lewine. London: Phaidon, 1969.

————. "Politics and Constitution in Florence at the End of the Fifteenth Century." In *Italian Renaissance Studies*. Edited by E. F. Jacob. London: Faber & Faber, 1960.

————. *The Government of Florence Under the Medici, 1434 to 1494*. Oxford: Clarendon Press, 1966.

Salvini, Roberto. *Tutta la pittura del Botticelli*. 2 vols. Milan: Rizzoli, 1958.

Savonarola, Fra Girolamo. *Bibliografia delle opere del. I. Cronologia e bibliografia delle prediche*. Edited by R. Ridolfi. Florence: Fondazioni Ginori Conti, 1939.

————. *E'Libri della semplicità della vita cristiana*. Edited by P. G. Ricci. Rome: Angelo Belardetti, 1959.

————. *Poesie*. Edited by M. Martelli. Rome: Angelo Belardetti, 1968.

————. *Prediche eccelèntissime del Reverendo Padre Fra Girolamo Savonarola da Ferrara del ordine de predicatori, nuovamente venute in luce sopra il Salmo Quam Bonus Israel Deus*. Venice: Brandino & Ottaviano Scoto a di sedese di Mazo, 1539.

————. *Prediche italiane ai Fiorentini giorni festivi del 1495*. II (on Psalms). Edited by F. Cognasco. Perugia and Venice: "La Nuova Italia," 1930.

————. *Prediche italiane ai Fiorentini, Quaresniali del 1496* III 2 & 3 (on Amos and Zachariah). Edited by Roberto Palmarocchi, "La Nuova Italia," 1935.

————. *Prediche quadragesimale del reve. P. F. Ieronimo Savonarola da Ferrara, sopra Amos propheta, e sopra Zaccaria*. Venice: Alovixe de Tortis, 1544.

————. *Prediche sopra Aggeo con il trattato circa il reggimento e governo della città di Firenze*. Edited by L. Firpo. Rome: Angelo Belardetti, 1965.

146

——. *Prediche sopra l'Esodo*. 2 vols. Edited by P. G. Ricci. Rome: Angelo Belardetti, 1955.

——. *Prediche sopra Ezechiele*. 2 vols. Edited by R. Ridolfi. Rome: Angelo Belardetti, 1955.

——. *Prediche sopra Giobbe*. Edited by R. Ridolfi. Rome: Angelo Belardetti, 1957.

——. *Prediche sopra Ruth e Michea*. 2 vols. Edited by V. Romano. Rome: Angelo Belardetti, 1962.

——. *Triumphus Crucis, testo latino e volgare*. Edited by M. Ferrara. Rome: Angelo Belardetti, 1961.

Scharf, Alfred. *Filippino Lippi*. Vienna: A. Schroll & Co., 1935.

Schlegel, Friedrich von. *The Aesthetic and Miscellaneous Works*. London: G. Bell & Sons, 1889.

Schnitzer, Joseph. *Savonarola*. 2 vols. Milan: Fratelli Treves, 1931.

Schultze, V. *Das Kloster San Marco in Florenz*. Leipzig, 1888.

Seward, Barbara. *The Symbolic Rose*. New York: Columbia University Press, 1960.

Seymour, Charles. *Michelangelo's David*. Pittsburgh: University of Pittsburgh Press, 1967.

Silz, Walter. *Early German Romanticism, Its Founders and Heinrich von Kleist*. Cambridge, Mass.: Harvard University Press, 1929.

Steinberg, Leo. "Metaphors of Love and Birth in Michelangelo's Pietas." In *Studies in Erotic Art*. Edited by C. Christenson. New York: Basic Books, 1970.

Steinberg, Ronald M. "Fra Bartolomeo, Savonarola and a Divine Image." *Mitteilungen des Kunsthistorischen Institutes in Florenz* 18 (1974): 319-28.

Steinhauser, N. "Savonarolas Einfluss auf die Kunst und Künstler." *Historisch-politische Blätter für das katholische Deutschland* 139 (1903): 423-34.

Steinmann, E. Sandro Botticelli. Bielefeld and Leipzig: Velhagen & Klasing, 1897.

Supino, J. B. *Sandro Botticelli*. Florence, 1900.

Sussmann, Vera. "Maria mit dem Schutzmantel." *Marburger Jahrbuch für Kunstwissenschaft* 5 (1929): 285-351.

Symonds, John A. *Renaissance in Italy*. 2 vols. New York: The Modern Library, n.d.

Thieme, U., and F. Becker. *Allgemeines Lexikon der bildenden Künstler*. Vol. 11. Leipzig: E. A. Seemann, 1915.

Thode, H. *Franz von Assisi und die Anfänge der Kunst der Renaissance in Italien*. Berlin, 1885.

——. *Michelangelo*. 4 vols. Berlin: G. Grote'sche, 1908.

Ulmann, Herman. *Sandro Botticelli*. Munich: Verlangsanstalt für Kunst und Wissenschaft, 1893.

Vasari, Giorgio. *Le Vite dei più eccèlenti architetti, pittori, et scultori italiani*. Florence: Lorenzo Torrentino, 1550.

——. *Le Vite dei più eccèlenti architetti, pittori, et scultori italiani*. 3 vols. Florence: I. Giunti, 1568.

147

————. *Le Vite dei più eccelènti architetti, pittori, et scultori italiani.* Edited by G. Milanese. 9 vols. Florence: G. C. Sansoni, 1879-1906.

————. *Le Vite di Michelangelo nelle redazioni del 1550 e del 1568.* Edited by P. Barocchi. Milan: Ricardo Ricciardi, 1962.

Venturi, Lionello. *Sandro Botticelli.* London: Phardon, 1961.

Villani, Giovanni. *Cronica di.* 4 vols. Florence: Sansone Coen, 1845.

Villari, P., and E. Casanova. *Scelta di prediche e scritti di Fra Girolamo Savonarola con nuovi documenti intorno alla sua vita.* Florence: G. C. Sansoni, 1898.

Villari, P. *Life and Times of Girolamo Savonarola.* 2 vols. London: T. Fisher Unwin, 1889.

————. *La storia di Girolamo Savonarola.* 2 vols. Florence: Le Monnier, 1930.

Wackenroder, W. H. *Herzensergiessungen eines Kunstliebenden Klosterbruders.* Berlin: Johann Friedrich Unger, 1797.

Waetzoldt, Wilhelm. *Deutsche Kunsthistoriker.* Berlin: B. Hessling, 1965.

Weinberg, Bernard. *A History of Literary Criticism in the Italian Renaissance.* 2 vols. Chicago: The University of Chicago Press, 1961.

Weinstein, D. *Savonarola and Florence, Prophecy and Patriotism in the Renaissance.* Princeton: Princeton University Press, 1970.

Weisbach, Werner. *Trionfi.* Berlin: G. Grote'sche, 1919.

Wilcox, Donald J. *The Development of Florentine Humanist Historiography in the Fifteenth Century.* Cambridge, Mass.: Harvard University Press, 1969.

Wilde, J. "The Hall of the Great Council of Florence." *Journal of the Warburg and Courtauld Institutes* 7 (1944): 65-81.

Wilkins, E. *The Rose-Garden Game, A Tradition of Beads and Flowers.* New York: Herder & Herder, 1969.

Wind, Edgar. "The Subject of Botticelli's 'Derelitta.' " *Journal of the Warburg and Courtauld Institutes* 4(1940-1941): 28-117.

————. "Sante Pagnini and the Art of Michelangelo, A Study in the Succession of Savonarola." *Gazette des Beaux-Arts* 26 (1944): 210-46.

————. *Pagan Mysteries in the Renaissance.* New Haven: Yale University Press, 1958.

Wittkower, Rudolf. *Architectural Principles in the Age of Humanism.* New York: Random House, 1965.

Wittkower, M. and R. *Born Under Saturn.* New York: Random House, 1963.

Wölfflin, Heinrich. *The Art of the Italian Renaissance.* New York: Schocken Books, 1966.

Young, G. F. *The Medici.* New York: E. P. Dutton & Co., 1910.

Zeri, P. *La Galleria Pallavicini.* Florence: Sansoni, 1959.

INDEX